LaRucco

Doc. Zippø

THE AUTHOR HAS VOMITED HER HEART.

Zippø is a call for honesty...
I feel blessed to have read the book.

from the introduction by **John S. Hall**

Document Zippø
Copyright 1998 L. A. Ruocco
Published by Soft Skull Press

Editorial: Karla Zounek, Sander Hicks, & Sparrow
Designed by L. A. Ruocco & John Hobbs
Cover Designed by John Hobbs
Production Assistance by Don Goede, M. Portnoy Soybomb & Dustin
Printed at United Graphics Inc., a worker-owned company
Distributed by Consortium Book Sales & Distribution

Photography:
Maurice Narciss (pp. 142-144)
Jared Collins (cover flap)
Spencer Tunick (p. 119)
Ricardo Sipio (p. 137)

FIRST EDITION of 1,500
Printed November, 1998
ISBN # 1 887128 29 8
www.softskull.com

This is dedicated to the one-eyed love. ✱

& also, to my mother, who rubbed my legs when they were cramping,
& my head when it was breaking.

✱ "one-I'd," double-entén: "cyclops" – eye see ref. Linguistics 101 pallindrone, **p. 117**; also chapter, "Bottom & Back Down Again," **p.212** for the eye *hole* in the dizzying kaleidoscope mosaic tile floor **that I am addicted to.**

Master Guide

Thanks For Visiting Zippø!
Your Cashier L. A. Ruocco

#1 Ønion

The Crack in the Constipated Spine of the Book
An Internal Reference Guide
& Bluepoint Blinkout-Blinkon Pupil Dilation Zone

SUB-SEQUEL TO CAFÉ ZIPPØ SUBSECTIONS

ONOMASTICON · ONOMASTICON · ONOMASTICON

Number 2

Escape Through the Bowels of the Planet

SUBSECTIONS:

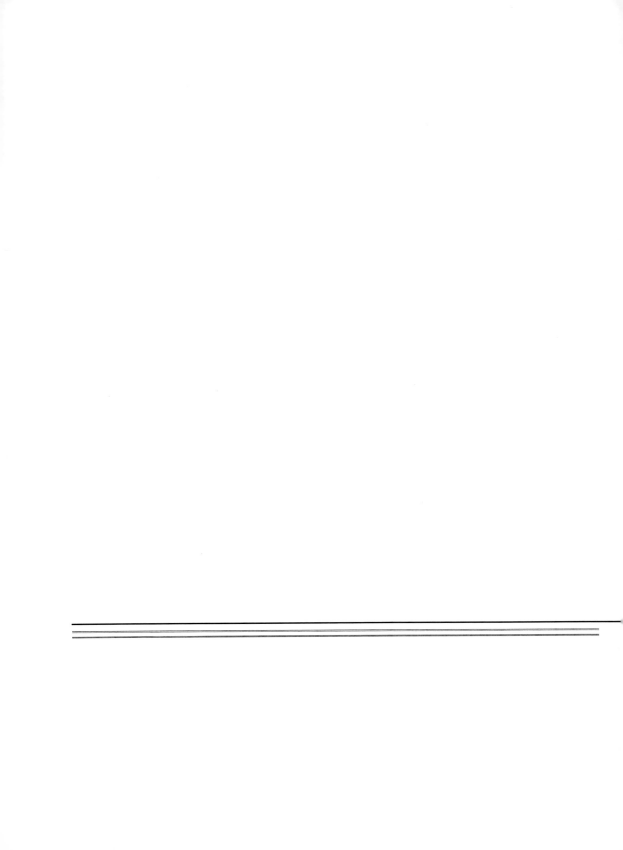

by John S. Hall

ABOUT A YEAR AND A HALF AGO,

L.A.Ruocco gave me a copy of ZiPPØ and said,
" I believe this belongs amungst your collection on this bookshelf."
It did indeed. The book was a work of art, with a hand-made, hand-printed cover on, I believe, corrugated cardboard. On the inside front cover was a piece of white fabric smeared with, I assumed, menstrual blood. I knew immediately this was to be a candid book. Since I have never been the type to say, "That's more information than I need to know," I pushed on.

I passed it on to Soft Skull, and was told almost immediatly that it was going to be published, which made me very happy. When I find out about something wonderful, I want to tell everyone I can about it. So here I am, writing an introduction to a book that has baffled and challenged me for some 18 months.

Although this edition has been mass-produced and each copy is no longer a unique, individual work, the new version of Zippø offers much more than the original. The original Zippø [of 179 copies] was comprised of what in this edition is merely the first third. Now there are not only three parts, but more importantly, copious footnotes that explain the concepts and art movements the author has invented, and the relationships between the narrative, artistic, and philosophical ideas contained herein. A few footnotes explain some of the jokes; some of the footnotes ARE the joke. If Joyce had made footnotes, I might have read *Ulysses* by now.

"All of these well-adjusted people are too detached to make a dent in life." L.A.Ruocco writes. She clearly does not have that problem. Here is an artist that refuses to adjust to the world. In an age where most artists trample over each other for the opportunity to blend in and sell themselves out for a quarter, this is more than refreshing, it is shocking and exhilarating.

"If this is madness / I'll take 5," she writes. She will go as far as she can, she will try anything TWICE. Matzoh balls, eyes, testicles, onions, pills, the egg, the roundness, the infinite circles, the fucking and pissing and eating – the adventures keep haunting me. Zippø is a call for honesty, by setting the example of honesty. The author has vomited her heart. I feel blessed to have read the book, and blessed to be able to recommend it to you. Read it! Keep your mind nourished!

ZIPPO

VOL 1
2
75¢
MAR 99

PUBIC ENAMEL

WRITTEN AND ILLUSTRATED BY L.A. RUOCCO

<u>Disclaimer</u>

THIS IS A WORK OF FICTION. ANY RESEMBLANCE TO A PERSON, LIVING OR DEAD, IS PURELY

COINCIDENTAL. ALSO, UNCERTAIN WITHIN THE WORK,* IS WHETHER THE NATURE OF THE PROTAGONISTS,

CHARACTERS, AGENTS, ETC. ARE FIGMENTS / ALTER-EGOS OF THE NARRATOR'S IMAGINATION.

L. A. RUOCCO

1998

1

* Ref. <u>Dissertation part 1</u> **p.115** for extensive notes on the literary genre invented within. See "Hypnotizing Metelepsis" **p. 117**, *Interpretive Monopoly / Vector Momentum,* & *Symmetric Resonation* (Fractal Phenomena).

Café Zip

p ø

"Honey and lemon?" asked the waitress. ✿
"Milk and sugar," I nod.

And we are left, opening sugar packets, pouring them into our beverages, and stirring with our spoons to the rhythm of his talking. Mildew breath of yellowtooth words beaten winded against my nostrils when words sat too close to me, and his arm coming around me, my boyfriend would never have allowed it had he been there, *hey get away from my girl.*

And my underwear is stained; I have not changed them in five days. This night is a convergence of all foul-sweet smells as the waft of these panties comes up having sexed in them several several times since I've been wearing them. They're pushed to the side or at my ankles when I did it with my boyfriend with big shoes still on; they're masturbated in innumerably, while he is there *and not looking;* I couldn't have him looking. I can show him later *and after the fact,* my masturbatorio finger which has a crack always, straight down the middle of the nailtip to cuticle from pressing so hard, the crack which houses the trace odor I put by his nose to sniff. I can amorphize ✚ my boyfriend's presence into fantasy and orgasm in his reduction. The first time I did it in his company or anyone's, he sat on my chest, penis hidden in my neck and I snuck my hand down my smelly underwear to bring up a holy come to a mindtickling conceptual itch. The unoccupied hand obscured his face and I am looking past him as he's looked past me.

I get horny negating Him. ✱✱✱

In the beginning I was so easily distracted, I could never masturbate with someone else in the room, no less watching or participating. My boyfriend would rub my legs, and the sensation would solidify into the abiding object of thought - to bring on the come, to be part of the come; but at times a palm would be in the wrong place, a leg would get in the way, He wouldn't give me enough room or some other bothersome annoyance would keep me from the shake, trip me over the come out and I would pounce in a fluster of aggravation and anger. I would shun Him into exile, un-flexing to my selfhood. *Don't look at me!* - I'd advise him frequently, tear His head from a possible gaze at my smelly underwear-covered-cunt attached to a middle finger rubbing. And that is how I know I am like Gabriel Lockwood (the kid my boyfriend

LAYing my Life on the Line

. . . (below the line)

❂ See ref. **p.116** *Dissertation*, on <u>Title</u> significance: Dantéfication **Zero - One - & Two.**

✿ See **p.118** of <u>#1 Onion</u>, *Symmetric Literary Resonation.*

✚ *"Can"* (double-entén), the **round**-assed female suitor the **square**?**p.122** cont. ref. shape-variable conceptual-stripdown: Sprout Theory © **p.126**, & *Voodoo* Practices, *on image vs. self,* Narciss Theory **p.140**

✱✱✱ Note: ref. *He,* as in "God," in biblical terminology (*conventional* capitalization of *The* pronoun denotes *the unspeakable* Name: Allah. To say it would be blasphamy, sacrilege).
Also see ref. "Dissertation chART": *Overt Negation.* **p.118**, exept this *would be,* *sarcastic* Overt negation.

might show contempt for): this rotten-mouthed bastard at the ¢afé$ falling into and out of his *hold-on-a-second* hyperventilation, his *you-don't-mind-if-I-tug-on-my-yanker-for-a-minute* s under the table. *Now* his very caffeinated arm passed-and-around-me, pounding off about hearing the voices and his devils. I understood this cat since I have my own compulsions to get on from one moment to the next, although much more diluted, and mostly only in the come. But I can relate very well, know what it is like to experience disabling distraction. I know what it is ALL about, because it is more than being distracted, it is an interference with some-thing ritual. Touching myself at times - just another physical necessity like pissing or shitting, writing, or feeling any love. This bastard.

The chair screeches frictionally against the floor, as I push away from his wrapping and rolling his seventh cigarette and unwinding the bagged tobacco of his eighth before he rolls it up; he licks it closed. I say, "Haven't you quite enough?"

But *he likes having them*, smoking them and drinking his coffee. ✕

He collects the compulsively rolled rods into his tobacco bag and there's tobacco loose all over the table. I would have been embarrassed by his mess the waitress has to clean had she not kept asking Gabriel if she could roll one for herself. He'd allow her each time, kindly. And **boxes** of them are tumbling out of every pocket, a supermarket generic brand,‾ *lights*. He pushes those over to the side by the condiments.

"I've never *seen* somebody with so many."

"What, *these?* These are my mother's. *I* don't smoke lights if I don't have to. I need some more milk."

They had brought him another coffee without making sure our milk container was full.

"*I* need some more milk," I sigh in agreement.

"Yeah, that's what I need," and staring at me in his deranged manner he began to spaz out.

He frequently tells me not to look at him when he is spazzing out, this process I have paralleled to my masturbation, a meditation, an epilepsy which he controls. So I lowered my gaze into my steaming herbal tea. But interrupting his own compulsion, he says to me, "*Excuse me,* would you look at me?"

This time, my gaze at him was the object of his psychotic compulsion, and he spazzes out a little more rocking, foreword and back in his chair humming some upsetting noise intermittently and flicking his eyeballs zanily til he had

✕ ref. List of Unfortunate Disasters #4, **p.154**.

‾Generic =White lable

enough. The freak. How dare he have these compulsions right in public. What gall. But I am only jealous and don't have the balls to go *masturbating* myself off at every urge. I get pleasure that I can come around my boyfriend at *least*, that I can take his innocent and kind presence and depersonalize him. I can make him go into my mind, I can feel him in my muscles like a juice in my nerves, like thoughts in my brain; and also, I can put him in my ass.

I shift my seated weight, subway-vibrated from one buttock to the other. I feel my underwear and cunt meshed together, the panties are deteriorated, the elastic is dead and pulling and tugging in all the wrong places. Finally we arrive at my stop, and I don't thank Gabriel for riding home with me. I wonder if I should have run off before, when he used the bathroom to piss out all the coffee he drank. I used to run off on him in high school when we'd go out after classes, except he hardly went to any classes. He'd stay in the park jerking off with the pigeons and they are cooing.

"Next time," he says, "let's meet at a café with free refills." He wants to meet *in* a cup of coffee saturating himself in substance, he wants to meet *in* a greasy spoon. He will lie *in* the spoon to writhe around as if it were a mortar; to reach without control to caress the smooth rim, grasp it with his slightly bleeding hands and lips which he can sip himself up with.

I take off my underwear finally for the last time before they will be washed; they cement themselves to the floor over there on the other side of the room. I smelled them as I took them off and it must be that I remember the smell, or could it be the stench has reached me all the way across the room, or is it that my cunt, so close to me, smells, or closer yet, the fingers which have plunged the area of the cunt to feel how hot wet and filthy it is there? Or did I touch myself there to ease the itch because, there, it is so disgustingly vile that the languorous sex has turned evil and diseased. Then I realized I could not scratch the too tender red folds, either from too much sex, or too much masturbation or that it has been so unsanitary there for so long the babycake icing is eating me away. In any case the smell is on my fingers. I shower only wondering when my clit will be healthier so that I can masturbate again.

I thought it was sex sex sexy not changing my underwear, never coming home. I jump out of the bath proud as ever recalling that I also finished off a period while wearing those same underwear. While they were still fresh I'd gone

through a couple of toilet paper tampon changes and one very rare episode of forgetting that I had a tampon in me while I got fingered and sexed and thought the sex was remarkably good - I had hopped to the bathroom with my pants down to my ankles immediately after intercourse in order to spit or wipe between my legs before lifting my clean or dirty underwear to my Vag. I sat down on the toilet and pee, blood, and tampon fell right out of me. I ran back to tell Him, "Hey, did you even realize I had something *in me* the whole time? *I* didn't!"

And He says, "Of course, I felt it in there from the very beginning with my fingers"

"Why didn't you tell me?!"

And He tells me He thought I knew; He thought it was some new trick I was trying.

So proud I am of all me and my underwear have been through together, I might pin the prize pair to the wall for the world to smell when I'm dead and I'm so famous they've made my room into a museum.

It's easier than you think to forget your menstruation hasn't finished. It's American that there can be change amongst no change. No underwear change. Let things be the way they are and fuck with them on your own time, godammit. These were also the very same underwear I told him I was getting off the pill in, tired of water retention and enlarged synthetic-estrogen fed breasts, seeming to carry the weight of coerced infertility. I'd rather him have to endure the aggravating although sometimes sexy ordeal of raincoats to insure protection against pregnancy.

It's *also* quite usual I change my underwear on a very *regular* basis; bathe as an obsessive regiment of removal of all dead skin and excretions. My vagina, an immaculate cavern; my nostrils, bare walls awaiting their *new* dirty smelly air; my ears, eliminated of their wax coating (I always painfully stick the Q-tip too far in). And once I gave myself an enema with a shampoo bottle.

Schooldays stories confused me to no end: the woman who would seek medical attention for the infection in her twat only to find a maggot-half-salami broken off in there - unnoticed for who knows how long. How repulsive, a man can muse over finding the condom he accidentally lost in his girlfriend a week later. Could a woman be so preoccupied on the exterior not to find it? Not enough realization to dislodge the salami? And I, no better, from one morning to its afternoon can forget the tampon lodged under my uterus. So I suppose these stories were possible.

I heard once a little boy got a large dill pickle stuck up his behind. He lost hold of it and it slipped up his ass. Nervous about the situation he told his mommy and they went to the hospital. Isn't that something else? Wouldn't it be funny to leave one of those up your twat on purpose just for kicks.[*]

*Pickles are preserved with sodium nitrates, which are said to be more lethal than saccharine if eaten. But place one in the behind thusly and who knows?

Also note satirical blame of desire for sex on Pop Culture, **p.27**.
[Note: ref. *anal* sex, (poetic) rectal fingering - Howard Stern's *Private Parts*, cites rectal thermometer for fever & *How To* baby book; by applying embodiment on memory: rectal intercourse with the mother is associated.]

13

```
YOGURT                    .59
YOGURT                    .59
YOGURT                    .59
YOGURT                    .59
YOGURT                    .59
YOGURT                    .59
ANTACID TBLT             3.99
         Total Tax        .00
         Total           6.72
         CASH           10.00
Change                   3.28
```

Shot Rocket HoteL

The root of my problems lies not in my vagina, but in my intestines. [¤]

It's the first time I've *ever* purchased antacid, and I hadn't eaten *yogurt* in over a year because I ate *so* much yogurt the last time I could ever remember eating yogurt, it'd taken a whole year for me to even *walk* by the yogurt section again in the super-market.

Now it's *all* I eat, and the antacid, this week.

If there's one thing I know, food'll either give you heart disease, or cancer, or it'll make you crap your brains out, but not yogurt; not yogurt. Pupil buckets overflowing with TV glare, my files are ready to be pinched out; I'm influenced by the masses, and the masses in my intestines, shit on televisions everywhere in every room trying to soothe, hypnotize with flashing, and non-fat yogurt commercials telling you you can live forever.

I get a burning, a swelling in the middle. The M.D. says antacid will do me some good. I am a piece in the assembly line. I have the **day**job, like most of the masses, the job at the place that ate their innards away. Eat or be eaten; eaten by your own stomach. Get up, go to work and eat up my antacid tablets, knowing I'm not living forever. So why take an antacid? Eat a yogurt? Do a job that's gonna eat me up?

14

[¤] See ref. *Novel Schematic* [p.111] and note that which grows <u>out</u>, *stems down*, **stalks**. Situated thusly [upside-down, onion lying between the two sides of the buttock, rectal/womb region], the roots'd take in the area above the seed-fruit, absorption occurring somewhere in the area of the intestines.

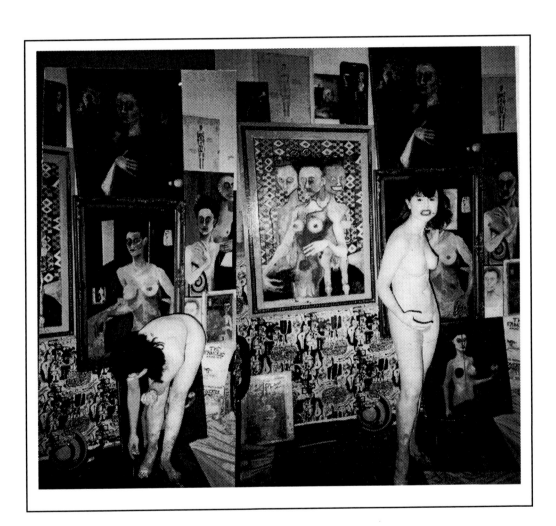

Usually I get onions. Mostly onions, and any of the other turnip-types and vegetables that are on sale. I eat several onions a day. People say onions make you fart. I don't eat them so that I *will* fart, I eat them because they taste good. I used to take onions *out* of the food I ate, but now they're most of what I eat, just like the antacids. And I don't sleep much at night; I do it to myself some-times twenty times, and sometimes with the vegetables, but I never tried pickles. No, I don't sleep a wink all night, maybe - all I do is come and pass gas, fuck and fart, listening carefully. That's when I'm alone, and have eaten many onions. When I'm not alone, I fart silently. My farts seep out so slowly when another is there, in bed and under the covers hoping to god it will dissipate before it floats out into the open air beyond the blanket's borders.

That is life: food and television, sex, sex and work. And dying is doing what you have to, not what you do do. And you would think I'm the kind or girl who would just let 'em rip with out a mention because it takes so much effort to silence a fart.

You'd think I could buy these designer condoms I wanted on my own, proud and perverse like my underwear which hangs on the wall. But like the fart, I have some girl I know purchase the novelty electronically-tested condoms because I don't have the guts. I give her the money and stand with her on line casually pretending I am preoccupied with my hair. After the merchandise is bagged and we're not even out of the store, I say, "thanks" - how silly of me — and take the change from her.

My boyfriend would fart silently as well, unless he was not farting at all (but I knew that he was). Whether it be consideration or shame — except when I might be laughing and a laugh might spontaneously come out the bottom of my ass; we did not subject the other to the sound of flatulence. Such excretes and refuse were already being offered to one another in the form of verbiage.

And He doesn't like it when I use His name in my writing. IT'S AN UNFAIR REPRESENTATION, He says. I don't understand, so I call Him nothing. My boyfriend is nothing but a pronoun.

"*You did the most disgusting vile thing imaginable,*" He said to me, "*Finding sexual pleasures in another.*" I did, while I was at the dayjob, as a rocket scientist I had moved away for the job which ate at my innards.

I begged Him to return to me. But I never understood why He didn't

leave me before that. Shouldn't He have been just as displeased with me finding sexual pleasures in my finger and my smelly underwear? Or the cucumber, or the carrots, or the turnip-type objects? Or when I mentioned the conventional sex with food I'd been doing? He never said anything *then*. He must have thought I was doing it for exercise, because I told Him once, I do it til my cellulite hurts. When the relationship gets bad I should let Him be finding *carrots* in me, and more and more. He would be competing with the vegetables for my attention; I wonder what He would say about finding carrots in there. I'd go skipping back to Him from my trip to the toilet to say, "Hey, did you even notice I had a pickle in me!? *I* didn't!"

He doesn't want me to have desire.

There is a biological need to live and a biological need to die. So you bring yourself closer, you do what you have to. And that's what's most important, getting remarkably exceedingly closer and realizing how close you are, important because *all* of everybody's life is mostly going to be spent dead. Six yogurts sit at the bottom of my belly. And do not exceed sixteen tablets in a twenty-four-hour period. Antacids in assorted flavors, and sometimes I just need more.
Maybe we* have to stop eating the onions.

"You try getting one of these off," He told me, when we used the designer *unlubricated* condom I went through a foolish ordeal to obtain. He says He doesn't like it and it makes **me** feel ashamed somehow. The condom in my garbage pail is wet *now* and heavy heavy in my mind.

Just as I was unable to masturbate freely with my boyfriend in the room for a long time, I was unable to sleep around people as a child. It was because I didn't want anyone thinking I was dead. I had a fear of scaring them like I did when my mother found me this one time floating belly down in the bathtub. She took hold of my hair and ripped me out of the water thinking I'd drowned, and I had merely been playing. What a scream she let out as she embraced my dear

seventeen

* Multiple-personality we; *we,* as in, the Kings "we" Also <u>*Post-Modern Jump*</u> **p.118**, in accordance to universal "we."

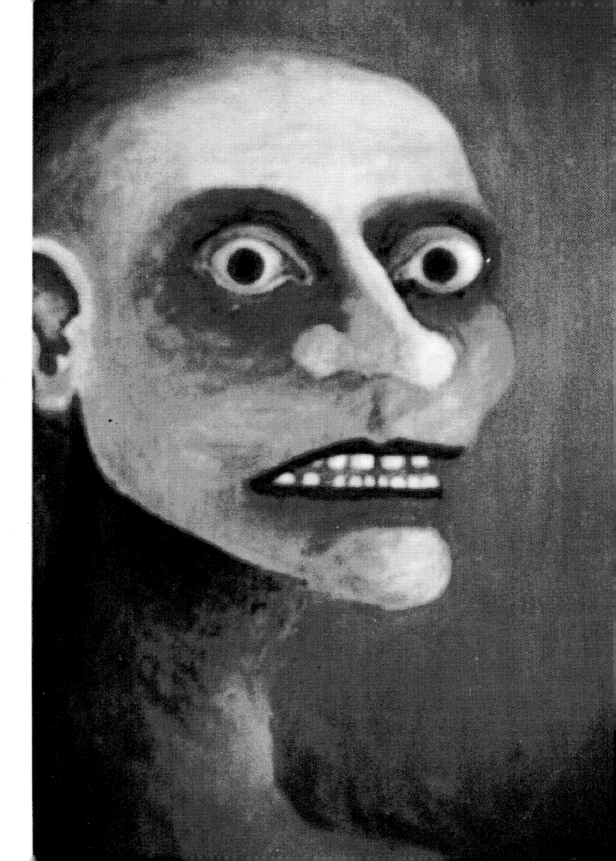

wet little body.

One night, He asked me why I was having such a hard time sleeping. I told him I was horny as hell. I wanted the straight and narrow in my behind, a penis, a stiff finger. I wanted to extend the nausea I feel a great deal of my life, a nausea I thought might be caused by life but might be diet related; and I always felt remarkably good after a good pass, so why the hell not.

"I want it in the ass." *

I wanted it in the ass and now I'm writing about my bloody asshole. I don't know if I went off the birth-control because I wanted it in the ass more, or if I wanted it in the ass only after the horrid abrasive novelty-rubber incident that rendered traumatic fear of *all* condoms in me. And because there are no eggs in your asses — as long as you don't eat them or put them in there intentionally from below. I'd not have to be humiliated by a rubber again. I got it with a finger and a soapy dick in the shower. He surprised me, it happened fast and it hurt really bad. I had the vision of Mom ripping me from the water as I ripped His dick right out of me in immense pain. I grabbed on to the wall and the hot water beat down onto me. When my behind could bear it again, I took His penis by my hand and put it in for some more. He enjoyed it more than me, I think, except for afterward when my clit felt like it'd been through an earthquake.

He couldn't believe I couldn't buy condoms when that girl I asked to buy them made jokes about the fuss I made. Yet I'll blab on about my BLOODY ass amongst friends til they turn green hearing about it. I bet I could go purchase a bloody ass in any convenience store; I'd have no reluctance there. All day since I shitted out of my sorry ass and wiped blood onto the toilet paper, I've been talking about ass-fucking.

●19

Before I left my room to go see Him one night very late afterward, I unloaded my garbage because I wanted to find the fucking condom, because I had to remind myself of my humiliation. At first I couldn't find it — it showed up, of course it was there, I had to do some digging for the rubbery thing. I even touched it. I picked it up with my bare fingers. Its potent old sex stench reeked so sweetly, like rotten fruit, like over-sexed masturbated-upon underwear; I couldn't believe it. I dropped it back into the trash and heard it recoil dully, as sticky latex will.

And then I was having a frustrating time in His bed, and He asked, "Don't you want me inside you?"

And I said, "yes."

"Then why don't you take me?" meaning fuck sex, not the hand job and oral finagling.

I told Him I was stupid and confused. And the humiliation rose to a

* Note: Although unwarranted, the above work has been at instances mistaken for "lesbian genre," since the narrotor is said to **metaphorically** be *able* to *take it in the ass.*

cataclysmic blush.

"Why did you go off the birthcontrol ?" He asked.

I had watched this white fish body become and become and come and come, and lose itself in tender-breasted infertility. But now my form was once again rejuvenated and its own, sore in the onion, but it was unchained.

"I don't know! . . . But I'm going back on it," I said.

"Do you want to be on it?" He asked.

"No, I do hate it. Pills are scary." (I don't know if this true for aspirins and antacids, and some medications, but it's surely true for birthcontrol: a necessity to eat every day like food.) Pills are attachments, you put them in your mouth and they become you, part of you, making you bigger, making more of yourself but you are less of yourself. "I hate the pills, but how else am I gonna keep the eggs from coming, from breaking out of my onion?"

All I could think about were the stupid nonlubricated designer condoms, each individually cased in a colored gold-circle coin, how cute I thought they were packaged. *Oh you can't trust these*, He said.

But they're electronically tested, I assured him.

How hellish, Him saying to me, **you** *try getting it off*. I only feel embarrassed by the fucking rubbers now, buying them and fucking with them and Him not liking it because it stuck. Him not liking it. Yet, I make Him finger my ass and I know He doesn't like it.

It's a shame because raincoats used to turn me on, the snap and the smell, similar to that of Band-Aids releasing warm scabby-knee memories . . . and the sweet smelling moment of getting to inspect it later, alone, me and the trash. But right then I was too embarrassed to break out with my disgraced raincoat. Pinky-finger assfucking, because I told him to. I offered my saliva as a lubricant, using spittle to his cuntly penis, but he reached over for the bottle of Oil Of Olay on my bureau; now my ass *looks and feels younger.*

#20

PKG CARROTS	.39
CUCUMBER	.39
ASPIRINS	.99
BAG ONION YELLOW	1.49
BIRTHCONTROL PILLS	.52
KIWI	1.00
CANNED PEACHES	.69
MULTI-VITAMIN	1.57
Total Tax	.00
Total	7.04
CASH	10.00
Change	2.96

Greasy Spoon

I tell people about my life and they're surprised, "So exactly *how* many onions were you eating a day!?"

If I lived with my mother like Gabriel, things would have been different. Mom would never have allowed me to consume so many onions. *"Don't eat onions everyday like that,"* she'd say smoking her cigarettes. **My** mother never smoked *lights*. She'd smoke like a motherfucker, perhaps more than psycho-Gabriel even, lighting another one before she realized she hadn't finished the one still burning in the ashtray. She'll smoke twenty at a time, unable barely to hold them all together with two hands in her wide open mouth.

Gabriel's mother debases his manhood, smoking her light cigarettes and, *here-let-me-put-this-cream-on-your-face*, motherly mother mother, *let-me-castrate-you-just-a-little*. He's always goddamn worried about castration and if the devils are gonna get him or if he should let them get him.

I feel sorry for the kid. But next time we meet I decide to invite my boyfriend along almost making Gabriel into an embarrassing novelty, a rubber. I told my boyfriend this frigging weirdo used to be a fat fucker, flabby, but I know when he saw him he was thinking about how gaunt he looked, with his sharp pale

face, beady blue eyes. I warned him already about how much coffee this kid would ingest, and the cigarettes, and told him about his compulsive behavior, fingers stained brown from unraveling smoking tobacco and who knows what, but I don't think he believed me until he saw.

When Gabriel is watching I wonder if he knows what I've got in my head: If he knows it's about his motherly mother mother and how I tried to demotherize *my* own mother by biting her tit (this was only a few months ago, not the nipple, merely the mammoric flesh and she got so weirded off by it she slapped me in the face). My mother never breast fed me, and she said it was because she was a smoker and did not want to give me smoke milk.

I'm thinking about balls, you know, *balls*. I'm saying in my head and to my boyfriend, *love your balls*, yeah, *and I love your EYEballs, I wish you had* **eyes** *on your balls, I wish your balls were eyes. . . . I wish your eyes* **were balls**, *get it?*[*] Yeah, kissing and licking into the corners of His eyes which he gets too scared of if I do it too well. He tells me to stop — oculingus; ✪ He gets angry. If it were up to me I would have bore lickin' into his brain by now through *some* orifice, but He denies me.

I wonder if Gabriel knows I am thinking all of that, and I bet he does, he acts like he does sitting across from me and my boyfriend, glaring. I look around the room and all I can see are people with heads and balls in their eye sockets. Pink leathery semi-hairy balls being blinked upon.

In conversation I bring up rumors I heard back from when I knew this cat in high school, how Gabriel'd have to get his underwear up the crease in his ass just right, another symptom of obsessive compulsion. He was surprised that I'd remembered and that I knew at all. I don't know if he still does it, but peeing out large quantities of coffee wasn't the only reason he would go to the bathroom so frequently, back then, at least.

And he talks about it in jest, like, *Yeah, that's how fucked it used to be and wasn't it fantastic?* Not only did the underwear he wore have to fit in the crack of his behind in a perfectly folded wedgie, but perfectly *up* his behind as well; he'd *shove the goddamn briefs into his ass*. That's exactly how he said it and I laugh in excitement.

I think I even saw my boyfriend smile over this funny kid.

"It must have been uncomfortable walking and sitting around with underwear shoved up your butt." I think about all the times I'd been having discussions with him and he might have had his goddamn underwear UP his

* Note: Dream List: Balls Hallucination, **p.156**.

✪ Latin Ocular: as in *eye*, Lingus: as in *tongue*. Shakespeare notes reference to *skull-fucking* (hence, coincidence to the [publishing] Company's name: Soft Skull Press) See ref. <u>Necrophiliac-Machine</u>, **p.51**, *fucking-with* (colloquial), interpretation of interacting with the living as if, or as though, they would be dead. Morbid. Kissing. <u>Necrophilia Mato</u>: You're *Already* a Memory.

fucking ass.

He explains that it was a matter of hygiene. To make sure his ass was completely empty — on the toilet he would push out his shit so hard he would pass-out into euphoric oblivion.

I picture the kid lying on the white tiles of his bathroom passed out from shitting too hard and his mother is knocking and turning the knob of the locked door calling to him to ask if he is all right.

Some people **never** eat the onion. The stomach can go bad if you eat too many. But I think I had the onion seed planted in me, baby. I couldn't get it out. Layer upon layer of experience tried to expel the seed, to digest the fucking seed, coating it to it's pearl form. The rock-hard mother of pearl, and the root stems down, it's my frigging onion. Û

Gabriel's talking off about the woman sick enough to date him who left him. And *I* nonsequituredly want to come in a man. I keep telling my boyfriend one of these days I'm gonna come inside him; I'm gonna get inside out, push OUT my uterus and stick it *to* him. He won't let me near his asshole, he gets real mad if I touch it.

㉓

Anal-sex and after that there is a *s p a c e* that remains.

On the toilet after that, something happens, a seeping of the air that remained in my asshole where the penis used to be.

A fart that appeared there, one I did not excrete.

I see my boyfriend's impressed by Gabriel. He doesn't usually like my friends one bit but this one, he buys a cup of coffee and offers him homemade matzo ball.

"No, I can't eat. I NEVER eat anymore," Gabriel expresses decliningly.

My boyfriend wants *me* to like matzo-ball soup; I can tell. He's always making it from matzo-ball mix and boiling them up. ✳

That night I had a dream that I was sitting quietly inside an intestine with my boyfriend and all of a sudden the syrupy-tissue-walls began to cave in all around us. ✳✳ And in tremulous doom He said, *I have done* **this.** We had been IN **the space,** the space that is created inside your ass from ass-fucking. I woke up as we were being farted out of a behind. It was at that point I began to think

Û Again, note Schematic Drawing, #1 Onion diagram **p.111,** "onion": commonly over-used metaphor for multi-layered; "stems" symbolize what *"Sprouts"* out, hence: *Sprout Theory* ©. Also, note **scatologic** *positioning* [signifies] *the crack in the constipated spine of the book* [represents, uterus, Vag., womanhood, etc.]

✳ See Ref. **p.175,** #1 Onion: "It doesn't matter if *you're* cooked; THEY'LL eat you anyway. . ."

✳✳ Note: Dream List: Intestinal Innards, #2. **p.156**.

I was becoming obsessed like everyone was telling me.

He thinks I'm on *the pill*. Enough time has not passed to catch the after-period twenty-eight-day cycle when women must begin taking them. Maybe he'd kill me if he knew.

But, "What are YOU doing?" HE asked ME after WE'RE *already* making it, His thing in my thing. "Is it all right?" He asked.

And I nodded *yes*.

"So soon?" He said, inquiring if it was really sAfe.

And confident in the rhythm method, we inned and outed. And to the jerking writhing smooth-rod riding, I counted the months on my fingers to nine from then — to make sure I would have graduated college before the baby came.

When it's over we were having the difficult task of extracting the pubic hairs that jettison off into our mouths, impossible to swallow. He was having a harder time of it than me, He'd been biting at mine and pulling at them intermittently. He was gagging because mine had clung to the back of His throat. And as He was busy with that, I collected all the change that had fallen out of His pocket into the bed as His pants were being removed. Sometimes I make a pretty penny — at least I have that. ✕

"If there's something wrong I wish you'd tell me," He said, still with His hands down His throat fishing for more pubes.

I gave a sorrowful look, like nothing can be done.

"In the *Joy of Sex*," He continued, "it says that if a woman doesn't come to orgasm in the first 100 pulsing strokes, then *she's* doing something *herself* to prevent it."

After what seemed like HOURS of IN-OUT He'd said, *"There. What was wrong with that?"*

In the morning He made me soup. He asked me how many balls I wanted and I said, "I'll try one."

"Just *one?*"

"All right, *two.*" But I couldn't finish even *half* of one. They are very heavy. I offered it back to Him when He was finished.

"No."

And I put it down onto the table. One ball sits heavy in a broth forever.

✕ ref. List of Unfortunate Disasters #33, **p.152**.

I made an appointment to visit the gynecologist to check IT out, then went for more breakfast at the cafeteria. I was having a spectacular time — then get this; I look over at the pretty-girl table and they're giggling — something is happening, they're passing around a clear plastic envelope of those gold-frigging-circle condoms and my jaw dropped.

I pointed in awe of the multicolored scum-bags disguised as coins. I shouted across the table, "I know what those are!"

And those girls smiled at me nodding, "yep," they giggled more, "we got 'em free in the mail."

A mix of emotion went through my mind, why didn't *I* get the fucking gold-circle condoms free in the mail? I told them right out, they were NO GOOD. "I tried those," I said as if I was on a talk show, "my boyfriend told me, **you try getting one of these off!** *We* haven't had sex since!" Although that was a lie.

The people I was with were hiding their breakfast-full mouths laughing under their napkins. Condoms can't be packaged with a lubricant in a snap-sealed aluminum case that pops open when you *"bend here."*

The pretty girls weren't enjoying my humor any more. One girl stood up and put the gold-circle envelope into her pocket.

"It's true!" I said to my friend. **"Sure, they're electronically tested, but they'll stick to his dick!"**

"I *believe* you!"

That day I began to develop Turret's syndrome, and the gynecologist gave me lots and lots of pills. Someone like me shouldn't be reproducing, they think.

I never wanted assfucking until I read about it in a bisexual-male-friend's journal — about getting his own finger up there in the shower; and that would make his third limb shoot. I thought I had experimented, with shampoo bottle nozzles filled with water for an ass douche, but I never had urges to have someone's finger in there. When I attempted what I'd read, I got a finger up there only about an inch before I had to run to the twalette. I always enjoyed toiletting, be it painful or exhilarating, but I never sought a boyfriend to give me those feelings, **until I** saw it on TV.

BEND HERE

Beware of Books With Tails

Same with sex, pop culture made me want it. I was perfectly content with my little girl shower massage and lying belly down onto plastic Star Wars action-figure dolls. Even when I got sex and it didn't feel as good and doing it to myself, I still desired it; wanting that elastic pink cream-rod pulsing to come inside me, developing new desires.

I wallowed about in the fact that I had fallen for a guy who wasn't psychotic and victim to desire. He doesn't know what that means. He doesn't need desire.

"What's the matter?" He mused as I stood lonely at the bottom of the stairs facing the door having my vulva vulnerability. "You're not feeling good?"

"No."

"Do you want breakfast?"

"No," I answered about to leave.

"Do you want some matzo balls?"

At that moment I realized how ridiculous He was, more than anyone could know if they didn't know me; I said, *"Yes."*

Had the matzo ball I didn't eat from first time not been sitting there? Or had it disintegrated and He forgot I wouldn't eat them.

If He knew what I was all about He would have offered me the onion. Matzo meal rancid and bready just didn't thrill me. How could He have not known I was jerking him around? He knew how I felt about the fucking balls.

He prepared it in bowls; stirred the testicle mix into the eggs. He makes them big, and I know they will turn out raw inside. I had not been paying attention last time He made them, to the *eggs*, which were a main ingredient.

Eggs, I can't eat eggs.

I'll be sick if I eat eggs.

Raw yellow eggs. ★

And as He dropped his balls in the water to boil, I rupture with confession, *"Let me tell you something.* I'm sick of your fucking matzo ball — just look at yourself making them, it's ludicrous."

His friend, watching the episode, thought **me** the cruel one. "Why'd

★ see *Symmetrical-Mimics* p.118.

you tell him to make them if you didn't want them?"

"I was fucking with him. I really didn't want them."

"Then you can't have any!" boyfriend said. He didn't care. He would eat them himself; He loved the goddamn things to death.

"You hurt him," his friend said.

My behavior felt so rational, like I had just proven the point to the very root of our problems. But no one understood, they just thought **I** was crazy. ***"All right,*** I'll *have* them."

He served.

"Are you *sure* they're *cooked?*" I continued.

He cut one in half, "Maybe they could use a few more minutes," He admitted and collected his testicles from everyone. He spooned them from everyone's bowl back into his boiling pot. He **was** ridiculous — dropping them onto the kitchen counter. As He tried to retrieve them He pushed them along. I had to leave, I couldn't see Him this way, it made me ashamed of myself for needing Him. I'd rather go home alone and cry.

The onion is crisp; it is vegetable; it is painful to eat; it is good. The ball is the ball of dough, mushy and flavored to your personal taste. If you leave the onion at the bottom of the refrigerator long enough it will grow green stalks and roots, but the humidity down there might make the onion sweat and sag and disintegrate like underwear worn on a pair of buttocks for two thousand years.

You can chop onions for soups, but ball soup notions are nightmares for me. From it stems—

the girl crawling around on her hands and knees in the dark looking for a garbage pail for which she can spit out her man juice. It is in her mouth, there are remains of it, which cling to her enamours enamel. It must coat her teeth like plaque. You can scrape it with a finger nail. Even though it came from his very own pumping machine, he will not kiss her after that.

"Why won't you kiss me?"

"I'll kiss you," he answers; but he is afraid.

And she is in despair; <u>in her sleep her teeth will rot away and fall out.</u> ✕

✕ See: List of Unfortunate Disasters ref. #8, **p. 152** ref. "I've snorted tooth-decay off the dental-floss dispenser," #1 Onion.

Also ref., "The Pink Pony" chapter to follow, Gabriel's teeth "rot deeply into his head, when he nods, the very small rocky fragments knock around lightly."

FLIP BOOK
BEWARE OF BOOKS
WITH TAILS

BY BARBARA ANN SLESCKA

excerpt: Treasure Chest

Wean me with poison

Please

I'd rather die than be without thy teat

COLLEGE COUNSELING SERVICE	*free*
BRAIN PILLS	6.69
Total Tax	.00
Total	6.69
CASH	10.00
Change	3.31

The Pink Pony

We are sweetly contained, bile and tears *in* us. My mother tells me to pee it out no matter what it is. Drink lots of water and pee it out, that way it won't come out of your eyes. [*]

The blessed bile urine peed nervously OUT into the sparkling basin ripplingly. A cure-all as it passes out soothingly, burning wounds sterilizingly. Shipwreckers and Buddhists-fasting drinking alike just to pee it out a second and third time recycling their own urine through their bodies repeatedly for days.

There is a place called the Pink Pony. It is hip there, not like the other places. There are writers and blowjobs in the bathrooms. Smoke flies like fire out nostrils. I meet the psychotic there and he is plagued. I see his lips are chaffed, his teeth are yellow, dissolved. He shouldn't be peeing out of his mouth. His breath is vaporous mucus.

"We're afraid to show our assholes. It should be out in the open," Gabriel thinks. "When we were babies," he says, "and we flushed our shit down the toilet we also flushed our souls and now we're afraid to show our assholes to

* Ref. Bile Flavor Color Wheel © schematic diagram, **p.147** note "Humoris," Yellow

Also note: On, August 1997, deciding American culture had not been capable to grow her suitably, Under Woman urinates discretely in vessels on stage, upon the third cup, she drinks from it dwelling on (with) her own energies – not to be confused with Alter-Ego: **Secrete Agent**: *failure*, see ref. List **p.151** & Critical Analysis, **p.166**

anyone."

But he is not, his mouth is an asshole I cringe to look at; his voice is his soul, his teeth are shit. I bet in his sleep they don't fall out like mine, but rot deeply into his head and when he nods he can hear the very small rocky fragments knocking around lightly.

I tell him, "Dirty girls show their ass holes. I'm not a dirty girl. I've started seeing a psychiatrist. . . . I did it because it was free."

"You don't have to make excuses."

His mother, who had not grown up as proletariat as mine, sent her son to *lots* of psychiatrists early on, but *he* had shown his illness so blatantly — genuinely finding evidence for what the masses are blindly faithful, (yet, *his* is the illness). He didn't go signing himself up. *"What do you think about those fuckers?"* I ask.

"Yeah, they're fuckers, but you don't have to fear them. They just want to cure you; they just want you to be able to function in society. And that's not a cold-blooded thing; it's a warm-blooded thing."

He's mentioned his brother now and again, with whom he smokes and has heated discussions about transcendence. He made his little brother out to sound just as fucked up as him. "Your parents didn't send your brother to one?"

"No, because he kept it under his hat," Gabriel's explaining. "But I had another friend that had a pretty bad time with them. They made him feel ashamed. I'm a little drunk. They don't know you, they're gonna say you're an unusual case because they don't have you in the books. But you have to remember you're already smarter than them because only you can penetrate yourself. They're only thinking about the status quo and how to get you there, but you don't belong there."

"Yeah, so I took the pills (the brain pills), I asked for them, one tablet daily, at the shrink's, and then I was frigging impotent. I didn't ask the lady to give me some pills *to take away my come*, to purify me, to clean me off. I told her, *I want to try life for a while completely without insanity*. I mean, I don't blame her. Anyhow now I feel like I'm betraying myself because torment is who I am and the pills have left me completely numb."

"Yeah I believed my soul was doomed and I thought they could take care of it; that if they could convince me that it wasn't true that would get me off the hook. It might be an immoral thing, I thought it was gonna turn me into one of them. They are branded by the death machine, but I also associated that

with yumminess and freedom and the ultimate redemption. In knowing the next level is there, we bring about circumstances that make us caught within the barrier — between the two levels. We have to know when to blow our cover at the exact moment."

Just when I think he understands, he babbles off about the fucky fuck.

I go out screaming, you know, screaming on my bike *fuck*, a two-syllable **fu-uck;** the word in the night squeezed out from beneath my fast clenching fists around my handle bars.

You go to the gynecologist and she gives you pills, you go to the shrink, he gives you pills and some more for the new insomnia caused by the other pills. And *those* are all for the same thing, to stop conception, one stops pregnancy, another stops torment, preferable to aborting conceived torment. Gabriel is right, it gets you off the hook, it's America: I take a pill for my headache and for my nausea my ovulation my constipation, diarrhea, insanity, my cramps and my backache. I take the multi-vitamin the psychiatrist and the gynecologist suggested with a 100 percent of every recommended daily allowance. * And I will confess to being mostly unaltered.

Most every aspect of the physical and emotional controlled by a drug.

"I wanted the pills O to see what they'd do to me. I knew they'd give them to me, but I'm not sure what they're doing."

"Yeah, you see they don't want to give you anything you can actually feel. *Caffeine* is always good."

"Caffeine makes me shake. I lose my senses."

"Oh I *never* have my senses, I'm always trying to pry my grip off the bar of control," the bar of my bicycle, on it chasing allusive beauty as I'm victim to turmoil.

We are laughing for some reason, we are talking about laughing and I am afraid of the laugh that might come out the bottom of your ass, his ass. I am afraid to use the bathroom after him to urinate the coffee I've been ordering instead of herbal tea. I'm afraid of what he's been doing in there, having compulsions.

* Def. "allowance": vowels and minerals, see diagram: "Nutritional Facts," *Vowels are a high source of Vitamins*, #1 Onion, **p.130**, **Digestible Poetry Labels** also, ref. to Sprout Theory ©, **p.126**, regarding diets consisting of eating while reading, and how, through advertising, American culture is habitually forcing performance art down our throats.

O seretonin inhibitors.

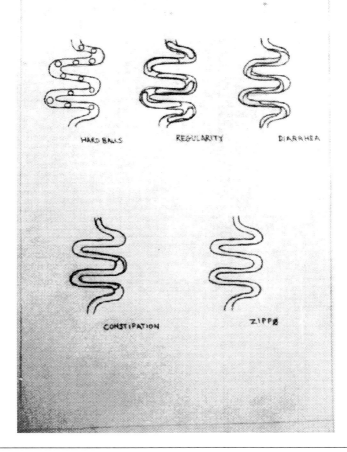

SCATOLOGY

HARD BALLS REGULARITY DIARRHEA

CONSTIPATION ZIPPØ

I told him I really couldn't bring myself to go in there after him, regardless of all the other horrors that must go on in there each night by dirty strangers. He told me it was all right, that it was cool, though.

He says when he'd have his girl over, he was always careful and afraid not to take too long in the bathroom because then she would know he had been taking a shit.

I'm really disgusted by the whole thing, since the accident (next chapter). . . . Since the doctor asked for STOOL samples. And I carried around my shit for a day and a half in my knapsack with my books, that's right.

The doctor was concerned about <u>internal bleeding</u>. She was wondering if I may have developed some <u>bacterial infection</u> and she wanted tests done.

She poked at my belly. "Does it hurt here? Does it hurt here?"

And when I divulged I was having discomfort in places, she'd say, "Here? There's a stool here." Poking at the tender packet some more.

So up close, handling it with a STICK they gave me to get it into the various test tubes. I had never, before this, encountered human feces, except for the time I accidentally had one in the tub. I was young. Damn thought I was laying a fart but I was mistaken, and a little poopy came out. I jumped OUT of the bath. I reached in there with toilet paper to transfer it to the toilet. But it was still well-kept cleanly in water. This time I realized how much I did not like it. And anyhow I havn't had a chance to drop it off at the lab. ✝

Americans really got it covered, building toilets minimizing the time to only seconds for which we must be subjected to the same

✝ *footnoted-sentence* is in present tense, example of <u>*Post-Modern Jump*</u>, narrative movement to <u>*Scata-Logic*</u> literature. p.118, 121

It is <u>*the literature*</u> under analysis, *the writing* behaving as the feces ready for inspection (tests). [symbolic]

air as it. Only for a second, or a few more, when a stool is passing from your intestine to the toilet must we be subjected. And then we saniflush, and it gets sucked down the vortex.

But I am worried.

I am coming home alone on the train in the night so late. The stops are coming so slowly. I have an awful vision on the train, half asleep. I picture that each of the seats is a toilet. My horror feeling's in the realization that they aren't; and that somebody is sitting and relaxing on it and is gonna do something as if it were!✦

I can call him when I get home; I can hear him smoking on the telephone, sucking it in and puffing out the infection of knowing.

Gabriel tells me, "You and I can get together and fucking scratch out a way for the messiah to come."

"What the fuck, Gabriel?"

"Metaphorically," he assures me.

I tell him, "When I sit on the hole, I think of all the other asses that had to remove their pants, bare bear their asses and sit on it, though I try to get it out of my mind. . . . I sit situating my butt cheeks as far from one another as possible."

"Metaphorically?"

"No! Literally; so I don't have to touch it!"

Gabriel tells me, "Don't think so much about the devil, act like he's not there. And that's the sexiest idea. After that, the world is yours."

Shitting and not being touched by it *is the most extreme slippery erotic feeling*. It gives me new hope, such a complete insight, it crumbles like waking. ✦✦

✦ ref Dream List #3, p.156

✦✦ Literary Resonance, p.118.

AND Note: "Jonny" = IN TERMS OF THE Name [boyfriend], the male Square, the Regular. American colloquial stigma, as: "to go to the john," as in, "Lavatory," or as in place of defecation, "temple of worship."

o

BLOOD DRAWING	40.00	
BUTT GREASING	350.00	
CATHETER INSERTION	410.00	
Total Tax	.00	
Total	800.00	
	C A S H	
	insurance	
Change		
	.00	

The Pink Pickle

Jonny made jokes about shitting out red from eating beats, but he didn't believe me when I told him it *did* happen, that my shit was indeed stained very pink *from beets*, a dish of them.

he sleeps and I can be tormented. he doesn't believe in my desire and torment, just like he doesn't believe in shitting pink, or using his name in my story, but I do. *

I don't know whether I *envy* or have disgust for the way sleep can take him, how readily he lets it, Jonny, my boyfriend, whose name that I choose because it does not matter anymore. he does not take me seriously. he says my very being is a phase.**

I actually thought maybe I could get the psychiatrist to give me a *new* pill, one that didn't fuck with my come. Then I'd be able to get along with Jonny because he doesn't appreciate my psychosis, debases me in any form of its emergence. I re-decided against abandoning torment, worried that things would go on never resolved, never felt and would fall to the bottomy depths with the shit and shame. I would be dead with death itself and constipated at that.

All of these well-adjusted people are too detached to make a dent in life, those who will ignore the torment, who are forgetting — reshaping themselves instead of cracking the structure,δ breaching the commitment that is life — not

* Case drops intentionally, similar instance site: footnote **p.34**; however this displays the loss of Holiness once held. No longer, as "Allah", an unspeakable. Represented within the lowercase-pronoun is blasphemy or sacrilege, disrespect.

** Narciss Theory: where the image of the self looks more like the self than the self, see ref. section later.

δ See: Custom Cut TuTu Theory, **p.136** on Shape Symmetry, folding, splitting: as in cloning.

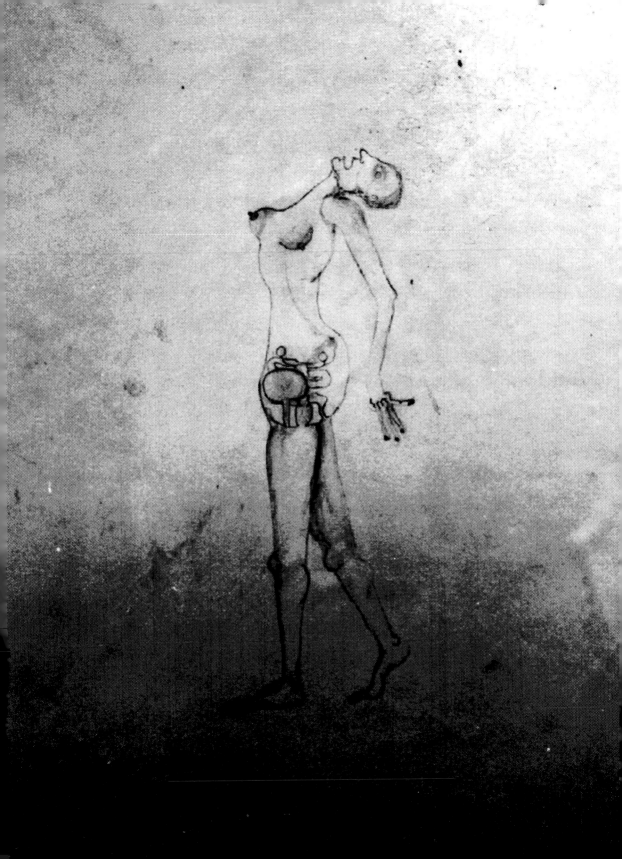

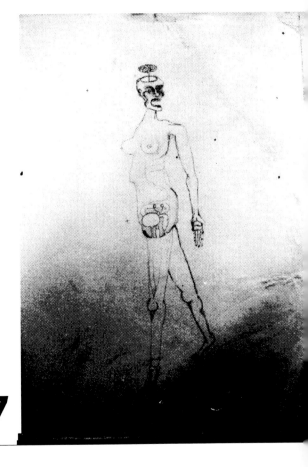

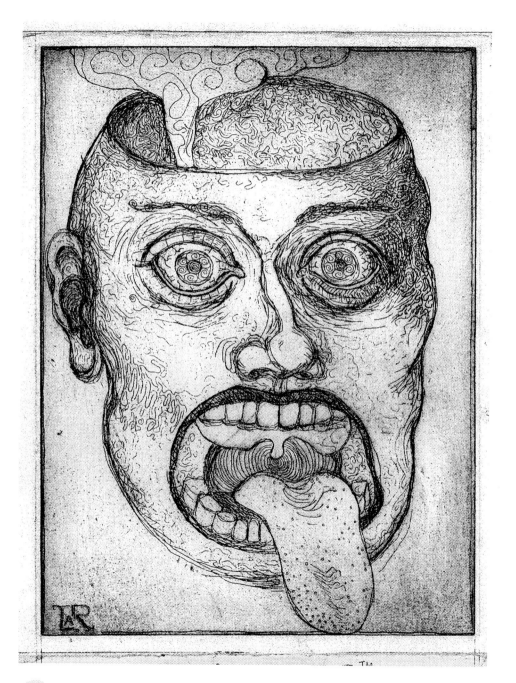

escaping nervously to the realm where
meaning changes fetusly, and form melts.
Everyone striving to be regular, and why not?
and creating death within, just the same,
where they can not see it, but it is there.

 Everyone is dying a little. I view Him
as the damned; and in sharing flesh with Him I
brand myself by *His* death machine. But I've
got my *own* death machine. We're all going,
something is killing ALL of us. But my death is a boob of gloom I want to milk.

 I don't shut down for him like he does at night waiting for his brand new
day. ✿ My boyfriend yells at me, why do I have to bring up these matters at 4:30
in the morning? Afraid of the marring, the killing will have been made; a suicide
you can wake from. That erotic surrender to love is Satan.

 Some friends say I've got to stop this: *it's no good for you;* a spiral
downward. *Jonny* says you have to let go, that I don't let go. But in order to kill the
pains I *must* embrace them, choke them a little, caress the vomit from their stom-
ach and poison from the blood, fuck it out of me. Feel it and turn it around in the
next episode.

 Maybe he doesn't want me to see his asshole because of the hair. he
thinks I am absent of etiquette, but I have my full share of it.

 Shitting pink was a separate occasion from shitting blood. Shitting
blood was a different occasion from bleeding from bloody sodomy. It was the
accident.

 We were riding fast when Jonny crashed the car. I was thinking how
good I felt, for not having masturbated in so long I'd tried at times and couldn't go long
enough, or come soon enough, too bored. What used to be my only solace was
secondary to sleeping, unsexitized on the new brain medication, which I was
going to GEt Off. My body was experiencing the smooth vibratory racing on the
highway through the dark, when we saw a pink pony on the road and lost con-
trol. We slammed hard. Jonny kept asking if I was all right but I knew he was prob-
ably most upset about the car, and we were coughing in our *at-least-we-got-to-
test-the-air-bag* gas. And the car was half the size it used to be, and I was so happy

✤ Voodoo; soul & spiritual possession directed by thoughts of the observer, see ref. **p.140**.

✿ I borrow the daily routine of the sun. ◄ March 1998

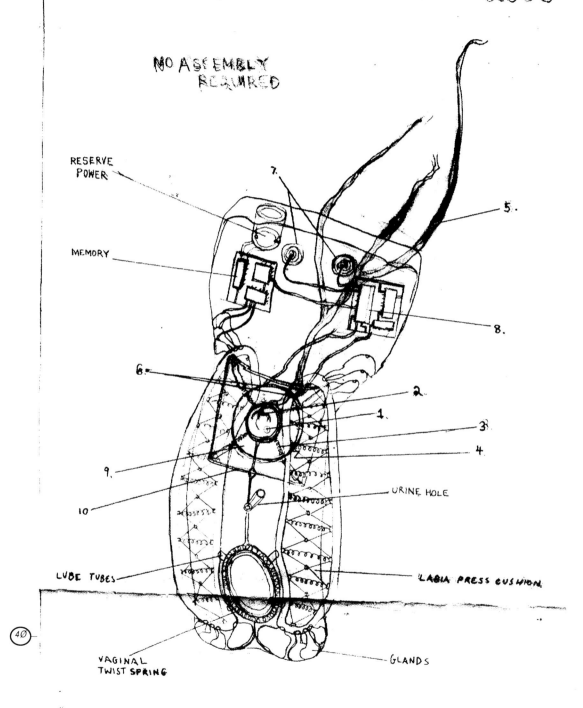

ELECTRIC-CUNT
2200

NO ASSEMBLY
REQUIRED

RESERVE
POWER

MEMORY

7.

5.

8.

6.

2.

1.

3.

4.

9.

10.

URINE HOLE

LUBE TUBES

LABIA PRESS CUSHION

VAGINAL
TWIST SPRING

GLANDS

40

it wasn't me doing the driving, since I once smashed his friend's car slipping on ice and he never forgets it in conversation with company.

The next day I fell violently ill in the stomach; it started at night. Jonny was asleep.

My hard shit wouldn't move; I felt strangled from beneath. I always had lived on the assumption you're not supposed to push, you relax and let your ass take over because you might pop something, but I was drowning in nausea, teeth clenching a towel, hoping not to burst my bubble. *(There are actual dangers in pushing, hernia, prolapsed rectum, even a stroke may result from hurriedly straining to push out refractory stools, rather than relaxing.* [*]) I felt like Gabriel trying to dislodge the filth of my corked passage, almost losing all hope when my bowels crept loose. I wondered later if that was the best thing for me, as I got up from sleep then every hour and a half in a stupor of pain and fever, to shit out mountains of diarrhea. After each passing I thought *that* would now rid myself of the nausea, but there was always some more. Begging for the sickness to leave me, for defecation, I pushed out all that was left inside me and wiped my ass to find the toilet paper saturated with blood. (Not until morning were my intestines left close to dry.)

Dizzy and in pain, I woke Jonny and told him I needed help.

He stayed by me for several hours in the hospital. He went to make calls when they took *more* blood out from me. He stood behind the curtain listening carefully when they greased my butthole to check and that by the way, I had a small hemorrhoid.

They told me to drink a whole container of water and not go the bathroom, because my bladder had to be full for a sonogram. They wanted to be sure my organs hadn't been smash-crushed on impact by the seatbelt. And the ultrasound woman was unkind. Yelling at me, if I thought this was a joke, and why didn't I drink all the water and asking me if I consented to use a catheter.

"WHAT?!"

And in this I discovered yet another h le. I didn't think it was going to fit, scared out of my wits yet so immensely curious. I finished off another pitcher of water and told the woman, "Is that really necessary? My bladder FEELS *really* full now." But the image on the sonogram screen wasn't good enough.

*ref. Spinrad, Paul. *The RE/Search Guide to Bodily Functions.* San Francisco, RE/Search Publications: 1994

It burns slightly, then the discomfort wanes as they were actually surprised how easily the catheter slid in.* I think I drew the tube in myself.

I saw the tube moving around in my bladder on the screen. I watched them position it and fill the bubble at the end of the tube with air as they flushed a solution into me. I saw my bladder expanding. I saw the other organs come vaguely into view, a uterus, insides of ovaries. They watched and complimented on my nice, smoothly-never-impregnated uterus and life juicy-rich ovaries.

Then they drained the fluid out of me while the tube was still in.

She held up the urine bag yellow in the light, "Nice and clear, it looks good."

They billed me MONEY for that.

Insurance pays for it.

The dirty girl says I'm not afraid but probably I am — more like the rest than I know. I'm afraid of the penis I still have in me rotting like the unattended **salami**, which fell off Jonny in my fantasy. The one he gave to me in my mind.

Gabriel is creating the smoke boob in his belly. He is digesting it; it is good food for him.

Once I dreamed the doctor pulled a placenta out of me and cut a piece of it with a scissors. ** It was painful to walk because a placenta hung in-between my legs but I was afraid to keep it in me because I might digest it with my acidy acids.

I hope Jonny gets me something for the holidays, the soft and elastic kind that you can strap on.

* A commentary on "language dyslexia": sentences as noted, work like mirrors upon themselves in respect to time and memory and mirror the greater picture of the work as a whole, similar to that of a mathematical fractal. Within the function exists a subtle referential switch, where writing feeds writing, circumstance feeds subject. For instance, the urethra Burns and the discomfort Wanes AS the procedure occurs in the past. See Poem: The Beast, p.106; catching writing dead and stepping over it. In a sense, a blueprint of remembering and practice at once, yet grammatically unstable.

** A commentary on "poetic license " = "a scissors " an exception to reason, singular article applied to plural tool, sensual, sound oriented - see ref. section, dream insistent, an act and result of stubbornness, and grammatically incorrect.

WHAt follows is the shape of an excerpt designed
to mimick the

c r o s s - s e c t i o n o f a c u c u m b e r :

SaLAD – (L e f t)

→

excerpt:

Building a Tolerance

(abridged and preferred edition)

The lips of my vagina are swollen beyond belief,
since we've begun doing it without a raincoat. I'm not immune to
him yet. I must build up a tolerance.
So he went and fetched some ice cubes, because this time I com-
plained; and he popped each one into me, and inside that puffy cavity they
melted quickly from my heat.
As he did this he asked me to look behind me at the wall. I turn around and near the
bed, the wall is tarnished with a brown smear.
"Do you know what it is?"
"I *know* what it is," I'm thinking the time it appeared there it was everywhere, on my hands, my
legs, in my clothes.
"I saw it there the next morning."
"*So did I*. Every time I come in, I see it and I get *hot*," I teased but the truth is I get slightly red from
embarrassment.
"I didn't wash it off so it would always remind me of that night."
"Lots of people come in here, but no one else knows it's *my period*."
"That's what's so good about it," he said.

As time is passing, his white knobby cock is feeling better in me. I still experiment, though, mastur-
batorio phases when I am alone. It's turning into some kind of obsession. One night I dreamed my clit
was missing. I searched for it with my finger up and down that carnal chasm, but all I felt was a
slippery firm flesh; and was quite sure I would not come from that numb gum. (I just now burst into tears
when I said that.)

Genitalia get lost all the time. Once upon a time a hermaphrodite cut her dick off, so all that
was left was a stump of it, like the stump of a tree, and two balls hanging between the legs of
my mind. *I dreamt* the little rascal was there -on me, slop smack back and forth the sides of my
thighs, he allowed me to borrow it—*in the dream, that is.*
Balls and all, the penis stuck to my cunt as if it were magnetized, like I grew it. I pulled
and pulled at it vainly, uncoming til I just cut it right off in frustration like the crazy wife
did to her adulterer-rapist husband on the news — except he didn't say she could
have it — and *she* threw it out her moving car window. They sewed it back on
him, but it probably never worked right again.
Stick with pleasure — I remind myself after a bad decision in
dreams — next time.

I cry a lot as a rocket scientist, because I am far
away, (and because he never got me that
strap-on). "That's a good way to get
a tear duct infection," he
tells me

RoTTeN – (RiGHT)

over
long-distance.

". . . And I've become deathly ill. " I tell him, not
to make him feel guilty— "I have extraordinary welts
on my tonsils and spots on my tongue. I hope it wasn't
something contagious from when I sucked you off those days ago.
Or perhaps *you'll* come down with something. If anything funny starts
appearing, don't hesitate seeing someone."
Even though I was peeved at him, I couldn't take the
distance. I traveled miles visiting often and therefore there is blood on the wall
again. He must have put it there, wiping it off his hand like the last time. This time not
a smooth smear, this time a small spot, a bit clumpy — when I saw it (and his head was
turned away) I actually tried to pick it off, my uterus scum, but it was too hard. I nearly
broke a nail, it must have been there all night. So I ignored it.
When he left the room to use the bathroom I use my saliva and an old sock to get my
menstruation remnant off the wall; and it was quite a chore — like it had been cemented on.

While I was alone I kept up with my experimentation. I did it with a cucumber, just to get off real
hot, but it was ice cold, because it had been in the fridge. But I'd been thinking about him, and I
kept visiting on the weekends. And noticing a cold sore on his mouth that keeps getting worse; it
makes it so hard to kiss him.
I leave and hardly bathe so I can still smell his come in me. And the next time I see him, the
cold sore has turned into a thick red scab.
"Everyday," he says, "I keep picking at it. I pick at it everyday."
My throat was not healing, the welts, the sickness, I was deathly ill **and a bit distressed** — you see,
I had *two* cucumbers in my fridgerator. One cucumber, I cut for salad — it sat in my fridge ripe as
ever, ready to be chopped again for another salad. But the *other* cucumber I used *in me*, that one,
left whole, had shriveled-up rotten like you couldn't imagine.
I called Jonny up right away to tell him my dangerous effect on cucumbers, but I was too late
and quite startled to find he was in the hospital.
He told me his penis had *died*, shriveled up like an old vegetable, and had fallen right
off and told me how sorry he was. I guess it was *him* who was not immune to *me*.
I couldn't help but tell him it was all my fault, and that the same thing had hap-
pened to the cucumber in my refrigerator.
He told me the next time I should try winter squash.
I felt terrible!
I asked him if they could put it back on like they did that poor guy
on TV, but he said, *"IT ISN'T THE SAME."*
I asked him if I could have it (the penis).
And he said I could, and that he should have
given it to me a long time ago.
I told him he was making all my dreams
come true.

Café Del'Artista*

(Aspirins for the Artist)

When I am in town visiting home, I get on the phone with Gabriel Lockwood, no matter the hour.

Mother comes into the kitchen to perform vanishing acts on some goodies and again.

I am lying on the floor tiles, I'm listening to the hum at the bottom of the refrigerator which she opens; her spidery-vein knuckle-feet situate by my head and she is cracking out ice from the ice-tray, an up-the-skirt vericose-**vane** that makes me into an agitated little pussy.

"Hello, *and it's Headquarters*," Gabriel sings in a good mood.

I meet him on the city street corner in my leather long navy tight-fitting jacket with my long face and my bad growing-out hair because I went *coo coo* and shaved it. I'm sad and hoping I don't see anyone, except for Gabriel. Although I know the encounter will be exhausting, I know it will be good. He arrives almost immediately; I see he's got the book he's writing in messy pages under his arm.

I tell him, "You know, once Jonny was talking about you, he said 'I'm not saying he's going to be the next writer of *Naked Lunch* . . .'"

Gabriel interrupts me and says, "Oh *but I am*. I will surpass that." Gabriel had not read twenty pages of it, *or anything*, with his distractions — with his compulsions. I'm amazed he makes it out of his bed at all. I had hardly read anything myself, though, which may account for the crappy writing, and lack of style. When writing is bad, why read? And when it is good my eyes get hungry with envy, like empty stomachs, the food falls hard into me and I want it, I want to make it my own. I would love to sit and be a reader and devour but I get fat with jealousy, and I have no clothes on because I've taken the title too literally.

"Psst," Gabriel winks me over and comes up close to my ear, looks behind him as if there may be conspirators watching and says, "don't tell anyone; I'm as good as *Shakespeare*."

And I feel jealous at that. *Jonny has stripped me* of any confidence I ever felt.

* **English Trans.** - Café *of the* Artist

* *Gabriel* in Biblical terms = the angel of Annunciation; see: Alter-Ego Guide List, p.150.

I am writing as it happens. And Gabriel Lockwood is doing the same thing, only what *he* writes is mostly happening in an alternate zone in his mind. He's better at it, in any case; this kid Gabriel, who's got it worse than me, sliding the pen down with urgent immediacy on three new sets of metaphors I'm jealous of each time, describing and excusing his behavior and he's ranting them and having that look in his face like he is feeling a little strange now.

Gabriel wants to be writing *or nothing*. Gabriel is worried if his hands are transparent enough; he'd rather write with no cohesion at all, no technique, no substance. He'd rather have <u>invisibility</u> grafted onto a page magnetizing from another dimension threadingly; ** and *I* am just happy when I can fix up my grammar so my fucking biographer doesn't realize I'm a frigging moron.

"Do you want to sit by the window?" I ask.

"Oh, that's the only place to sit as far as I'm concerned."

I get myself really fucked up on caffeine. Usually I try to avoid it. It used to be only herbal tea, I'm thinking he's a bad influence. Two cups and lots of sugar does me in, sugar sugar a thousand million granules; the waitress was so tired of returning each time with a new sugar bowl that she came lastly with a five pound bag of it, poured it straight into my cup for a long while and left it there on the table for me. For Gabriel she could only serve hot coffees so fast. But he always looked sad, because he always seemed to be out. And he'd forget that he was. He'd bring the empty cup up to his mangled lips to drink and there'd be nothing, he'd look into it sadly, get distracted, then do it again.

Hands are shaking. He is dropping his pages He jokes, *I have a little demon in me, that's okay.* I am drinking and the spoon is still in it. I am tipping the cup up to get at the sugary solidification, the spoon is falling smearing coffee syrup along the side of my face. I tell him my girly problems: the insanity that creeps up the inner skull-walls banging like cans, cold like ice kept at the back of your tongue; that I want Jonny to scream in my ear, and chase it down, but he

** See ref. the knife-cut razor-letter typewriter, **p.84**, whose type you can read right [write] through the page. (*A Well-Timed Redundancy*)

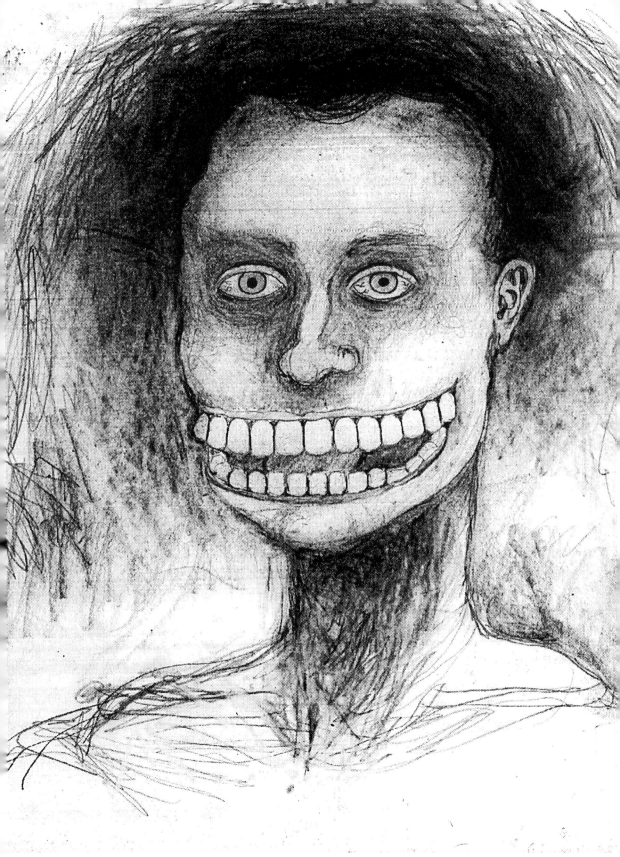

rolls over in the bed angry at me because I won't let him sleep. If he turned on the light he would see the yellow in my face, which is my fear, my dying, I am showing my decrepitude. I don't have a mask that perfectly embraces the curve of my skull. I can't help it. If only I was a bit more asleep, in the dream world I would let the devil take me.

Gabriel says *he* would never roll over. He says Jonny's full of shame, and he has a mask covering it, and every time I see him I just keep pulling the mask off.

"All I have is pity for Jonny. Love, but mixed with pity," I say.

And Gabriel will breathe on me and I can get highwired from that. He says, "Yeah, he's never going to *get* it. He wants to do what is right, but he is never going to know what is right." He says that as he puts his own slimy hand on my leg and I keep taking it off me.

I called Jonny twenty times for some action that night from Café Del'Artista re-checking the number to see if I got it right; I *do*; he's just not there. Staying and staying until they have all the chairs up on the table, receiving back my same twenty-five-cents from the hole at the bottom of the pay-phone, hoping to get through. I am swollen-bluevein-miserable when I get home. All I wanted to do was degrade myself by going to see Jonny and telling him he's right about everything so I can be with him, but I could not have even that.

And I'm sitting vexed with hellfire. There comes a point when you let yourself go numb so you don't feel the terror. Dr, Pain puts himself in excruciating agony just to hurt you; he'll cut off his own hand to replace it with a claw just so he can tear at you, because he thinks it's what you really need; but you tell your Doctor Pain to take the night off and that night to sleep with analgesia, eyes open wide, straight and disjointed in bed removed and pathetic. ᴹ·ᴰ· I spend the holidays alone, and never get my strap-on. He hadn't even broken it off with me, he said he had to walk some dog three times a day, so how could he possibly see me for festivities? He wouldn't talk to me on the telephone because he said his soup was getting cold.

I guess it's not hard to emasculate someone with a dick as small as his. And the balls to match.]

M.D.

Note language delicacy, personified emotion nuance – versus Alter-Ego, Dr. Pain (PHD) character; double-éntén on altered or doctored anguish, read as: to doctor. See <u>*Elusive Adjectives*</u>ᵖ·¹²¹ & see <u>Protagonist List</u> ᵖ·¹⁵¹·

So anyway I am at the café with Gabriel.

He is relating to me about his past, "*I would feel dirty and be in the bathroom for an hour. My asshole would be bleeding.*"

"Why would **your** asshole be bleeding!?" I ask.

"Why? Because I'd be wiping it so much!"

"Really!" And he is in the past roaming the place with toilet paper in his hand asking people to look at it, to smell it and tell him if the shit he is hallucinating is really there.

"But my friends would tell me, *listen, we don't care if your asshole's dirty.*"

"*Really?*"

"*Yeah.*"

"Would they *actually* smell your toilet paper for you?"

"No."

The plunger is his sword because his toilet is plugged up from too much compulsion to clean his asshole and too much toilet paper in there. So when he tries to flush, it gets plugged up, but the devil has stolen his plunger and all that night he has to take a shit but he can't so he just keeps on writing. The devil is standing there, I know, while his guts are full of caffeine and worry.

It is becoming not depressing but scary as I am riding home from the family get-together during a holiday pARTy. I am thinking: I just wanna be a junky; I just wanna eat candy. And I can't hold my shaking lips against my teeth any longer, it is beginning to cramp. I am screaming loudly in the back seat of the car, a low moaning wail and my mother gets angry with me. She thinks I'm being rude, she says just because I FEEL bad I don't have to ruin everyone else's mood. She is the only one bothered perhaps because my voice began abruptly while it was *her* who was saying something, *the seven layer cake Alba made wasn't as rich as last year's.* Everyone *else* can ignore quite plainly my clawing at the windows, why *should* they care?

I am thinking there must be some greater reason why I am so submissive to this torture.

I push Mom over as we walk in to the door, she is yelling "EXCUSE ME!" and I am alone in the bathroom with all the faucets running on full blast, hot as they can be, I am bringing my sour pain to a bitter green-tasting metallic-smelling spit I let fall out my mouth. That is my baby.

I realize that what I mostly have is fear. It is too scary alone, and anyone who is capable to be with the girl I am, I deem unattractive. I seek the weak and the blind, only to incriminate them in the end when they fail for being incompetent and not having seen. And then swim in the doctor pain pool I've filled.

This disease, which has overtaken me so easily *can't* be something so rare. Why is it not more popular; why is there not yet some fast cure or pain alleviation?

Jonny told me he wasn't *hiding anything,* that he contained no shame, no mask; and that it is *his FACE* I keep coming over and tearing at. And He has <u>no</u> mercy taking off my panties, I shouldn't have waited til the morning to ask for something, after lousy boy's been down my pants and he's asking me not to bestow guilt upon him. I shouldn't have gone to Him at all and been a martyr for love.

I am no great artist like Gabriel; it is not fair that I am tortured and art may be the only sensible relief, besides masturbation and dumb men; I don't have the guts to cut off my ear or the pinkie-I am betraying art. My heART is abandoned, my heART has left me, and small squeamish veins pull me, internally victim. I slide on the abrasive canvas and it burns me. I've trouble letting the breath ride smoothly through my constricted throat, I am choking, there is no boy's penis to plumber my pipe of which I need to swallow pride that does not go down easy when you know you have failed so badly. I have betrayed myself, I have been grossly mistaken, horribly deceived. The cheated flesh then must forgive the ignorant being for impeding it, for not thinking of something better to do. Aspirins don't help.

Gabriel goes to the typewriter store. That's what he tells me.

He has not been able to write as fast as he needs to. But he keeps on getting up too late for the typewriter store to be open. Finally he went there with his mother, and he wants the black one. They don't want to sell it to him because they know it doesn't work. He knows it doesn't work, but he has to have it. They offered it to him for a week and so when he comes to his senses in its disfunction he can return it.

And it *didn't* work for shit. "I knew I'd *eventually* need a working one," he explains.

"Of course."

"But while I had it for that week, I wanted to type as much as I could on it."

Then he tells me, he typed his soul out on that necrophiliac machine ✡ though the letters didn't come down easy. He got a *second* typewriter that didn't work for shit either. And the people working at the store saw that he was obviously crazy, so they just gave him the same deal. *Okay, try it for a week and when you realize it doesn't work, you come on back.*

I don't know if the deep blue[**] one is the one he has now, or if it's the one he returned the second time, or if it was the first one that would speak to him in the devil's voice or which one becomes part of him. I don't know which one he used to type the pages he was dropping, blackened with typed **ink**, he says gets sexy, but he never gets to that part when he's reading it to me, for however long can he read read read to me in the café. We have our conversation. He would like to hear me tell him a story or a dream:

"I should have let go of the handle bars. My bike would have ridden me anyhow, in an objective snapshot of my surrounding, which I play to, puppety. I shake down my puppet and make it wink at the audience. *Don't be scared by this, it is an act.* Then they can touch me; they

✡ "Necrophiliac machine," as in *mechanical version* of THE *metaphorical* murderer. See Note **p.22** " the

Greasy Spoon "

[**] Shades of blue, deep, powder & cheery exist outside the Bile Flavor Color Wheel © **p.147.** "*Blue*-vein" miserable is also metaphorical and not in its nature a fluid of the flesh. It represents the outer demon, the sky, the Moroccan room, the bike, the typewriter Jubilee. Gibraltar rock is the source of the color, dug and freed from the earth to be mixed as pigment into paint.

can define me. But that is a big big lie, by bike *is* an obscenely dangerous way to travel, and you have reason to be afraid."

Gabriel goes insane and he'll be roaming the halls and the hall monitor will say, *"Hey, you better get to class."* He won't try to hide, he won't say, *I was only fooling,* run and sit down in his chair. He won't say, *I'm a rebel delinquent, get me to detention.* No, Gabriel says, *Hey fuck you, I'm an obsessive compulsive.*

"Oh."

And he is untouchable. ✠

Gabriel is speaking, "There is cunt juice dripping from the cunt. It is a safe warm feeling but at the same time has an ominous tone to it. There are nerves in your cunt; your cunt can slip."

"The cunt can slip?"

"No, *your* cunt in particular."

"*My* cunt?!"

"*Your* cunt."

My eyes slide out of focus, I am ready for eventual disaster.

"You're wired up. You have a squeamish feeling about your own cunt. Like you had electrode wires hooked up and the devil is feeding them a current. But in the come-down the wires get burned out and you don't like having them there."

You can't see the wires on the sonogram, but they are there and he is wrong. I *like* having them. I'm thinking someone should attach a spinning wheel to my masturbatorio finger, because my writhing action would spin rumplstilSKIN and then there would be a man created there by my sexy blood lust orgasmatron: an onion skin man.

It's the ideal marketable model, Electronic Cunt 2000, a machine you put a quarter into, in the slit like a telephone and press a button to choose from the three flavors: nasty™, scanky™ * and period™. Outside a self-lubricating spongy cover; inside, Taiwanese microchips leading sensory perceptor impulses to the NERVE. It plays music, it vibrates; it's got a thirty-day money-back guarantee. It looks, feels and acts like a normal cunt but turn that sucker on! Use it good baby and when you're finished take it out like false teeth, you can put it in the dishwasher, screw clip it back on to the

✠ Author has done <u>extensive</u> research on the unconventional and conventional "crazy." Unknown is how much truth and hearsay there is to the guises she coveted to spy. Unknown is what symptoms she actually carried or adopted during her science. Rumor holds the joke: *narrator (note protagonists list* p.150) knows how to spell Bellevue because it was printed on the sheets she slept in; see List of Unfortunate Disasters #12 p.152. Incarcerated or straight-jacketed, the freedom of psychosis is the denouncement of Satan, that *gets you off the hook,* p.152.

* Purposeful spelling error, as in **s c a n k y** Inc., scanning devices

knife-plate platinum bone. It is my own, it comes COMPLETE WITH A LOCK CAP KEY FOR PERMANENCY.

I'm thinking there's a Band-aid for the cancer growing on the soul, but there isn't. He is corroded and action must be taken, action only one artist can do for another.

Burroughs claims he's woken from some junkied coma-sick delirium, not having precise memory of writing *notes* which comprise *Naked Lunch* ©, so I start wondering if I can wake up from **this**, denying *later* what I did. But THE disease *I* demonstrate isn't vaguely as serious. I detest *Junk*, the scurvy needles, quease and shrink at the thought of getting them in my arm. Don't even smoke. My only detrimental addictions are to intermittent excessive sugar intakes, and my consequent withdrawal — sometimes the sugar-substitutes and the deathness accompaniments. I sporadically get hooked on TV crap; I chew on pens, and I'm addicted to some boyfriend who doesn't like me — but *that* accompanies my addiction to marred selfhood which anyone might admit they've got. America, a nation frozen-constitute of emotional masochists lurking in the crevices of culture because we've got nothing else to feel bad about so we grow pain ourselves. Torment is not mass-produced on government farmland, or manufactured in some black-market laboratory, you can't cut it off, sell it, or bribe anyone with it; you can't manipulate, build up or bring down any massive bureaucracy. It eats sugar too, it eats at you; it's parasitic; and if ignored it kills me. *It* makes me victim like junk does, making men and women shiver themselves into sick frenzies, turning them inside-out creating breaks and isolation, ice-souls. Burroughs *says,* "A *rabid dog cannot choose but bite.*" He talks about the psychosis within a society. *I* cannot help but act any other way than I do.

I'm looking to pull tears out, bite upon the viscera, bones slowly cracking under pressure, slowly breaking teeth and it's STILL sour after I read it. So partially undercover Gabriel is floating across boundaries, physically ignoring any

53

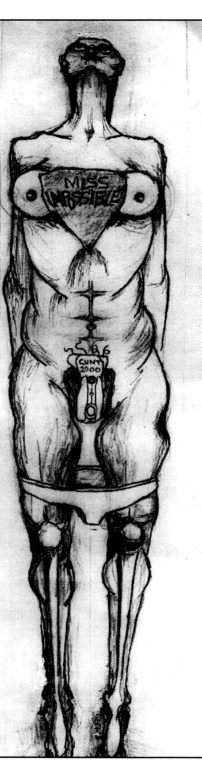

semblance I try to make of it, and I go hiding
in the attic with my hand down my pants. A
f l u c t u a l
misery, stuck in lamentation as I walk from place to place, rubbing to make up for
lost time, to feel my familiar release, rubbing to dream, rubbing to feel such pleas-
ure — so much, I fear my head might come off; embracing pain in the most unfor-
tunate manner. I cringe my face and sing the song of weep.

Gabriel basically has a clear complexion, but he is corroded, and
when he writes well, the demon stands *near* him, and the only reason it can't
touch his tantalizing disfiguration is because each of his words is being chosen
pristinely, ironically, **from** that deathly presence. His sores are in a continual
state of healing and oozing puss, which gets smeared into the pages. The soul
that fills his body when he writes, does not fit quite right into his body anymore
because he's been so disfigured, but that just influences, provides occasion for
new tricks that his soul didn't have before.

We are the same in that none of it will go unspoken. But I treat him like
why you leave the table * with your hand over your mouth. You leave with a sick
feeling, out of horror, out of jealousy. And he is beckoning me to his home, to his
room so I may see where he lives and where he writes.

I am afraid of the serpent on remote control.

55

* It's on the table.

Gabriel Lockwood's
(I Went To the Bathroom, At)

He opens the door balancing on two sticky legs.

"Put some PANTS on for crissake!"

Into his place: Tobacco-smoke odor reeks from the furniture; *you'll* reek like that when you leave. The garbage's overflowed with empty yellow *stay-UP-with-VIVER* caffeine-capsule boxes, and used nitrous-oxide containers, "What if your parents came home and found this?!"

"They'd be horrified. . . ." he says. "Not by the nitrous, I mean, by the mess." He clarifies, "My mother smokes reefer."

"And *lights.*'" I remind him.

In his room there are pages covering everywhere, especially by the little typing table.

"This is the blue one?"

"Yes, this is the one with the devil in it." [*]

Where the Devil Machine spits out pages there is a pile three feet high. You have to sit on the pages, spill your coffee on them and plug the fucker in to type on it. You have to plug it in. It's mumming a gum and Gabriel is shaking his knees up and down like a madman, "Yeah, the devil came to me tonight."

He gives me the creeps. But I should have come here a long time ago and typed on this. It's a fix.

So the Devil Machine is spitting out the pages I am typing to the beat, it is an instrument just like a guitar or drum with its mum and its tap clap and bell. I am handing the pages to Gabriel for him to read, and he is saying, "Hey, did you write this?"

"Yeah, I wrote it."

"No shit, I typed the exact same words on this when I got it." *Jubilee Jubilee. You have to plug it in. I like it. I have it.*

"No shit."

"Yeah. Yeah, yeah." He is jumping up and down like an infant.

"So I bet you type really fast on this thing," I tell him.

"Very fast, yes."

"Hey, how bout you show me how you type on this thing?" And we change seats.

Yeah, he types all right on the thing. Jubilee, Jubilee that's the name of the thing written in metal letters on the blue body.

He asks me to hold his rolled cigarette for a second while he pours us coffee. I must have blacked out for a second. Next thing I know it he's already

[*] **Blue demon,** see ref. Voodoo Theory © / spiritual possession, **p.140.**

back with the coffee and it's quiet. "What hap-
pened to the typewriter, it doesn't work." My fin-
gers press flatly on the keys that won't go down.

"You can't leave The Devil Machine
plugged in, because it can get hot," he says.

"I think you unplugged *me.*"

He's now asking for his cigarette back
and I don't know what I did with it. He's telling me
I stole it. I can't believe I lost it; and I'm gonna pee
my pants if I don't get to the bathroom. I can hear my own heartbeat in my ear.
I am running around the house crazy looking for it and the cigarette; I know his
parents aren't home and his brother looks like a female.

So I'm on the toilet, I let the faucet run so he can't hear me, even
though he's got good music playing loud loud. I had an itchy buttonhole that
evening, if you get my drift. It's always pleasurably disturbing to me when that
happens. I am aware of that hot area and have to get to it, with good reason —
then there is cunt-hard-mucus on my panties. I felt it jump out when I pulled them
down. I finish getting fixed. I come out.

There is a glass on the table filled with about an inch of coffee and a
thousand cigarette butts floating in it. The table shakes as I type rippling the
coffee and the butts that are floating. I am screaming because I thought we've
run out of paper. It's a bad joke. "Forget about the coffee, the cigarettes, and
the castration! What the fuck do we do when we've run out of paper!" There is
<u>nothing</u> worse.

We are fighting about what's more important and he's gonna go
damn into convulsions if we don't get him down stairs to the store to get him some
more tobacco. This is the heaven torture chamber. As I am typing, typing this, I
am biting the pen into pieces. The plastic is sharring off; I blow the pieces out like
teeth; and it's tooth-fairy season.

Ink fills my mouth, and we are activating the Satan cycle.

"Help me in the hole. Help me out of the hole. Help me in the hole. Help
me out of the hOle, and it's Crazy," he sings to me. We are screaming, I am
screaming and he screams with me.

With the serpent-wriggling nerve biting across my mind; I just want to
die. I'm dodging my boyfriend's shame tonight because I've seen it for too long.
I've been acting for him, and he doesn't even love my puppet. I'm shaming

myself even more by pretending that it's okay. I look down at a piece of paper at my feet and there in black and white it says, "In Headquarters, any soul that has ever felt love is forgiven, no matter how far it has strayed."

I'm thinking I don't want to be forgiven, I just want Jonny.

Gabriel thinks I don't have a slab of squeamish meat between my thighs, *I'm* pumped with dildo perception. He's telling me about this amorphously - fat **black**-girl who'll listen to him talk his head off for acceptance, she would allow her fat fat ass to be fucked by Gabriel Lockwood just to feel that she belongs in the world. She has to have taken a shit fairly recently, he says, and maybe she hadn't because he couldn't do it, only up her cunt.

"It's just a question of patience and lubrication."

"Oh, I AM THE MASTER OF LUBRICATION. I'VE ALWAYS GOT A JAR OF THat. Back in school the kids used to be disgusted by me, they didn't know what the fuck I had all over my shirt. I was gross and my brother would always be so angry at me for having Vaseline on the doorknob, you know, if there was petroleum jelly completely all over everything in the bathroom it would give me new hope." ✕

Before cigarettes Gabriel was addicted to chapstick.

Sexuality leapt from my hung-up cunt wrapped in squeamish wire giving that biting-down-on-the-finger feeling. He'll tell me to unlock the demonic wiring fastening my pussy like the pills did. He doesn't know I'm a hellbaby. This is what I'm made of; I can feel the hellfire so readily when anything in my life remotely reminds me of sin, even my own sin — the fever dream swaying my body sweatingly. I can't believe I used the bathroom at Gabriel Lockwood's house.

I try to tell him something funny, but dialogue doesn't matter anymore on the Jubilee Machine.

Don't you find that funny?

He says it came across more like poetry than a joke.

✕ See ref. <u>List of Unfortunate Disasters</u> **#2**, **p.152.**

Zippø = 0, Zip meaning nothing.
In Shakespeare nothing being a euphemism
for sex,
nothing / naught Ø naughty

JUBILEE	.59
RUBBER STRAP-ON	.59
PICKLES PINK	.59
CONDOMS RIBBED	.59
BAG SUGAR 5LBS.	.59
ONION RED	.59
PETROL JELLY JAR	.59
KY JELLY TUBE	.59
BABY OIL	.59
YOGURT	.59
VITAMIN MULTI	.59
Total Tax	.00
Total	6.49
CASH	10.00
Change	3.51

Zucchini Restaurant

I'll point to the spot where your dick can be cut off and if you touch it there it'll get ten times stronger.

I have a dick that becomes so disfigured throughout the night that it's basically dysfunctional and useless. But it's *never* **useless.** Ready to surrender, thinking that you are doomed. You're at the end of your rope, almost ready to cut the dick off so it won't fall off on its own, pushing teeth against the wall to bend them from their gums, twisting and pulling at them so you can feel and taste the sweet bloody pain, pulling at your tongue. In eerie revelation your intentions blacken. Your most depraved dream leads you to reality. The disfigured penis was only in your mind, but you were really going to cut it off, and now you have the thought. I'm thinking, it's a scary scary scream. I'm thinking of the placenta dream:

The doctor I went to reached in and pulled out my placenta and cut it with a scissors to check if my baby would be retarded. In uproar, the doctor came with wooden sticks ● sticking them into the cervix hanging low and heavy between my legs. I didn't understand I was receiving a castration until it was over and I was scabbed where my body didn't even exist. An abortion with no messiah-baby to begin with. I carried heavy something else: the toys and ice I used to stick up there —

● . NOTE: CHOPSTICKS-acupucture voodoo
See: Dream List #4 **p.156**.

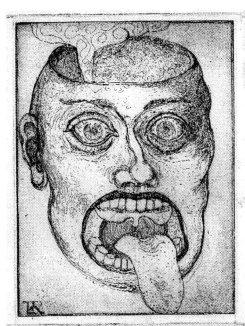

Licky Good™

GET IT AT YOUR LOCAL CANDY STORE.

SPONSERED BY ZIPPS INCORPERATED

(not the ones Jonny would insert when I hurt from his irritating sex) — the ones I used to put in when I was small. Four or five of them and el masturbatorio would go to work, vibrating a hole through my clitoris — melting the ice-cubes — shooting them out my vagina. My Messiah, my conception gone. ✪

I am not dreaming, it is all waking self-initiated scrutiny, horrified reflection of a pathetic face broken with spasms and sobs pressed up against barren walls, if only to become the wall, inanimate with frozen self-pity and pain, which doesn't flow, and become alive. This is the predicament of human existence. I want to become an invalid and not in-valid. The human condition is the human condition and the same one I am perceptive of is the same one he is unperceptive of. God, aren't you afraid, having balls so small that they're gonna fall out of your head?! If you are going to be deficient and weak it should be because you are willing to accept any suffering or thrill it leaves you naked to.

I am impenetrable because I am unsecreted, but not invincible, only insanity gives you that, and I weep because I am a failure even at going mad. I am the woman with the mouth too big for her head. ✱ I open it wide to **absorb,** I don't mean to frighten anyone away. But they all run at the sight of it. And that was the exact opposite reason I opened it up to begin with.

I pull closed the zipper of my mouth; I am shamed and beaten because I was misunderstood, and that is my greatest sacrilege. And they score a point. They score a point when one person gives another shame. That is what is American: defilement, irreverence. A surefire ruin.

A sick silence comes over the room; you are in the come and there is only infection surrounding you. I'll lie in the bed of toxin-solid gas, confident my breath will find a passage past it to the window and hope I will not come down with influenza. The devils push me into the shadows and twist my face into a mockery of acceptance.

This is an insane asylum and the inmates are stirring their tea and accusing each other about breaking the typewriter.

"I need a woman to blow my cover," Gabriel says, "to rip it right off, to point and make me look and touch it and say, 'I don't blame you for that.' I was thinking I could become a typewriter salesman and get shitty typewriters

✪ Note: external vaginal cavern, another identity for subconscious phallus

✱ See: big-toothed drawing, detailed pencil sketch, **p. 48.**

that don't work and find girls roamin' them and tell them that if you transcend the confusion of the typewriters' stubbornness then you really pinpoint the devil's action and send it to hell. And then I would ask them to trade me their typewriter and *every time* they would say yes. Then I'd take their expensive typewriter and sell it. They'd be all my customers, all attaining transcendence and writing files for Headquarters and I'd be making a profit and I would say my line of work is causing souls to attain transcendence."

"I think that's a fabulous idea."

He tells me, "So anyway the ***a*** doesn't work on my typewriter anymore. You know what the fuck I'm talking about, necrophiliac machine ring a bell?"

I didn't know what the fuck he was talking about. "The Devil Machine. The blue one? "

"The blue one is my *only* one."

So I see where he's been typing, "From now on the letter thqt is not here which I cnot type becquse the devil stole it."

Maybe the lady at the typewriter store will be able to fix it.

"And so lately I've been feeling a little constipated." I'm thinking, I've heard people who masturbate too much get constipated. I tell him, "I'm afraid I'm going to blow up because I haven't been shitting out as much as I've been eating and I'm afraid to get any ass-sex, because I'm afraid that when the guy puts it in me, I'll be so backed up it might come up out my mouth." ✳

"Caffeine usually does the trick," he says.

Caffeine, I'm thinking, meanwhile two days of sleep have passed. I can't move, I'm going through sugar withdrawal, any normal food I eat makes me tired because I don't have enough energy to digest, wake up with a headache, maybe sugar's the key to my digestive problems.

I had a dream balls rolled across the floor: � I'm holding onto Jonny's penis, flaccid in my hand because I'm scared. Jonny's yelling he's *out of eggs. We've got to go out for eggs. There's no goddamn eggs!*

You're out of eggs?! What about me!?!

What about you?

My *eggs!*

✳ Reference: <u>Dyslexic Literature</u>**p.118** ©, & **Baking Agent** ᵀᴹ: "Art may be bulimic conceptually, one-way physically."**p.132**

des See also Dream List, #5: Billiard Balls, Rolling Screaming, "Eggs!" **p.156.**

I'd been woken by the telephone ringing. "Hello?"

"Hello." It is the Secret Agent; he asks, "Have you been eating and editing your vitamins?" ❖

"Only the vowels."

"Good."

"And?"

"You're not letting anyone dismantle your EC 2000, are you? Word's out."

"Oh?"

"And I'm just hoping it doesn't go rusty on ye, in the meanwhile."

"Don't worry, it's self-lubricating."

He's in the toilet on a cordless phone peeing out bright yellow urine; "It is all the vitamins," he's saying, "so how's Zippø otherwise?"

"It's **denser** than most things you get on the market. But nothing much ever happens."

"Think of it more as a religious experience than as anything else."

Hmmm.

I'm wondering if he might be a spy working for the *other side*, Agent INFORMal, and I'm thinking that it may not be wise to function under such constant circumstance — always too high on your horse bound to fall over and again. ○ I'm wondering if status quo hasn't found some way to live between perfect oscillation of the horse and the hell, or do they ride in isolation? Am I the one missing something? Who is wise; who is learned, barely brushing against euphoria in pain, the burning in bliss? Do they have their *own* good sting in life I am unaware of? Do they recognize themselves by different means? They eat their vitamins and pee their yellow urine, and what more is there to it?

❖ Secret-secrete: some words I now stay clear of (as in aqueous color) as in fluid. Ref **p.148** Bile Flavor Color Wheel ©; Nutritional Facts, **p.128-129**.

○ Greek mythology, Trojan Horse, or idiomatic *gift-horse looked straight in the mouth*, or *to beat to a dead horse.*

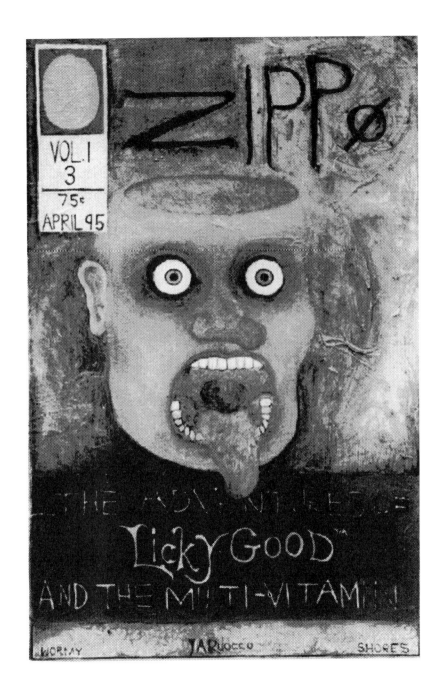

Dishes of Golden Wishes

He used to spit canned peaches at me.
I met him in college, one blondy pretty, outspoken boy.
Yep.
He'd slurp up an orange, syrup glazed, fleshy wedge of fruit you'd get
 in those little desert plates, and blow it out his mouth so it'd
 slop smack on my forehead.
What joy. Scream out like the crazy girl in laughter and avenge pick-
 ing up peaches which fell to my lap and serious-giddy-
 wristed toss them back at his loaded cheeks.
The people would complain around about the *sound* of flop'n
 canned peaches when he told them, "You *don't* have to
 watch." And then we'd get tired. . . .
After too long.
Left about us murky-smiling, only empty seats, desolated wet tables;
 they're gone in disgust.
Beyond our dripping fingertips and glasses of cranberry juice and
 lemonade, glistening at their bottom's rim a circle of the
 liquid they once held, down by our shoes at the chair's
 stool end, dozens of dead canned peach wedges, look-
 ing like the sad sight of surfed whales on a calm-waved
 afternoon. My heart filled, beating sweet metal-essensced
 peach syrup; lovely.
Did I please with a certain acceptance for his dinner habits? His
 waterfalls—spewing applesauce; tender lips I liked to kiss.
He charmed me,
But I ruined everything; he couldn't stand a complicatedly clever-sim-
 ple citrus-mad mind. And a tasty tongue or a sticky fore-
 head is too much to hope for.

Jack Fruit Market

Beneath my tongue through osmosis it's getting into your head.

I'm more and less myself. The smell is steaming in my nostrils, and I can taste the familiar notice-with-the-appreciation-of-a-child yet interpret the sophistication of a mature mind. I've been mentally raped, but don't worry, it happens.

I knew things would move on without me, but when I returned to the table they were arguing about Jack Fruit, even drawing them with colored pencils.

The conversation: "Jack Fruit, it tastes like vagina."

"Well, what does *vagina* taste like?" I say.

"Itself."

"Where did you get this information?"

"Some people were sitting around . . . eating it, trying to describe the flavor, and then someone shouted, *Wait a minute!"*

We're on a pace infested with the static of others. Reality allows itself to be stagnantly fuzzy and disjointed to account for everybody who wants in.

Who knows how it's hitting this guy who didn't let it dissolve in his mouth, accidentally swallowing it with some dessert he ate and it'll get in him through his stomach.

I make a phone call to Gabriel.

"Ah, a little bit, I love having a little bit," he sighs mournfully. He wants some too. He'll want *any* substance you put in front of him anytime.Ø That's one difference between me and Gabriel — him always wanting some; I picture him and some friend of his snorting candy and one says to the other, *Not so much, we don't want to overdose*, and they decide, what the fuck.

"I smell the smell of it, you know," I say.

And he tells me it smells like crotch.

Hmmm. I hang up the phone.

Back at the table once more, "Now, tell me again about this fruit that tastes like crotch."

"We should get one if we can!"

The waitress is here. The one me and Gabriel found sexy has a sexy accent. She is near us talking about the times she's seen me here, about all the tobacco left scattered on the table. She's saying she likes the work and there are interesting people to meet.

"Yeah, like crazy *Gabriel*," I interject.

"Gabriel, is that his name? *Gabriel?*" she inquires. What a sweet chick.

Be it tobacco or a load of pencil sharpenings, sweet chick's getting a

Ø Substance cited, ref. Uranium: *They* put in the water we drink, see Morocco ref. in Sect. 3, et. al. (so *they* can make movies of you when you go to the bathroom).

mess and not minding too much.

I am sipping the last sips of the cold coffee and we're bickering about paying the bill and how the money's gonna spontaneously generate itself; he might even ask the waiter for it. "And wouldn't that be counter productive."

I'm being over protective of the money I've got, as well as all the possessions on me.

A cold chill runs slowly through your body, you can pop right out of yourself and trap yourself back before anyone flinches.

I took a cab to see Jonny, and it turned out real bad. I showed him a note I wrote that I thought was pretty funny. "Don't worry, just a little," it said. *Get it, **just a little***; he didn't think that was funny one bit. Nothing like somebody looking down at you when you're tripped just a little; I can barely take it. So I let my Miss Impossible come out and I'm thinking *No fucking way, man. No, fucking way.* I ask him if he wants to go out for some air, and I tell him *I'm* going out for some fresh air.

No need for me to race in some cab to see Jonny since he didn't want nothing to do with me anyhow. I should have walked or took the subway like I saw the last of my friends running across the street and down the stairs as I'm getting in my yellow-square-taxi telling the driver where to go and isn't the weather nice this evening.

I FEEL the cellulite and muscle jiggle delicately into place, into beautiful-woman form into the shape of one firm buttock, every step moves into place along with the rest of my sway because I've captured some rhythm, tuned into the frequency. Yeah I'm walking down the street and I've got my pencils clutched and I'm looking for a new ¢afé to go to around here. And I'm wondering if I'll wander too far until I'll have to take *another* cab just to get me back to Jonny so he can mock me some more. But he's not mocking me; that would mean he understood somehow. He's gonna sit there unhappy as ever, the same way he would be if I walked in there culture-unaltered.

I'm just scared cause I think it's late and all the cafés around here have "closed" signs on all their doors and I've got no where to go. But something is coming — I run across the street from the traffic chasing me and as the rumble underpass of the subway shakes me, I see something must be coming ahead. A

pink place — might not be as nice as where they speak to you with sexy accents — but there is something. And I'm not scared so much anymore passing the stinky motor truck running, garbage men walking by me and filling up their truck. I pick the 24-hour place; it stinks more than trash-stench ✿ with the overripe pink-flowery sugar smell, I arrive at the counter to choose a donut to eat.

That's America: fatty sweet colorful plastic donuts to eat in the morning and at night. I'm hoping the money in my pocket doesn't run dry. I'm thinking what a horrible place to be — and should I get a donut before I go?

All this I contemplate deeply before the man comes to get my order.

"Hum," I say. I can't decide.

"Hum," I'll try something simple — cause I'm already feeling so crazy. I take the very plain donut to my seat. I have not opened it from its bag yet. I am sitting over it watching men eating their own donuts. I'm thinking if, this time of night, people like them *really* come to a place like this just to eat donuts? But maybe it's true, they do. *I* come to bear the very worst of life — be with a very plain donut because a man could not bear it with me. *Just a little.* Who was I fooling? Not him, so here I am in some city that's supposed to be the one I like with a plain stale stale donut in the stale stale world. I'm afraid because I left the happening part of town to see Jonny and what I find is nothing — but what, am I gonna spend all my money going cross town all night?

People can just snap off I think, cause if *I* don't hold on, I'm gonna snap off. I've been holding on so tightly, I squashed my donut.

I make it to Gabriel's door — it's the middle of the night — his mother's asking on the intercom, *"You wanna COME UP?"* in some little whiney voice. ✳ I would like to meet the lady, but I only see Gabriel when I get up there and he's telling me the acid queen fairy brought me here and that I've come because I could smell his penis. Because of acid, I can smell his penis because his cock smells like acid and I had the scent in my head. Fuck that shit and the walls are moving and I look at my pretty hands and I can see the print of what it is to be a womanly woman, the red pattern of youth, shaking buttock-jelly youth. I'm trying to keep a handle on my hallucination nearly scaring myself out of my own mangled body.

Gabriel says, "I'm feeling a little nervous," and he has to go take a shit. The walls are breathing.

I call up Jonny to tell him I am all right. Yeah, I act and LOOK and even

✿ Example of nonacoustic synomic: *"Well-Timed Redundancy "* ref. techniques **p.120.**

✳ See ref. chART: *"whine,"* SprOUT © *structural stripdown* of letters **p.119.**

sound like the little cute pretty girl yeah, you should see me in my cute little hat, but I'm all torn up with power and scorn. Jonny says, "I'm blasé about the whole thing."

And I'm saying, "That's how you are about me in general, about me, and everything in my life?"

He hates the fuck out of me so I don't god-awful know why he'll keep sticking his little dick into me — why I bother calling him up every day. Yeah, I'll go there and beg for it — no way man. I would have done it tonight maybe but instead I had to run from the staleness clenching it in my very hands as I've been running through the streets and writing. Yeah I've kept little Jonny up my ass all night. And all this time Gabriel's still in the bathroom trying to get his shit out or maybe he's in there dancing with the toilet paper. I can imagine it, to the rap-music he's got going. He's wrapping it around and around his arms.

He said he never thought he'd get out of there being so frantic washing his hands. I tell him he's an angel, thinking of him with toilet paper streamers dangling from his arms and body like a ghostly gown. He says, "Yeah, I'm the Gimp."

Mostly I came here to type on his Jubilee but it's still in the shop. "They say it may be in there for a couple of days, before they fix that *a*." ✺

He said, you know really, in the beginning, he couldn't type on the Devil Machine until I came over and was acting like it was a cool thing. He said it would actually depress him to write on it, and so did the whole musical-chair of typewriter ordeal.

And then you know what the fuck happens? Gabriel breaks his glasses. And I'm thinking that it was intentional; it's paranoia and he says uneasily, "Now I'm really gonna look like the fucking Gimp with tape on my glasses."

I'm starting to get a headache. We go to the kitchen. Lightly coated and easy to swallow: he gives me four. I don't know any better. I eat them up. He says, actually they might make me slightly high.

"Well, why didn't you tell me that *before* I swallowed them? *I'd like to go to sleep soon.*"

"Nah, they won't interfere with sleep."

And meanwhile since he can't find any tape he's tying *string* onto his

✺ See ref. chapter: "the *a*-okay Café," where Gabriel gets the "*a*" fixed on his typewriter, **p.179.**

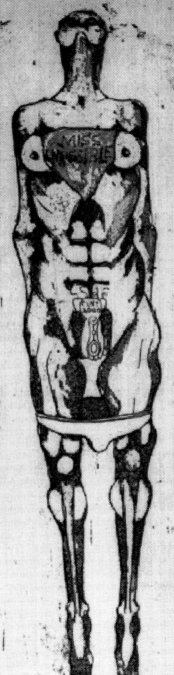

UNDER
WOMAN

EQUIPPED WITH
SHOT ROCKET
ENGINE

glasses.

I'm thinking, he must be joking. Is he for real intending to *tie* his glasses to his head? He *must* be joking.

He is following me calling, "Can you help me?" The string is passing over one of his eyes and around his head. It's so hilariously funny that I'm gonna pee my pants. The string's end is in hand, he's reaching out with it, "Can you tie this, please? Look, I'm the fucking Gimp."

So we're making tea now. "Do you want some *crotch* flavored tea?" he asks.

And I'm thinking Jack Fruit, but see, I know he's joking with me — he took *regular* BRAND tea out the cupboard and sticks it down his underwear and rubs it on his dick.

"No **I don't want it!**"

"So you want yours without the *real* flavor."

He says he's gonna give me the ass flavored one.

I know he's fucking with me. But now that he's broken his glasses, he's pleading, "You got to help me find some tape."

He says one time his girl friend made a cigarette for him with pussy hairs in it. That's true; and I'm thinking how jealous I am. I'm thinking no way, no fucking way. I had to get away over to gimpy Gabriel. We are making tea, he is balancing sugar so carefully on the spoon.

Excuse me, I'm writing nonsense. I must have looked like some kind of weirdo on the street writing and running. Just fuck me — you know that's all I want for some god awful strange reason, just to have it fucked — the cute assed, period vagina-ed baby teeth cutey fuck me right out of my womanly woman body. How could he desecrate the woman? God, the walls.

"Are you writing anything good lately?" I ask him.

"*Okay*," he says.

He's reading to me.

I'm thinking, you know what? I'm afraid the cute little girl's gonna crack. She's a shell like a bug and she might crack, the little girl — a spider (woman) decrepit might crawl out. She'll crack like an egg-shell, she, MY head right off. The demon will possess her, yeah, and the girl will be crying and

meanwhile she is being broken and taken over and somebody's gonna find himself up against a monster spider that never was me. And I'll be glad.

I'm thinking I can't be what I can't. I'm thinking, "Do you mind that I'm writing and writing?"

"I like that you're writing; although sometimes it seems like you're not listening," he says.

"I'm listening."

"I know you're listening."

I take a cab back to see Jonny. It cost me six and a half bucks and when I walked in he didn't wake right away of course, I had to ring the buzzer annoyingly. He was all red-eyed like a bull and called me an asshole.

I slept lonely, on the other bed completely. ✕

In the morning I told him I was so sorry. He told me he wasn't gonna condone that business one bit. I told him, you don't condone *anything* I do.

Somehow we had a tolerable next couple of days together. Miss Impossible must have had to do her laundry to get out the tobacco stink from Gabriel's room and the suit was busy in the wash. That must've been it.

✕ Ref. List of Unfortunate Disasters, #17, **p.153.**

excerpt: Feeling Insane

I took about six aspirins,
sat down dead in front of the TV.
Mom told me to
when I told her I was feeling insane.

MY MOTHER'S

Gabriel is coming over to pick up a typewriter that's been abandoned in my old-maid aunt's basement. I offered it to him while his was in the shop. This one is dusty old and very heavy.

I was wary of his approach to my mother, his appearance and the attitude he might take on in front of my parents. I didn't want her to assume him some street idiot and accuse me of associating myself with those loser-types. It would just get her alarmed, but they get along fine. He politely smoked my mother's cigarettes, she doesn't mind as long as he doesn't leave her empty.

He had walked in the door with tape on his glasses, yet had to hold them up because the tape wasn't fastening anything together. It just sat as a bulbous mass at the top corner of his frame missing the ear hook.

Mother asks about them, of course.

"Yeah, I went to the eye doctor shop," Gabriel said, so earnestly, "They told me they'd call me."

This made Mother chuckle.

"That's also what he was told about his broken typewriter," I explain, "that's why I'm lending him *this one*."

The folks offer him strong Italian coffee and alcohol, he accepts them like an open-eyed wonder-boy, and proceeds to talk to my mother about visions, and addictions. He's talking off about a friend of his who OD'd on heroin. And my mother's saying things like, "Well, we all have our bad habits and can't really condemn anybody for anything."

I thought my mother might be referring to her fixation on the many instant win Bingo Scratch-Off game cards she's been buying and playing hoping to win. She's been playing them all day.

We transported the typewriter in a old-lady shopping cart on the subway.

"I'm thinking about writing about a typewriter salesman, Gabriel."

"That's good because I probably wouldn't write that. . . . Not to say that I'm too good to write about that."

"Oh."

"Did you think I was saying that?"

"No, I wasn't thinking that."

"You know, because I knew some lunatic, who when I would say, *did you think I was saying that?* he would always say, *yes.*"

I am returning home in the drizzle that's been the weather these days. The nights fall dreamy dreary each time with mist and fog. The dirty birds are wet-feathered. It is cool as I walk back to my parent's house, to the door under the awning I see footprints of someone who has walked in before me, the door is unlocked.

My mother is standing all about inside acting more than nervous — she's asking to borrow a large sum of money that she has lost gambling.

She feeds family money to a *real* devil machine, not Lotto, not the scratch-offese to win cards I thought were cute when she had a dozen of those *win for life* brought home with her packs of cigarettes which you could tell she's been at all day if you didn't see her because she has neglected to sponge off the piles of scratch off metallic twinings on the table. This was much more serious, new American electronic slot machines with arcade porn queens spreading their legs in the convenience stores. She's a homely woman, she says but she gets this urge inside her. Maybe it's cause there isn't much else in her life that thrills her. I'm thinking why can't she be an alcoholic or something cheaper. It happens quite often and my mother's in her frantic horrible come down, she's gambled to nothing.

I'd tried to bust this place before, because, for now at least until the laws change, it's illegal in this state, they hide the machines in back rooms locked in boxes until their victims come for it. The pigs * only give me the run around.

It was so nerve racking I called Jonny over for solace. But he is abrasive, "Why don't you just call Gamblers Anonymous?"

I do call some counseling service and make an appointment for her, because this really breaks her up. I know how that feels; I get that way, worried over nothing I've done.

* **The fuzz**

"Thanks for coming," I tell Jonny, "my father is home, and we are acting as if nothing had happened. "

Jonny greets my mother and she can only offer expressionless smiles of discomfort. She knows when my father finds out it's happened again he's going to wring her neck.

My father will talk off about the damn impersonal-ness of the city and how it's so different in a hick town. Meanwhile, if everybody was smiling their toothy smiles at each other's faces it'd be just as hard to speak to a stranger unless you were asking for directions of talking off about the weather, or the traffic.

On the train you can talk to just about anyone. After eye contact prolonged in a strange but peaceful way, one of you is bound to speak about the other. I'm watching a black man in a blue suit leaning over these leather box cases. I'm dying to ask him, *what ya sell'n?* but there is that wall that is between, 100 times thicker than the s p a c e there is sitting and standing around on the subway. Finally he notices and is staring back with a frightening recognition. He is doing some motion with his hand, at first it registers as some obscene gesture. He is merely referring to something weird that is sticking out of my hat.

Oh this. **˃ᐠ** So I say, "What ya selling?" I'm thinking encyclopedias, I'm thinking dead bodies, I'm thinking LEGS like in some Burroughs story I read.

He just says, "It's for lawyers."

A crowd moved in on us obstructing our communication. When it clears again I realize god there's nothing more to say — the people around who had witnessed the communication are glaring crazily.

I'm feeling crazy — I missed my stop.

I catch a train going the other way and miss it AGAIN.

I decide to get the fuck out and walk.

I'm zeroing in.

I've been missing my stops all the time these days and sometime I end up in the bad part of town, or even worse some musician's district and all the musicians are getting on the train with their cased instruments. It's no fun asking a violinist what he's got in the box.

˃ᐠ A cute boop fixture

Potato	5¢
Potato	5¢
Potato	5¢
Potato	5¢
Potato	5¢
Potato	5¢
Potato	5¢
Potato	5¢
Potato	5¢
Potato	5¢
Potato	5¢
Total Tax	.00
Total	.55
CASH	10.00
Change	6.45

excerpt: At least

This is my life. Me and Jonny are on the bed. Jonny is watching television; I am
 masturbating. Jonny notices I am masturbating and every once-in-
 a-while takes the time to rub my legs with his hands.
As I continue to do it to myself, I every once-in-a-while laugh at the jokes being
 spoken on the TV.
After he is tired of television and me of masturbating, I suggest we eat; he
 wants to eat too. But I've got mostly nothing he wants, we have to
 settle for starch. Well, I'm looking for some starch when I find an
 ant. He says, "You see one, and there are twenty."
"Twenty!?"
"Or *More.*"
So I get a sponge and I clean the floor.
And he watches me delicately and quietly; the television is still running, but his
 eyes were on Me as I moved the little fridge on wheels, which
 makes knocking noises at night, to wipe up the crumbs from under-
 neath. He watches the floor get a little too soapy, he watches me
 take care of business all around that room — cause I couldn't
 stand the thought of twenty ants — well I didn't mind too much,
 but I thought he might mind that I didn't. And all this, after a long
 day at work, and all he did all day was just sit at home with the
 ants.
"I found another ant," I admitted to him 'cause he might have seen me pick
 it off the floor. . . "But it might have been the *first* ant," I told him,
 "since I didn't kill that one; I threw it into the hall."
He nodded his head, as if, no need for explanation.
I haven't seen any ants since that day, I guess I've been more careful with my
 crumbs.
Ahem. . . it has to be starch because I won't eat meat, and he won't eat
 vegetables, the crunchy kind, he says, but potatoes are okay, the

crunchy kind, only if you cut them small and if they're not mushy.

"Potatoes are mushy."

"Potatoes are okay," he says. It's a grim puzzle for me.

We do everything with potatoes. Potato, potato potato potato potato, potato potato potato, potato.

I don't really like it, in fact, I think it rather bland, and I don't know if he does, but we eat it at least.

I'm embarrassed when I see the maid. I have made a mess of my bed, in my bed, from doing it with Jonny and my period. My maid cleaned up the whole goddamn mess, but she doesn't do the floors. Those ants could eat me out alive and she wouldn't pick up the crumbs I leave around.

All the maid does is the beds, the beds and the towels. I hardly use the towels. I bet I should though; boy, it was a big mess that dripped out of me into the bed.

He used to be the dripper. He was a real softy boy before he met me, a rotten tangerine, overripe bitter semen, his testicles two old shriveled figs.

After a short one he'd stay in me long and flaccid. I'd go and get a feather caught in my throat and have a coughing fit.

"You're squashing me."

I knew I was, every time I coughed and I coughed him right out of me.

I guess there was more in that mess —
the smell of sweat and sex.

What she must have been thinking when she changed those sheets . . . I think that's half why I cleaned all the crumbs off the floor. Not because of the ants or The John; I didn't want the maid thinking *all this fucky mess in the bed* and the filthy girl can't even eat straight. Then have an ant cross her and she'd be furious.

But the more I get to thinking, I think I should eat in bed, since all she does is the beds and the towels, but then she might be miffed by crumbs in my sheets and after all that other mess.

I'm in a one roomer, they give me a maid and a fridge on wheels. And I've got a starch eating boyfriend. There's a girl here who told me once a guy held her powerless over an ant bed, and the ants were coming out and eating at her and she was screaming.

I am consumed, I am the potato, I am the crumb
I fear a night will come
and the television on wheels will be running running, and rolling, the ants will be coming and I will be rubbing, rubbing my potato. He won't need to hold me, and the ant hill is miles away. But I will be eaten and be on the very news he is watching. That is my life.

Crap-Happy Warehouse

— Pee's on the seat in the public bathroom that I didn't notice and sat on. I feel it wet and acidic on my legs. This *is* the spread of tuberculosis and hepatitis and the flesh-eating virus.

— A common fear is the toilet at my friends house, fear of a *weak* toilet. You might go in there and find a nightmare floating in the sanifresh water of the previous person that didn't make it down. It's expelling spores, molds and fungus.

— You've got to know when not to breathe, *only exhale* while your being passed by, or crossing the red-lighted gaseous fume <u>black</u>-smoking truck, and bums flatulating from what seems the oily pores of decayed civilization.

— We've all got the same television, commercials for deodorant, breath-fresheners and air-cleaners to make your bathroom have a NICE SMELL, oh no did I forget to use the mouth wash this morning, maybe my love will smell my dark breath and never love me again. I don't mean to cheapen the experience, but the dichotomy of cleanliness is dizzying. *

I go and ask Gabriel for help with my writing, but he doesn't understand the concept of editing, * cause to him it either comes out or it doesn't — like shit.

What I'm learning from him is what it's like to stay at a food place for so long it makes the owners uncomfortable. Gabriel has done this at a place with free refills in his neighborhood on the Upper-West Side time and time over, spending a single 55¢ on hundreds of cups of coffee a night.

I'm remembering this fucked job I had in the middle of nowhere, and how they put me up in a one roomer hotel, painted pink of all colors, the one with a refrigerator on wheels, and ants. I'm learning I don't need all that school'n and experience for skills when I already got ideas for a new candy called Nipples. It's the cherriest, snipped assortedly to cotton-candy perfection.

My mother broke her appointment, even though I told my father about it and to drive her there. *"Italians don't go for therapy."* Jonny tried to convince me but I didn't believe him.

* see: <u>Number 2,</u> **p.203.** *Escape Through the Bowels of the Planet,* travel into grime & filth

 * fear of consumption

And he's getting suspicious — he's accused me of taking his change, of all things. I told him it must be getting lost behind the bed and under the rug for my mother to find, and how dare he be so careless with it, because he's just feeding her gambling addiction when she finds the extra money lying there to feed into the machines.

And lately my shit is coming out too much. I'm thinking that I haven't even eaten this much and maybe it must be growing in there with the torment. I'm thinking maybe Gabriel shits out his cancers and that's why he has such a serious time with it.

Ma had something, not a miscarriage, but once a large globule of blood came out of her. She cramped for days before she expelled it into the toilet and when it happened they didn't know what to think of it. They took it to the hospital with them wrapped up in a bag to have it analyzed and it turned out to be nothing.

In 1991 Burroughs wrote an afterthought retraction, he was just foolin', *obviously*, he *does* remember writing it; so now I'm walking around with *two* copies of *Lunch*, the old printed and the new and feel protected, like they can stop a bullet.

In high-school Gabriel would recite in front of poetry class: " Fuck, fuck, and fuck this fucking teacher. "

She failed him, but mostly cause he cut so much, and when he didn't, he said fuck.

And Jonny is sleeping as it turns out, also often, while I am writing and although he demeans my disquisition, he says it comforts him when I do it *near* by him like a large and heavy pillow he used to keep on his face at night. That, and loose change, I have.

I'm cowering over a naked lunch with my fork in hand and a pill of some sorts caught in my throat. I'm thinking routine.** I'm thinking Jonny's right and my novel will only get as interesting as the next day that passes. Jonny says I've invented a new literary genre: autobiographical lying. *** Artists **have** to map out their viscera and soul blatantly.

Burroughs *knows* his love for *anyone* is pretext. Innocent bystanders are *guilty* of being in an artist's life.

** See ref. p.206, regular routine. . . . <u>Number 2</u>, "The Sad Sandwich Shop"

*** **Please Note Disclaimer, p. 7**

"Burroughs, Burroughs is all I hear. Why don't you get your own life."

Once Jonny told me he was glad I finally **had** a writer I liked and now he's telling me, *"You know what? He isn't even that good."*

I'm supposed to take his word on things like this. It was he who told me it was once Burroughs, Kerouac and Ginsberg who sat around the living room trying as a group to fill up a glass container with semen, and that's mostly why I've been racing through all the literature looking for that and all the other dirty things printed throughout the century. I'm thinking I can let him go ahead and castrate me, because I haven't even ordered my dildo yet. Gabriel has asked me how **I** can do it, *"How can you castrate someone who is already so emasculated?"*

Soon, he won't like me up all night writing every time like this I know, he'll tell me to turn out the light. And I'll beg for a little longer. I've had caffeine coffee in the jazz club we went to, the music was *so* awfully bad and he didn't laugh at my jokes then, when I said, *" It must be ' Bad Night. ' "* And now I'd got some humming in my ears, a vibrational mum like a swarm of bees.

He *is* rolling. I can hear him getting up and nearing the pullcord of the lamp light in the other room. He is not red-eyed — his whole body is pale white from dreaming nice, *maybe*, I'm wondering. I'm wondering myself if this is a dream. I'm thinking my novel is getting very slow now.

"What are you doing?" He comes in.

"Um," in a cracking murmur, "I had caffeine."

"Well it's 5:00. Why don't you come to bed."

I am shivering cold. It's getting so I can't handle it. I need someone of real authority to have a look at it.

I creep under covers to find Jonny's warm warm body, I'm thinking he keeps warm because he breathes shallow. I'd been kind of nauseous that long night. When I get out of the bed in the morning there are dead bees dried out on the carpet.

"Jonny! What are all these bees doing here?"

"They must have flown in," he says.

"And died?!"

"I guess so."

"Through the window!?"

"I *don't* know."

Reality BaKe Shop

"It's good to be on the phone with you. I can breathe my mind into a safe space. It's hard to find a safe space. VERY HARD, " he whispers.

I'm thinking of the space we are occupying outside our heads and in the phone line. He continues, "The reason I was so fucked up is because I only knew one word."

"What was that?"

"I don't know. But I realized I had to go to school so I could learn all the other words."

"Really. You are going to school."

"I'm getting out." He's going to a place that I talked about previously in this story, but edited out because it was *so* inconceivable, a kid like that moving out of his parent's house. So think of a time a while back in New York City, Gabriel is sitting in a café, one we used to go to. As he sat writing alone, a couple is watching him and summoning him, telling him there is a place for him. "I'm going to Headquarters," he's saying.

"Does your *mother* know about this?"

"Well she got me registered and then it was getting so I couldn't get up for my classes, and she asked as I was lying there, 'How come you can't get to your classes?' I told her, I wasn't like those people, they're not squares, they're square squares." ✳

So he may be heading out of the city. I told him it sounds risky, it sounds hippy. I told him I've started hearing my first real schizophrenic voices. "I only heard it on one occasion, but I'm thinking, what if they start coming now?"

"Well if they start coming, just listen to them."

I'm not gonna argue. ✳

"I'm really getting bored of mourning over fuck. The exhaustion has become lifestyle. Agony gets reduced to depression. I can never sleep and one excruciating day bleeds into the next, and the next.

Say? have you gotten your glasses fixed?"

✳ See ref, "cubes" in section <u>Number 2</u>: (right cheek), square squared = 3-dimentional regulars

✳ *I can feel it. That's why I can talk. Otherwise, I'm just shots in the dark. Let me argue with you.*

"Yeah, I got a new pair."

"And, how do you like the typewriter?" The one I got for him I know has a switch-button you can pull to lift the ribbon up, and if you type this way, the keys smack bare onto the page slicing the letters into the paper cutting without ink so that it is in a sense transparent — only visible when you hold it up the light seeing the negative space, seeing through the letters.

"I'm thinking you must use both, if you've gotten the blue one fixed."

"Yeah, I've been typing the cream flow love song switching from one to the other."

I tell him, "I went to the English Department looking for somebody to help me with my writing."

"You don't need any help with your writing!"

"Yeah, well anyway, I got a call from a professor willing to advise me."

"Don't listen to anything he says."

"Why not!?"

"I would find it terribly emasculating. . . Is he a square?"

"Yeah, he's a square, but he's got sway."

"Oh, he's got the sway?!"

"Some sway. Don't you think it's good to talk to someone who's got credentials?"

"All I know is he's going to have his own agenda."

"He's *just* going to tell me things like what I might want to cut, to write more aggressively, and things about writing."

"It's not about writing though; it's about a religious experience."

"I *know.* . . but when I met with him, he asked me *interesting* things like *when* I write and he said he might tell me to write at different times of the day than I do, so my mind might have more control. He tells me to post a little yellow note on the front of my keyboard that says, *'Dramatize!'"*

"What the fuck, man! What the fuck!" Gabriel is becoming very uneasy. He continues, "You should have just cut his dick off."

"What are you talking about!? I *want* to hear what squares are going to say."

"I guess it's good that it doesn't bother you."

"Yeah."

"Yeah, he's got credentials."

I'm dependent on people's validation. I had been complaining, comparing the jealously of a carrot to that of another man. I am trying to keep my boyfriend informed of the almost-affair I had before this story ever began, but he won't hear a word, instead he snuck, reads it in my diary which I left in a bag in his room. And he locks me out, that scoundrel, and all my stuff is in the hall, I'm climbing beggingly in through the window; I am seeing around his room he has smashed my art I had in there. Friends are in awe that I put up with it, pouting, "Nobody messes with somebody's art!" They say it is a monumental moment and there'll be biographies written about the disgraceful act.

He was at a movie the night after. We'd made up, but I said I felt sick at the last minute while he already committed to going with friends, and I snuck out to the dumpster in the dark and cold wet to fetch the journal he'd also ripped into pieces and threw in there, ultimizing either this goes or I go. And the people are shocked when I tell them *yes, I'm still **with** Jonny. "He ripped up your writing!?"* But as I said, I removed it from the dumpster in the dark, all the pieces, and taped it up in secret, and later I tried repatching and repainting but it never is the same. They say he is violent and abusive. He has never beaten me, but that day I was broken real good. And I can never bring it up, or else he tells me, at least he wasn't *sleeping* with somebody else.

Jonny is at a movie tonight, I said I would meet him there. I'm dodging him even though we made a date.

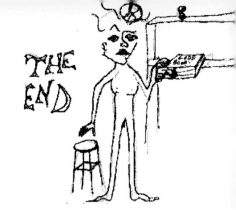

Gabriel is still on the phone, telling me about the new drugs in his life and I can't believe it's real.

I'm talking to the English Professor telling him, "Of course it's fiction for Chrissake, who could eat SIX yogurts?" + + + + + +

Gabriel is telling me about the chemical in the spinal cord that makes you dream. It's on the market and you can smoke it. He's saying, "I was thinking, *maybe I shouldn't fuck around with that stuff.* "

"Yeah, it sounds dangerous, but it also sounds so good."

"So then you write late at night?" the Professional asks.

"Yeah, I think I write late late at night. But I think I write all the time. When ever I can think of it. But whatever I write I find in Naked Lunch."

"Well you're just going to have to write about things that have happened, and been invented *since* him."

"He's STILL alive though. Fuck old, but still going." *

You know what? I pick my nose while Jonny is asleep. It sounds disgusting and it is. I go in deep digging out the large pieces, making careful effort not to push them further in — what can happen then is it might go down the *back* pipe and you end up swallowing it and that is a horrible feeling (reminding me of a time I was eating spaghetti and sneezed at the dinner table as a child, and after a bit of tearing in the eyes and uncomfortable nose blowing, a full sized spaghetti strand came out of my nostril. I pulled it out of my face in such an obscene way, that my brother fell sick right on the spot and vomited.) It wasn't the last time it happened, but I never did it on purpose — so I'm lying in the dark with gunk all over my hands trying to flick it off or wipe it on the side of a desk when flicking fails, ^φ hoping he won't stir awake to put his arms around me, beckoning my affections while I'm so preoccupied with mucus. He's worried that I don't have my own life but I do.

"So did you smoke it or not?" I ask him.

"I did. I took a small hit and it only lasted for ten minutes. I collapsed."

"You did!?"

"Yeah. I threw myself right there on these people's floor and there were

+ + + + + +

When I Order, I say, "I want my yogurt on the bottom."

* William S. Burroughs 1997, RIP. Paul Bowles currently lives in Tangier.

φ See poem, "Roasted Boogers," p.91.

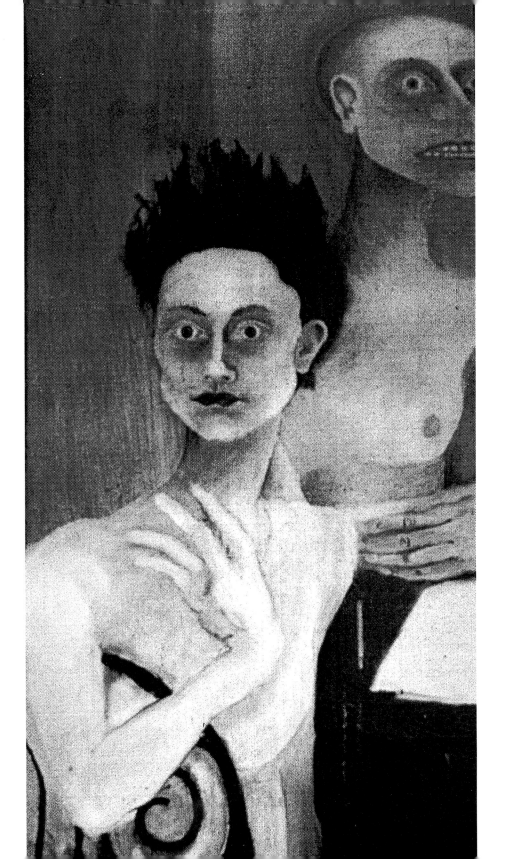

two woman in the room who came to my aide. They were rubbing my spinal cord which was aching from the dream decaying. Sour tears ached so sourly."

"So tell me; Jonny will read about himself putting you down and then puts you down?"

"That's right."
"And then you'll write that."
"I'll write everything, that's what I'm telling you."

I am pulp in a pod, puppet-like, and unbloomed, a structure at the top of a flower s**t**emmed **⸸** from a people so ambitious to classify and over classify what had been and what was then, hence left, grown in pretext, born just the same as every baby thrown into beingness in the twentieth century, **§** not any-more evolved like the killer bees and ants we got crawling in our pants these days, no more mutated by the cancers, and no more externalized into our gadg-ets that might offer us extra cybernetic brainal capabilities, telepathies, and empathies. Popped out my mother's vagina spewing the confusion of a subcon-scious education and lifestyle I have apparently taken for granted, one I obtained when she sat pregnant — and television infiltrated vibrationally into the womb penetrating the placenta. Leapt forth never having to wrestle with the ideas that precede. The moderns over-avantgaurded, regarding the rear-guards after that a thousand times, exhausting *post*-modern passed and after neo-post-modern-pop, which was obsolete before it was published. A shot rocket bounce surpassing the exponential rate we have come to redefining ourselves from the very beginning when our bodily EXCRETIONS defined us, MILK, the process of milk production, mammal, mammalian, we called it milk, and defined what will be written, and now we've got a terminology gone nervously awry, naming what hasn't been predicted or even possible. I can say the words to you and tell you post-neuro-psychotic-streamocounscience-exostentiotranscendental-fuckme-upthebuttsicle-deconstuctthissentcicle-presancti-messiacal-classdefuntable, fuck you. You only read them so you can say that you have read them. It's about the word I knew and came to college becoming very educated and over-educated to reassert the meaning of; the only word we dedicate a life to trying to define by all the other contrived terminology that were stemmed *from* it. That's logic for you. It's not lingo, and there aren't any answers, it's just fuck.

That's the word.

⸸ Note: <u>up-turned</u> stemmed, SprOUT Theory ©: **that** which grows *outside* t h e s e l f ; metaphorically: the Onion *s t a l k s* (double-entén, as in *s t a l k e r*). See diagram: **p.111**, Schematic diagram of n o v e l .

§ Nineteenth-century literature left little to interpretation, written with omnition, a certain *godmind;* it was an art of completeness, perfect explanation. Through the Evolution of Literature, customary <u>tradition-of-moral</u> (morals) loosened in post-modernism and existentialism. Twentieth-Century Nihilists wrote with an onslaught rejection of meaning and sense. see **p.122** . Sprout Theory © is the turn-around attempt to embrace the *"Vague"* that had been abandoned, returning to, an alhemical (turn-of-the-century, Twenthy-First Century) guidance in Reading, a **Hypnotizing Metalepsis** ™ **(p.117** "Linguistics 101"). [Also cite **pp.170&173** : "The Egg Screen Play," & "Express," in which *they monitor your every move*, offer grand-scale concept employment of the literary method. <u>Explicit Cold-War</u> **fear** of & *anecdote* in the method — which may have led to (or IS) the process itself. Also note *Hypocritical Semantics, Interpretive Monopoly,* & *Volume Control* in <u>the List of Technical Pallindrotic Double-Enténs.</u> **p. 117**]

And I try not to worry about it, matters are out of my hands realizing my very brain thinks how it does and creates what it might because of society.

I can't help but spend my efforts trying to secure my place in this history through notation or other means, even though I hold so much contempt for it, for defining me. ♥

You'd think that with a body being so fluid, we'd be so readily able to reconstruct our identies, but we don't, or I guess we did, but now for some reason I will always be relatively the SAME every damn time you see me. ✳

I place unearthly faith into intuition, paying little attention, only writing how I think it might have sounded and that's how it is getting skewed and why there happens a new idea. It's creative because it occurred, and then it was filtered through a cellular gaped mind thul has a bias and imagining a large percentage of what it sees, reads and experiences with a subconscious infected so much with dreamy pop-culture in the first place. My brain is a stomach absorbing the surroundings ruined by American preservatives, pesticides and nitrates then shitting on the pages you're getting.

I have to twitch myself away from the words I type because I didn't write them, history did, I am only some means of something and I know what it is: fuck.

I watch the writers and Gabriel display the disintegration, and atrophy of language, and still allow it to be readable because it's words, the disintegration of culture, yet it's still livable because it's life, I sink into despair yelling, **"Where is it headed?"** Just where is fuck taking me and why?

And it's been done, it used to be the thing to do. You either have got to become comfortable with the fragmentation or stop toying with the laxatives.

Rules to break the spine.

I ask Gabriel, "So your spine, it was hurting, because it was a spinal fluid drug?"

"No, it was just they were rubbing my back, and my shoulders trying to soothe me. I was shouting to them, **'Who am I! Who am I?'** and they kept saying, **'You are you. You are you.'**" The eyes flicker, the jaw loosens and the mask falls off. Sounds like the device to finally screw up your gismo for good. The fear is in the smearing of the face, contortion's expression saying, no, it's really not okay, allowing him to feel the transitional pulsation.

The girls are sitting over him telling him that he exists.

And before he went crazy he had gotten the feeling this had always been happening and it was like things had always been like this. He was sure that the moment had always been there, and he was aware this was the time it happened, THAT TIME IN THE ROOM WHEN THAT THING HAPPENED.

"Sounds dreamy. All I'm wondering is about the pencil I'm beating into

♥ define: removal of prestige, defilement. See ref. Voodoo Theory © **p.140**.

✳ Ibid Ref. Voodoo Theory © **p.140**.

a head, hammering horribly straight into the corner of an eye, as if into a sack of dead bees; I have to twist the boy's neck — in a violently strange dream I had — because listen, there was no turning back because I had punctured into the brain and he was feeling the sharp cold stab in the head of death, although he was not dying. So all I could do, no matter how I badly I felt about it was to twist his neck and hope it snapped." ✕

Gabriel tells me, "That sounds like a dream I had. I was looking at a woman who said to me, ' That's o kay that I'm blind.' It was a horrible feeling to know that I had made her blind."

"You thought you made her blind?"

"Yes, and her tone acknowledged that it was bad what I did, with expressionless tone."

"Well at least you hadn't hammered a pencil into her head."

That night I dreamed that I woke up on the floor of a strange room. re wl noticed theas something in my hand. So soft, I looked at it in shock to see that is was the end of a flaccid penis. I believe it was still alive and still attached, in fact. It was *very* long, like a rope, trailed along and through the door. I was just afraid to find out whose it was, secondly to find out how it had gotten so long. I was afraid to let go, and I was afraid to move at al in fear that dropping it or stroking it in anyway would get it erect. I was so scared.

I'm looking for the fast and zippy answers and that's how it should be, this being the age of the super-highway-information, and the pulp-pods should at least understand the importance of the urgent immediacy and how it relates THIS to you.

And when you ask, "How much do you got?"

And "Zip," you hear. You know that doesn't mean *NOTHING* any-more, cause there's *all* space, negative space and space on hold. ¥

And Gabriel is in cyberspace, and that's where he has always been and this is the girl on the urgent immediacy of orgasm and all she needs is the finger, and out from cyberspace it touches her and pushes her button. ✪ And she's on the turn on switch and she is on the line and she has hooked up her gismo and the other one, and she's gonna shot rocket a cyber-syringe made for a cyber-onion to fit into, and there is a cyber-squeeze on the launch-pad stripped and raw.

I send my agent to pick up the files while Gabriel is gone to a place I didn't believe, so that his mother doesn't throw them out.

✕ Dream List, #6: Pencil Head Nightmare, **p.156**.

¥ Cyber hyper space, god space

✪ **The work and entity <u>Zippø</u> is a subject- and fetish-type item which never belongs <u>as</u> cyber-text / in cyber-world, it is, rather, a Result of it, a work containing a commentary on the hyper-realm.**

Performance MONSTER ©

SEPTEMBER 19A

The PROGRESSION

"YOU" → as AN American
WHOLE

→ NICE SWEET CHICK → DISCUSSION AT MOVIE-SITE → Performance MONSTE
 WITH MICHAEL PORTNOY

excerpt: Roasted Boogers

On infrequent occasion I will remove the hard green-black boogers from my nostrils. I'll line them up on the desk beside my bed, so I will remember to throw them away in the morning. (One time it turned out bad. My mother came in and found them; she sponged them up; she knew what they were.)

Other times I pick them, the dry monsters from the forgotten orifice. I let them fall from my thumb and finger tip to the radiator, hidden, far below behind the bed. I hear them drop, they land with silent tinny thuds, where I know they will cook, the roasted boogers.

My eyes surrender their gluey sleep from their crammed corner to my impure fingers — I wipe it, I can't remember where, on the side of my pants, probably. The drool from my mouth to my pillow, is absorbed into my sleeve. Those benign excretes seem to disappear, but not the boogers.

CybeR-Pulp Library

I'm in Cyber-Pulp Library and there is everywhere here and you can get the best drugs. And there is: the back of the dildo factory where there are all the defects, the two and three headers. I am rummaging through them, filling my pants and pockets with as many that will fit. There is: Headquarters where all the files will be shelved. There is: god, in Cyber-Pulp Library, and it's not America which is here, it is something that overlays parallel to every step but in a higher dimension where everything is just a little more transparent and more accessible, so you got to watch out for your private-parts. ✪

And there is cyber-Gabriel on my answering machine asking if the message is still going and how could it be, he just must not have noticed when it ended, but it's getting it all down.

" I guess I'll Get Off now. Yeah. Please call me, *Okay?* Please call me when you get a chance; call me when you hear this; after you hear this, dial my number and call me on the phone and I'll answer the phone. "

✪ See: George Orwell, <u>1984</u>, note: *eyes are Everywhere*, concept origin of *Zero Privacy*. [& As the Hermetics attempted to take advantage of language as a tool to protect against the **mis**-use of profanity, becuase TOOLS DEFINE OUR ACTIONS Orwell contrived *NewSpeak* & the *Thought Police*. {sub-Note: All Language harbors circular reasoning; Hermetics <u>preferred</u> illustration to word for Biblical purposes because w'rds themselves were a hieroglyphic curruption holding the Holy-Spirit fettered in grammatical bonds, or linguistic iCons. Images, however deceptive, are prettier.}] Also ref., *under surveillance*, <u>#1 Onion</u>, chapter "Express." **p. 173** .

I know you feel uncomfortable. I do, and it gets worse.

There are different types a woman can wear: the fitted-black-and-studded-leather strap, the you'll-never-know-the-difference plastic model, there's the rubber model which can be sewn onto the front of a pair of underwear; there are the no-straps which clamp on to pubic hair, or there's also the kind which fasten by suction and tend to fall right off even if cleanly shaven. (It itches when it grows back. AND I bleached it once — it got burning irritated. These are mistakes we regret like sex with the fat- assed girl.)

His asshole friend betting and convincing Gabriel, "*You* can get laid."

"Yeah how?"

"Well, I know someone who will fuck anyone."

"How ugly IS she?"

And when she first came to his house he didn't know if he'd even be able to fuck her, being she was so hideous, but he touches her and there is no offense. She's for the taking and he finds something erotic in that.

His mother opens the door while they're doing it. She didn't want the girl there because she was so young. She didn't want the ugly black fat-assed girl fucking her baby son. Eventually the police did come. I'm thinking Gabriel's mother must have flipped her lid.

Supposedly the talking he did to her inspired the big-arse to leave home. He said it didn't <u>seem</u> like *she was registering* the stuff he was saying, Gabriel told the police he didn't do anything.

Gabriel spends nights on end combing the streets, retracing his steps, thinking he's feeling calls of chicks which steer the directions he goes. And when he finally encounters one, he is thinking of what excuses she will make, they've *got a date.*

I unscrewed the dildo from my dildo holder which strapped on over my 2000tm, and got an un-marketed broomstick from the broom closet if you know what I mean and what I'm in for.

A penis this size isn't even large enough to make me man enough. I need a strap on heart. He could have got me one of those pumping organs for the holidays. To make me feel loved.

Jonny lives up a hill I can never make up with my bike, that has been stolen anyway. He hardly visits me anymore, so I MUST go up. The breaks [*] don't work and I'd have to jump off real fast when I'd start rolling backwards attempting that hill.

All my bikes get stolen, the blue one was the third one that was stolen and that was the last one I got. [**]

Is there a time I became conscious and didn't know what from when and what end. As theory has it, literature might throw a hero into a novel with no history, his actions might have no relation to what has happened, there might be no hero at all, because there is no individual; and if there is, he is psychotic. Literature is doing everything these days, trying to form the structure the story in cyber-space in your mind, when on the paper it cannot be seen.

The pulp-pods are all walking with their very characteristic but very predefined identities intertwining. The only history is three broken stolen bikes, and three broken sold typewriters that got thrown out; and a used typewriter salesman rescued them from the dump yard and fixed them up and told Gabriel Lockwood he didn't want them and he could bring them back when he realized it. Somewhere out there three people are riding on three <u>broken</u> bikes, or maybe they got the brakes changed and the gears fixed typewriter gadgets and changed the front wheel on the first one with an <u>ink-ribbon-wheel</u> which was crooked since Jonny crashed it cause he's so stupid while he was riding me, and the wheel got crooked and I flew and nearly broke my crotch on the bicycle bar. Except I didn't have to go to the hospital and get a catheter in my urethra for *that* accident. Or maybe they got taken apart for parts, except I don't know what kind of parts you'd expect to get from an all-around broken bike (besides the Bar-of-Control). That's why I bought cheap locks, cause I'd keep thinking *who'd steal this?* I bet I had a black-and-blue bruise mark on my banged twat except you couldn't see it cause the skin is already so dark there.

There IS the point when you don't know who you are anymore and why it is different from who you were, and so you don't know who your friends are or if the boyfriend you have now isn't the third one who was blue or made me blue.

* brakes

** Back ref. **p.62**., blue typewriter: This is the one with the devil in it.

excerpt: # The Nipple Story

From a single breeze their nipple erections had spread throughout their entire bodies. But *I* could move, and I panicked, and you would too, everyone around you turning statue-like.

In my arms appeared a big glass jar and a pair of little scissors, and with no control over my actions, I flew about the train station, *(and you're not going to believe this one)* snipping off people's nipples!

I couldn't believe it myself, I was possessed, and out of ALL the criminal deeds to be committed by Satan, decapitating chests, pruning the tops of tits was it!?! But it was not a *crime* that was being committed, it was the *punishment*, and it all seemed to make sense — where the *hell* I was — a level of hell Danté had yet to reach; no wonder my nipples lived outside the more than decent pull of breasts all my life, this was *Nipple Hell!*

I slipped slyly into their shirts and plucked each blossom, clipped every teat. I amassed them as a child would hoard jelly beans or marbles, round and soft and pink, I robbed as many people as I could. I enjoyed what was happening, I began to think it was a dream, but it was just too real. *They'll write this into the history books as* The Great Acquisition, I thought as it happened through my own hands.

But there was no time to revel. I, in my untamed bliss, had not conceptualized the terrible consequence of the action my hands had taken. Placed back where I had been before, and the world seemed able to move again and finally, I had control of myself. Standing there able and in awe with my jar and weapon, all the evidence, everyone became red in the shirt.

I'd forgotten about blood! All the people whose nipples I had severed began to spew from their chests' two red fountains (like-volcanoes on mountains).

I felt the urge to somehow sew everyone up, or sew their nipples back on. (Although to match nipple to person or to even pair up the nipples would have been a chore. I would have had to give them fake eraser implants.)

I hadn't touched *him*. <u>His</u> corks remained corked, his little knobs knobbed just fine.

As he came back to life and saw my jar filled with the dead, once-erect nipples, he took it from me and ran off for track two. I ran after him.

Everyone else was pretty much in shock and tending to their nipple-amputations crisis. Some ran about with a finger on each, plugging up the holes.

Dildo FaT Candy facToRY

diLDO-Fat

And there is dandruff; something in my eyes, they were floating and turning about, dust bits, white bits.

In the morning I tried to comb it out of my head, and it would fall, snow-like . · . · . . down on my leg and knee, and I kept at it and it wouldn't diminish at all, just kept pouring down.

And after about half an hour it was still going down at the same rate, from the same part of my head, on and on, more and more, until my foot was turning powder blue because not enough blood could get through, because part of my leg was buried under a sizable mountain of the white specks. If you are not taking good care of your hair, or you're drying it out by washing it *too* much, it is difficult.

Jonny is a pulp-pod who eats his balls and drinks his gizm.

One night, it was so dry — our throats were stripped and raw, torn up from the passing of the dry dry air in our lungs. In addition, we were ill in the bed and tired and half asleep and asleep in a stupor of dryness, too weak to get up for a drink.

He must have thought to himself, *it will have to be urine or sperm*, and he thought sperm better to coat his ailment, (he doesn't know about the Buddhists).

It must have been the case because in the morning I smelled it on his breath and tasted it on his mouth. ✽

I kissed and sucked off it.

Now it's like food.

Do you know about Food? Nourishment that we all EAT. In food there are things.

> normal fat
> saturated fat
> sodium, salts
> carbohydrate
> and protein

✽ Dilussional

Never mix large amounts of simple sugar with fat because sugar releases insulin, and insulin is the skeleton KEY,➡ which will open your cells like mouths to anything digested, opens the cells to the fat. You'll be FAT. When you eat a sizable sum of sugar your body doesn't know exactly how much it is, and releases some amount of insulin to try and compensate and then there may be too much, then you're in trouble, cause you've got to eat more sugar. Jonny will tell me you can't feed someone poison and sugar and expect the guy to be fine from it. But he's not talking about food, he's talking about me.

There is a 2000 calorie diet, it is recommended.
2000ᵗᵐ

"Are you eating up your vegetables?"
"I don't think that's any of your business."
"*I'm* reasonably healthy and careful to eat a wide variety of things through out the day. "
"Yeah? All *I* eat is onions."
"That has it's benefits."
"I never fart from onions; if **that's** what you're thinking. And If I happen to, I use the designated room for it." That's what I'm thinking, people don't go farting off around in company saying it's natural. Shitting's *natural*, we don't go doing *that* in the public. Gaseous feces, the air that is the very essence of fart. *Designated rooms*, I'm thinking, *built in with exhaust fans. Yeah.*

The Licky Good candy company likes the nipple candy idea.
THEY'RE SO GOOD BECAUSE THEY'RE REAL!
"Yeah, they're *real* good," the masses respond.
NO, They're REAL
"Yeah, real GOOD!"

And women go on getting their breast reductions, and the surgeons are removing the nipples as doorways to the excess baggage they wish to extract. Wouldn't it be somethin' if they misplaced them before putting the nip-

➡ Ki, & cap-locks key

ples back on, or someone deliberately hid them. Somewhere * two nipples sit cold on sterile metal, a tray. And they're in a frenzy asking for a donor, and you ought to start thinking about writing *nipples* on the back of your drivers-license for organs you want to donate if you're killed DEAD in a car crash. And would anyone really be outraged besides the poor patient who noticed something differ-ent besides the size of the breasts.

Technology.

And across the land *floods and fake tits* I hear. Not a good mix I'm think-ing, because the fake ones don't float the boat. I'm thinking it's no accident. We have long dry and chaffing sex

I dream: Jonny's trying to penetrate. I'm helping to spread my labia apart with my fingers. I feel something strange there. I run away to check it by myself, take a mirror down to it and in the way of my hOle is a little bump where my cunt used to be. A nipple feLL down and clogged up the hOle. **

I'm thinking, Just my luck. I'm walking disappointed with a long face, say to Jonny, "It's a nipple now."

He says, *"so sorry."*

I'm thinking he would never say that. That's how I realized it was a dream.

Swarms of bees and a pill gets caught in my throat, it's a nipple.

This girl gave me pills — she said they would burn my fat away. She SAID THEY GAVE THEM TO PIGS. AND THE PIGS GOT THINNER.

I WAS SKEPTICAL.

I WAS THINKING SHE READ THE LICKY GOOD BOX WRONG.

I THOUGHT SHE WAS FUCKing with me and they were FAT Pills, made from pig FAT, that make you LOOK and FEEL like a pig.

But I TOOK those pills and I felt GOOD.

* Hyper space the place the lost matzo ball has been forgotten, (the place in the memory of the reader).

** Ref. Dream List, #7, Nipple Plug, Nipple Hell, **p.157.**

excerpt: Blue Candy (modified)

Everybody wants one thing or the other, sucked out or implanted —
 they're reading in the news about how to check for leak-
 age and if they'll wake up one morning and it'll be gone,
 or worse, and ended up somewhere else or a sack of
 dead bees.
This is the age of blue candy,
 and the kind that goes snap in your mouth has gone out
 of style.
Blue sugar so they can snort it up their noses and make their boogers
 blue, eat it concentrated and their shit will be blue.
This is an age of floods and earthquakes and migrating killer ants,
 and they're evolving. Toxic trash and extra limbs, yeah, so
 what, and tartar control.
The only reason I never sit on the toilet is because the person before
 me, or before her, couldn't pee straight. I can't even pee
 straight anymore; can't shit out my nausea.
People are gloating they were born with their sexual identity, others
 are frightened cause their genes have gone out of style
 and communism.
And a bigger mistake than trying it
 is telling my mother about it. *

SnøT MuSEuM

When static is coming through the frequency you have to write about
things like snot and dandruff.
 It really ticks my wiggle.

 I gave Gabriel a stapler so it would make it easier for me to GET his files.
 He called me up to tell me the agent made it. "The man came to get
the files. He took a whole slew of them and they're on their way. I gave him the
files."
 "So when are you leaving for permanency?"
 He's going on a bus, he's taking the portable electric blue Jubilee.

* See ref. tooth-decay P.237. Number 2, "Letters To Mom"

He's saying we have to experience the unsaid things. Feel the s p a c e of what we haven't said yet.

Gabriel is the angel and enunciates the Messiah is being born through the narrator even though she's on the pill. That she swallowed the Messiah and it's going to grow inside her and shot-rocket out and cook the kitschen.

I ask him if it is Zippø, but then he was vague, he drifted away, on a bus over the telephone.

In the coffee shop I meet Agent INFORMaI, "Mission completed, I guess." He says, "Let's just make this a drop off. I've been very busy, and I called my psychiatrist and told him I'd meet him at the normal time."

My agent sees a shrink and has worse digestional problems than I DO. It's risky hiring him, he collapses on assignment and ENDS UP needing one of those colonoscopies, where they stick an eight or ten feet long FIBER optic camera UP your behind. First they give you sedatives[*] — then they fill you up with a i r, and when it's over you have a ridiculous and hilarious fart. They won't let you leave until you've farted it all out. The preliminaries are the worse part. They make you drink up a concentrated saline solution so all the water in your body will draw into your digestional tract, they give you an enema and then give you *another* one. My poor agent.

"Well, at least give me *some* information, what did you think of it?" (the Gabriel encounter) I ask.

"His place was a shithole. There must have been 500 containers of nitrous everywhere. I was slipping on them. I thought it might have been a trap. His parents must do it too."

"I don't think they do. I think they go away for weeks on end. His moth-er smokes reefer."

"And what did you think of him? A psychoanalyst's dream, no?"

" Have you read *Capitalism and Schizophrenia?*"

"I'll call you later."

I'm thinking the phone's tapped, spies are infiltrating and having an influence.

On another line, agent says, "YOU KNOW, at ONE time words actually did mean things." The files have been infiltrating him. He's telling me I should read the dictionary to find out what words *are* actually in there. He's telling me I should-

[*] Demerol and valium

n't get so bogged down by the PAST.

"We can't ignore history," I plead, "or we'll make the same mistakes."

"Oh, we'll make the same mistakes, this time we'll make them more efficiently." He's not just some chump who spends a lot of time with probes up his behind, he knows. "You're thinking very western Judeo-Christian," he says, "where the sense of narrative is of importance. We learn from television to think of our lives as crisis and solution. History places us in a story, a story which promises us an end, a beginning a middle and an end.☛ Every night receiving situation-comedies pulling the antenna out of our heads; we're modeling our lives after it. But happy endings, ideas of cures, any ending are false notions; it is a ridiculous assumption that everything is going to be okay. "

Stuck in history, bending under the weight of cultural influence, deter-minants, factors, patterns in media and thinking. When people got tired of that they decided to forget about the future, and a sense of time got screwed up, no moment is any more important than another. This is the horror. Doomed to repeat and yesterday doesn't mean anything because there's no point of reference. It's hard to locate the one thing when it's all over.

The brain's just another organ of the digestional track. We EAT trash, LISTEN, WATCH and READ trash. But the brain isn't as good as some other organs, like the kidney. It doesn't know what to filter because it doesn't know what's good, bombarded by SO many poisons and some in disguise. We're in the Anal Age — America obsessed with the regularity of stool. My agent would get on the phone and recite bowel poetry to me. He was to first to introduce me to the world of Coprolites.☧

They're a real find; persevered properly you might contain the most valuable piece of shit in the world, some day. One in good condition combined with DNA chromosome information can provide anthropologists and biographers with detailed information about how I ate and what I did. ☆☆

The laxative industry is capitalizing on the obsession with proper elimi-nation. It's either, scybala — small balls of feces formed in long motionless tenures against the wrinkled recesses of the interior of the large intestine and colon, or diarrhea. All I know is my asshole HURTS.

One-hundred thousand years from now, they'll be in a laboratory releasing my own stool's unique odor, like that of a fart which derives itself from

☛ See Dantéfication, parallels context where beginning = zero (zippø), middle = #1 (Id), & the end = #2 (the second), **p115**.

☧ Fossilized turds

☆☆ Cloning & cryogenics combined to meet one's form / makeup outside themselves - excretion provides vital informa-tion on environment & experience that completes identity, minus spiritual episodes; see ref: #1 Onion, Voodoo Theory ©, **p.140.** (Urge to take one single DNA strand of the body - snip it in half and inject yin -> sperm, yang ->egg and have them fer-tilize. An immaculate conception of the Narciss-self.

the volatile chemicals intestinal bacteria breaking down food's more chemically-complex nutrients. And they'll find feces produced while fasting, urobolin, and other non-food body wastes which have little odor. They'll find it in a place, I have to figure out where, because I can't keep carrying it around in my knapsack like this.

I'm in the bathroom and I'm thinking FUCK. MAYBE I WOULDN'T **FLUSH**. MAYBE I WOULD *LEAVE IT* THERE TO TURN THE WATER R A N C I D only to RETURN to it NOW and AGAIN to defecate to feel familiar. To feel the feel of familiarity. This is **my** shitbowl where **my** shit would be. And here the biographers and anthropologist and media would come, to see the large large pile of VAried feces, the unpre-dictability the CHAOS of my omnivorous vegetarian digestion trying to be suffi-ciently specialized to produce a clean one every time but mostly failing.*

*When I pass #2 I ask 2 Questions? 1. What did I eat? 2. What did I do?

Intestinal N

excerpt: When I Saw The Kiwi Halves Emptied

 I saw sitting on the top of the garbage pile
 in the garbage
 pail in the kitchen,
 kiwi skins.

 They were cut just the way you eat them; the way you taught
 me. Once in half then it's innards are scooped free
 with a spoon.
 I used to skin it with a knife, peel it like the grape that cannot
 be peeled.
 When I saw the kiwi halves emptied
 I thought you might be there, but I knew you were
 gone
 and that maybe just more people eat kiwis this way
 than I ever could have imagined.

 Eggs in the ass, and I was thinking just how it might be if I did manage
to get one in there, from below and if it would be easy to push back out again,
because if it were easy it could look like I was laying an egg, and wouldn't that
be something?
 So I've got it in my head and in my behind, that somehow I've got to
LAY this thing I've greased and placed into my ass, and I'm trying to figure out just
how I'm going to bring about the notion of, *hey want me to lay an egg for you* and
do it in such a way it doesn't seem that that was my main intention. I'm trying to
act nonchalant about it, I'm thinking I used to do this all the time with Star Wars
action figures. I put them into my Vag. when I was younger and walk into kitchen
where my mother would be cooking or that's where the company would be. And
I would have a little glow in my eye, because they didn't know I had Luke
Skywalker and his moveable light-saber IN THERE. Sometimes I *really* felt like I was
putting one over on them when I'd have a whole crew in there, however many I

could fit and sometimes they wouldn't and their legs would be sticking out of me. I pretended I was a sex spaceship Shot Rocket, giving everybody a ride.

And so as I sit down and Jonny is there and I'm thinking of a way, he tells me he doesn't feel it any more,[*] you know? When I feel a crack inside me, and I know it is broken, my heart and my egg, and my whole mission must be aborted. I'm remembering now that the same thing happened to me as a kid, when I put a small water-balloon in there, to see if I could walk around with THAT in me and it broke. The water burst out of me, but <u>this</u> time it was in my tight ass and would not seep out. I was quite worried just how I WOULD get it out of there, dreading shitting RAW egg and cracked eggshell, and my ass has been hurting so much already.

Curiosity is a healthy trait, only sick when it becomes habitual, an obsessive recording that becomes dillusional. Mundane detailed accounts brought forth in a reverence for writing, not for quality, for functional revealing. And it did hurt and was quite disgusting. And I didn't let that discourage me. After practice I could get a couple in there, and lay them properly. Greased in my behind, I'd walk squatingly alone around my room, drop an egg, turn to look at the clean white oval and then lay another.

Without Jonny's approval It made me feel dirty, sick and obscene. I would have liked to show someone, but I didn't know anyone that perverse except for Gabriel, and I wouldn't want him to have that image of me contained in that mind of his, and also he'd flown the coop. I vowed never to do it again, even though I never did it *really.*

Jonny and I have broken up 2000 times, so you think I'd be prepared for when he finally [squared] it away. And he did it final just when I was thinking hard about eggs. Even liking them; even ready to devour his soup.

Dreaming of eggs and of laying them and caring whether I might go to hell for it; and would it be all that bad? Fasting, getting very educated, not paying attention, only writing. Letting myself die in reeling terror, with hope in the romanticization of it. How foolish.

Dreaming the eggs that I Lay hatch open. Either being the phallus or having one.

-->

[*]When one person keeps disconnected for too long, holding out, *the other* is kept *in the dark* - the chance miscommunication rises exponentially in relation to the element of surprise; there is high probability for mi direction and unwarranted vacancies.

excerpt: The Beast

Pages do Pass.
Alas.
I capture the savage beast running.
Stab it with my pen so cunning,
I smear it on the pages that do turn,
only to find another beast that will allow my pen to churn.

Tape Worm Valley

I am an egg or was contained in one.
I'd used Jonny to plug something up in me,
 and as of now it's all riding loose, yolk, and urine, riding with
the mucus salt river and the bottom of the chasm of my onion.

Gabriel's found a place where he gets MONEY for being mentally dis-
abled, and there are many crazies like him around there.

It is of course not okay and my bowels have gone haywire. I walk with
my intensities in my arms and growing out my head; there is a tapeworm in my
stomach that is my mind. I feel in my hands slippery and shaky, the lower entrails.
I feel there is an egg I left in there, it is not me, it is the placenta that hung out. I
walk with the long long organ draping around me like long long hair.

I count the months on my fingers, to see we're I might be when the
Messiah in me or brought forth by me will be born. I count the hours of sleep; I
count the days it takes to get over Jonny. I pass over the fingernail with the crack.
I will always miss him, all that I missed him as he was falling away, and now all that
more.

I take the files out of cyber space, because I am a person and cannot
be there. I am pressed in a dusty shelf in the homes of people who care very
much about scatology, who are not frightened off by their own inadequacy.

And Under Woman is in me ready and waiting.

Exit.

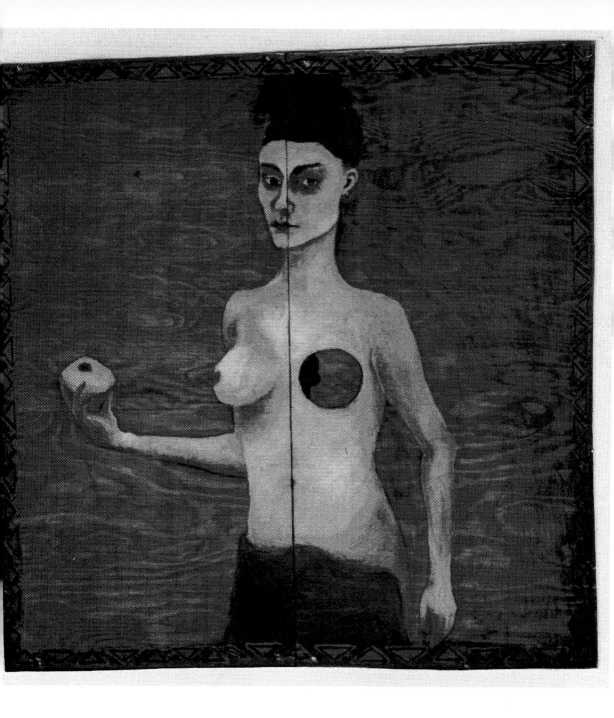

#1 Ønion

THE CRACK IN THE CONSTIPATED SPINE OF THE BOOK

AN INTERNAL REFERENCE GUIDE

BLUEPOINT MULTIUNIT
BLINKOUT-BLINKON PUPIL DILATION ZONE

#1 Ønion
The Crack in the Constipated Spine of the Book
An Internal Reference Guide
& Bluepoint Blinkout-Blinkon Pupil Dilation Zone

SUB-SEQUEL TO CAFÉ ZIPPØ SUBSECTIONS

The Crack
in the Constipated Spine of the Book
Crack Half-Time Bluepoint Multiunit Pupil-Dilation Zone

Schematic of Novel Entity

2 Cheeks[*]

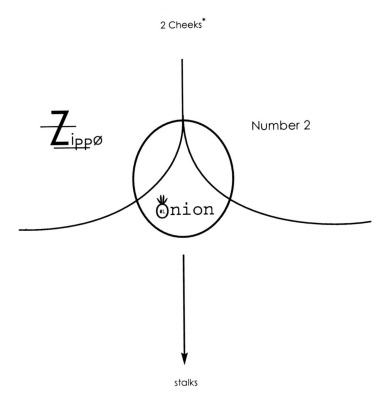

Zippø

Number 2

Ønion

stalks

(what comes out) Sprout Theory ©

Onion exists within / between 2 buttocks; the Crack Half-Time

* See: Custom Cut TuTu Theory © on Body Symmetry & (cheek to cheek) Resonation Tracing, diagram, **p.137**.

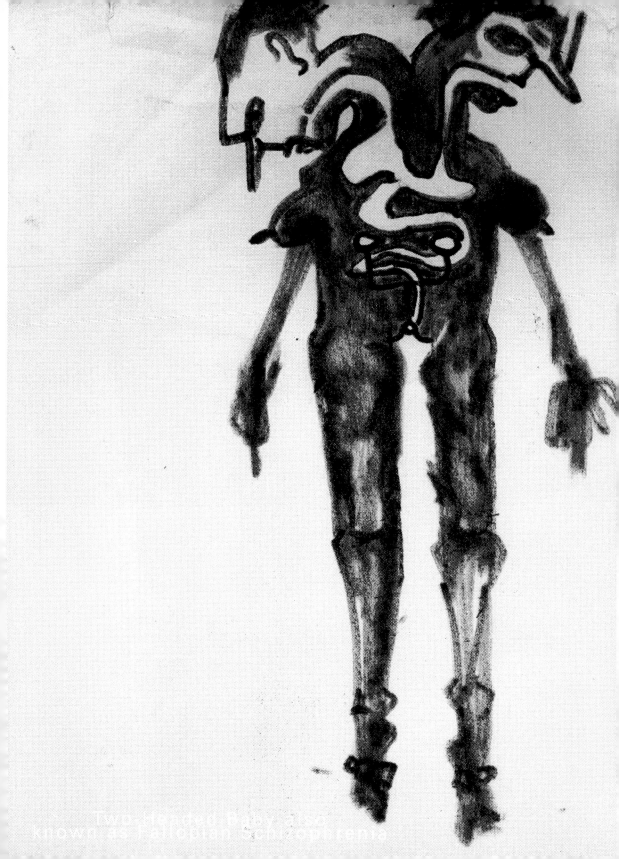

Zippø Cover Woodcut Print, May 1995 Self-Portrait, Morocco August 1996

Book Synopsis: [synapses]

Café Zippø opens to [a used Panties Swatch &] a world of addiction *[a place called headquarters; in essence: habit, compulsion (masturbation, substance, color, fluids)]* . The narrator oscillates from psychosis to square, from filth to sterility, represented through the documentation of alter-ego character-protagonists, Gabriel Lockwood: the semi-schizophrenic, and Jonny: the regular.

Under the stimulus of Platonic Dialectic (dualism) transcen*dance* to Pythagorean Divinity Café Zippø undergoes a phenomena known specifically as:

Dantéfication ©

Eruption into trilogy.

[in this case through dissection and resolution.
The ideas have fulfilled themselves into trilogy.

[in this case, dissection and resolution of the first. The ideas have fulfilled themselves in *Performance* (Section titled: #1 Onion) and Travel (titled: Number 2)]

Each book or eruption entity, may correspond to a level in Danté's Divine Comedy.

Danté	L.A.Ruocco
1. Inferno	0. Zippø
2. Purgatorio	1. #1 Onion
3. Paradisio	2. #2 (Escape Through the Bowels 'o the Planet))

The Trilogy begins at zero (zip) instead of one.
The titles are symbolic on many levels:

The Divine Comedy	The L.A.Ruocco Trilogy
Inferno	**Zippø**
Hell ' Ignorance/Knowledge	Zip ' Zero ' Nothing as in oblivion, Shakespeare, sex
Purgatorio	**#1 Onion**
God/Fuck, Decision, Language	as in the Freudian ID or Ego, I am # 1,
Paradisio	**#2 Number Two**, as in the scatological
Heaven ' Lies, Shit ' "Art"	second form of elimination, caca, etc.

Linguistics 101
Useful Information About

MEANing & proximity

Zippø is a language DEVICE to decipher mechanics between performance and audience, action and causality: <u>Zippø</u>, was becoming a matter of *this* goes with *that*. (reduction of the big O.) And all I <u>halve</u> are befores and afters. Hadn't quite finished, and started it wrong. The book as an entity, acts as grand model[*] of **Mirroring,** of splitting, entering and exiting; a verbal dyslexia consisting of sub-palindrotic nuances, [ie. 101,] constituting a very large metaphoric palindrome [ie.: Paradise, representing the beginning or opening. As <u>Purgatory</u> or *purgatoria*, from the Latin (Greek) "*purge*," [●] as to get rid of: see BAKING AGENT **p.132**, signifies coming back out, which extrapolates that Art may be bulimic conceptually and One-Way physically.

Structure and vanity govern interpretation to a great extent within the mirrors of language on *American* culture, and visa-versa. In exploring meaning proximity we study the acoustic, sensual, & visual.

[*] Note: How even politics halves into dualism of <u>Left</u> and <u>Right</u> (Wing).

[●] Purgation: in old Law, the act of clearing oneself of an alleged crime or suspicion of guilt.

Theory 101 [Freudian derivative]: At varied sub-levels in your MIND there are stream-o-conscience perceiving and screwing word's FACE value, with the intention of the idea at SOUND value.[✦]

Example:

SOUND value, utilizing the common synonym, homonym or pun:

i. e. **Number** (noun) You are #2.
 (adjective) You are number too. As in:
 I am number than you.

FACE value depends on word appearance, on aesthetics.

i. e. [see ref. "O-vary" **p.127**.]

List of Technical Palindrotic Double-Enténs

Hypnotizing Metalepsis[tm] [*]

When values are engaging for 2 reasons, this is called Double-Enténdré. One moreover initiates <u>The Joke that Never Ends</u>; i.e. something IS funny *because* it GOT funny.

Double- Enténdré CHART

Face/Sound value Effects

		Verb		Noun
Symmetry & question — [y] why?	→	Eye	=	I
Sub-word, objectification [ear]	→	Hear	=	Here
Overt negation, K [no, now] W	→	Know	=	No
Physical mimic	→	Halve	=	Have
Structural stripdown, h l y	→	Wine	=	Whine

Symmetry: an elegant exemplification of "*every* sense-of-the-word," (every way in context) backwards / forwards, anyway conceivable, in this case, consistent in **verb-ification** [making verb of noun or adjective]: **My eyes,** meaning *that which I behold or conceive.* **&** The Y existing as a question, a known subjective.

✦ Sprout Theory Linguistics technology practices are solely applicable to English in that they are particular to this culture and its words, although inflection concepts (of rhythm and pitch) can carry over and the literary techniques may be understood and utilized.

* **Hypnotizing Metalepsis**[tm] is the ***Platform*** for Sprout Theory © in <u>Document Zippø</u>. *Webster's* definition: *Metalepsis*: n., [L. from Gr. *Melalepsis* participation, alteration from *metalambanein*; meta, among, and *lambanein*, to take] in rhetoric, the continuation of a trope in one word through a succession of meanings, or the union of two or more tropes of a different kind in one word. DEFINITION: *Trope*: n., [L. tropus; Gr. Tropos, a turn, a figure of speech, from trepein, to turn] also, any of various short, formulistic phrases.

Symmetry is key especially in writing *BACKWARDS* as in Hebrew, and the Moroccan Arabic. It plays a major role in the influence of dyslexia in language & the <u>dyslexic mentality</u> of the narrator. Handwriting is a big clue-in and **TYPE** *really* conceals a lot. This way. That way. Any way you say.

Criss-Cross, spun-around, run down.

Meanings are dependant

Divine HandWriting = Moses TypeWriter

on intonations things make sense in the slightest end of turnaround, in the hintest effort of retrospect.

my handwriting might seem right now, devine in this context, also being ambidextrious & dyslexsic, I always make sure things seem to make sence backwards & forwards, even away from the paper

Symmetric Literary Resonation: **occurring again, only a little different**. Resonation Tracing © displays where Symmetry re-presents itself in nature, as in the *"Symmetry of the Ass,"* within the guide to Custom Cut TuTu Theory ©: exposing cheek-to-cheek symmetries, and <u>FRACTAL Phenomena</u>, as in ear and foot reflexology.

Objectification: sub-word, or a noun inside a verb, a word in a word, in this **case** the tool used to give action to the verb. The opposite of Subjectification (rhymes with *Dantéfication* ©).

Overt Negation: **a lie w/<u>circumstantial evidence</u>**:

See ref. Contextual Box P.159. on Circumstantial Evidence

i. e. **Know** (verb) I know! I know!
(noun) no ! no !

Inflection and tone (pitch) behave in accordance, in accusing someone of intent, sub-word; you'd only halve 2 yous phonetic spelling for *YOUR* jokes to work. [does he no your nuts?]

In: "I don't <u>no</u> you enough." Someone is, in essence, negating you.

Inflection and tone holds constant for the opposite possibility.

But, *Knowing*, is a two way street. Responding, "I know," deflatingly to a statement, diminishes the value of the originality of the statement preceeding, but there exists, within the same wording & intonation, its opposite value / intention — denoted in the Shakespearean homonym, "Aye, no," (yes, no as an exclamation) implying a meaning empathy, displaying a compassion, *heightening* the value of the statement.

We can find the reverse truths for every word in its negation (negotiation) in the multi-contextual universe (inverse unnerves).

Post-Modern Jump: ? Postmortem: happening or made after death Postnatal: after birth, afterbirth. Post Nasal.

Physical Mimic: the action used to make the word IS the definition of the word, semiotics. The word contains a physical counterpart of moment.

i.e. " We halve an Hour. (We have an our.)"

– Drawing a line between letters, marking a strike at the middle, is in essence, halving the words into two sections.

Similarly, terms tied to Physical Action, as in sign-language, are homonyms synonymous in the form of numbers, using fingers to denote amount; holding up your hand to signify & display *how many*.

i. e. thumb-index indicates: a-okay

third-finger flick indicates: fuck you

full-finger-extension hand indicates: high five

Structural Stripdown: contends with the physical character or face of the letters, the dismemberment & reconstruction of letters,

$y \rightarrow h$, and $K \rightarrow W$.
Flipped, "y" is similar in shape to the lower-case "h" upside-down.
Rotation, $K \varnothing W \rightarrow I + <$

analyst Ø analist refers back, "why" becomes "I," who?

Also

Anatomic Structural Stripdown
in the Physical Character of the

Human Form.

Example:

The Stomach Monster
At one time the Stomach was actually said to have been a separate animal!

[Under-Woman stood in a handstand (upside-down) in front of an audience, "This might be my
s t o m a c h
talking. . . .Talk about your <u>2 for 1</u>. . . Talk about a <u>Dialect</u> **(Dialogue)**." Di-electric: display of the Physical Double-Entén.]

"My stomach was hiring lawyers out on myself."

Reports exist of North Americans born with a substantial amount of brain-cell growth at the base of the spine near the stomach, and also, those born with tissue, reminiscent of gray cerebral matter attached to the stomach, hence the term: _thinking with my stomach._

Double Standard Reverse Ambiguous: contends with an Agenda,

the double-entén in the truism of the retrospect.

I'm teasing you with Hypothetical motives. . .

Overt-Implications, [end a question with a period for tenacity.] Defiancey. Idea techniques can lend affirmation, sneak subverted conviction into an ego trip manifestation.

"." period - noun to noun ratio, punctuation utilizes inflection and visual intonation; the menses denote the cycle [note Hypnotizing Metalepsis™] the "period" cannot escape its aSSociation to the sentence, and the composition of the sentence [subject & verb] and its incorporation to the paragraph, hence a cycle and a recycled idea contained.

<u>*Well-Timed Redundancy*</u>: reinforcement, rhythm. Explicit DITTILOGY, or Ditto.

 To be heard, again, or over, moreover; in music, the repeat " ||: " symbol is used for Re-evocation.

Dual or Extra Popularity of a phrase. In poetry & prose " ||" or merely the " symbol is used.

for example

 Schematic of a Conspiracy: How To: TuTu

 TooTooLew TuTuLu

or

 the repeated homonym: buy bye [bye bye, buy buy, by the by, buy the Bye]

 That was a no no.

the Ditto is used in the following poem:

Millet Muffins

Maybe my mother was mean to me to get me out of the kitchen. She wouldn't let me make my millet muffins, so I cooked it up like Grits. Then dad got mad at me for using his special jelly,

 Monday millet steaming up my wig.

 I put a lid on it.

Mom used to think I hid it in my wig.
 " " " " " had " for " "

 I had it in for my wig.

I've Stopped bringing men home with me. All I BRING IS WIGS. I Get in them, Get into Bed with them.
I knew a man who wouldn't talk to me, until I gave that man a cookie.

I don't know the difference between a man and a muffin.
One day I looked for a Muffin NOT a man.

 *

<u>*The Acoustic & Visual Aphorism*</u>:
 pretty funny
 coming apart at the seams; seems correct, an abandonment or adoption of:
 Seeing is Believing or **What you See IS What you Get.**

<u>*Ultra-Meaning*</u>: "<u>My I's Lie in the deepest of cavities.</u>" (Eye sockets, tooth decay); poetic significance persists in the extension of the pun. "To see with my sugar tooth." [tooth-*cavity*, decay] [*lie*, deception]

<u>*Rabid-Ass English*</u>: speech containing nuances, with a depth only obtained by adopting a language into one's exclusive make-up, personage of style, & rather than merely using it to communicate.

<u>*Meta-Structure*</u>: Metaphysical, Zen approach taken in understanding: Smell the whine.

I searched my parents for who I could be, but I'm not some **Equation.**

F-acts: Fucking-acts, are things written **with the same validity as the physical fuck.**

Scata-Logic: Having to do with the digestional processes, as well as a series of events.

Quadrupal fold Acoustic Pallindrone: tu=you (Italian); tutu=2 too or you two

Third Degree Burn Phenomena: A merging of idea of feeling to medium to language, fail-safe triple to infinity, through the skin, to interpret ideas to the bone. Response to reaction, threefold.

Volume Control: BIG talker technique, you sound like a **know-it-all**.
But really you can only know what you know (no, negate).

Elusive Adjectives: Neutral, uncommitted, impartial words. Used to disengage, generalize. Standard, having to do with no instance in particular. Device to slip by. Lends Immortality to description, description that contains **Meaning Up for Grabs,** you choose.

Interpretive Monopoly: In reference to the reader, the Narrator monopolizes all characters, situations, and events — information is driven by the momentum of the Reader & Author. The story breaks down — is no longer important, only the movement (Vector Momentum).

Hypocritical Semantics: written to persuade . . . as *anything* said.
Participatory alteration.

TransCase: a method of special Letter "Case" (d.é. *case* senario) Mixing used to denote a double-éntén in TypoLoGic (Behavioral) & PictoGraphic (Symbolic) text.
These are textual inventions, *to come* in: LinGuistics 2Ø1.

When I got Back I spent my entire savings on Zippers of specified lengths.

DIAGRAM	*THE CRACK HALF-TIME*	THE BLINK OUT BLINK ON PUPIL DIALATION ZONE

The Shape (Study) of an Ass

critical analysis of the fleshy hemispherical buttock

While in the cocoon, The Larva [¤] **completely** liquefies before becoming BUTTERfly,

people go through puberty.

At times <u>my</u> Ass's been Unrecognizable.

The world has a lot of catching up to do on my ASS.

Quantum Theory : not to be confused with, but to be compared to, Quantum Mechanics: [±]

Based on General Consensus: <u>*No Matter How heavy or skinny a person becomes, his/her body'd generaly STAY the same **shape**, from birth til dawn, altering only in proportion and skewing.*</u>[➤']

After extensive research in regard to proportionality, size, and shape of the ASS in America, it was during a progression sub-experiment — <u>A Study of the Ass</u> (within *Ugly Narciss Photo Album* ©), a contrary truth was beheld; an ass is seen to switch from **round** to **square**!—[] This deduction opened doors, shattering previous universal beliefs in language, communication, and in many other truisms about natural phenomena. Many <u>constants</u> now perceived as <u>variable</u> gave ride to physical and conceptual possibilities at the most basic to complicated manifestation. Seeing with an **X**-ray vision [where **X** represents: a mathematical variable or vacancy] with the superpowers to **Match** [as in, to Link concepts], {in the multi-contextual universe, Variable is like a weapon, Variance} is seeing, like a Super-Hero (super-human): *the Triple-to-Infinity Agent* — the

[¤] Pupa, [pupil (as in dilation)]

[±] I'm not sure what you know of Einsteinian Relativity, but it only takes simple geometry to see a behind go from round to square.

[➤'] Skewing: being like that of a stigmatism, (*stigmatism*: as in *to correct vision*.) Prolate.

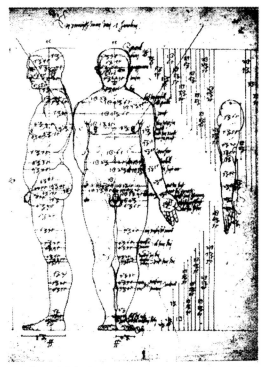

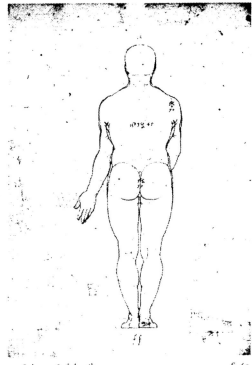

23. Ldn 5228, fol. 26ᵃ S. 60

24. Ldn 5228, fol. 26ᵇ S. 60

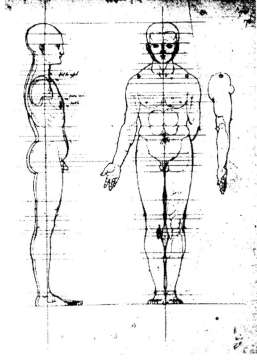

25. Ldn 5228, fol. 175ᵃ S. 60

26. Ldn 5228, fol. 175ᵇ S. 60

123

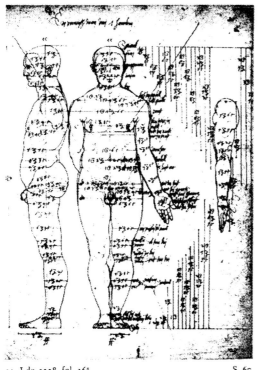

23. Ldn 5228, fol. 26ᵃ S. 60

24. Ldn 5228, fol. 26ᵇ S. 60

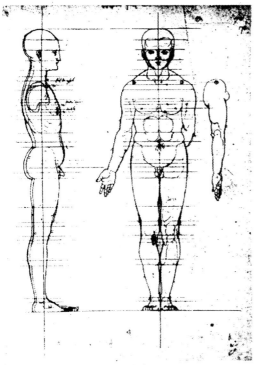
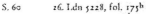
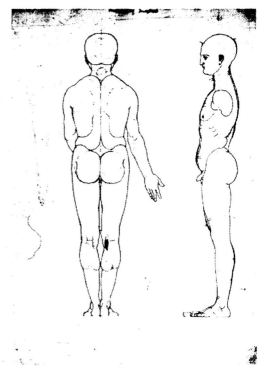

25. Ldn 5228, fol. 175ᵃ S. 60

26. Ldn 5228, fol. 175ᵇ S. 60

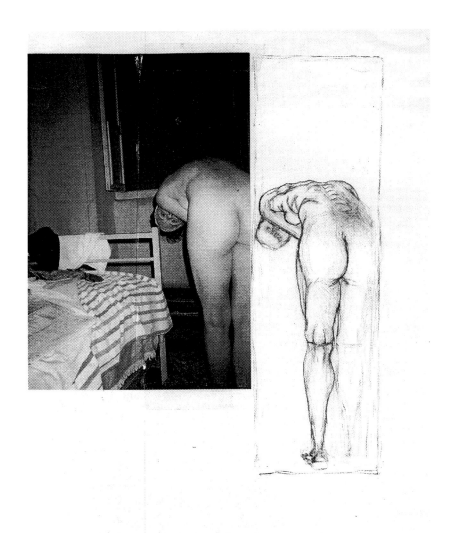

expert of stripdown of process and form, and an expert performer in breaks of word and idea-play down to the core.

[The Sprout is utilized, being the {food} **core,** smallest Viable (living) GROWTH, which cannot be split further.]

In American Language, where vanity governs growth and the interpretive extent within the mirrors of meaning and proximity *in* and *on* culture, we see art mimics life.

Through:

Symmetry and Dyslexia — Mirror and Reverse — Object and Effect

Thus:

SPROUT THEORY ©

Sprout Theory © outlines where **conceptual stripdown** of words/language parallels that of the **material stripdown** (as in that of plant, the sprout being the germination form). The theory begins with the postulate that the English language is a conglomeration of association at an exponential rate, as in *one thing with another.*

[The F-actor: (as in facts or verbal acts with the validity of fucking)]

In (1993) when *"Nutritional facts"* became a requirement on all packaged food, it changed what it means to have a dieT *(as in: to die, long-term suicide).* Corporations, once taking advantage of the habit-forming Two-For-One strategy, no longer *needed* the sedating strategy, the seduction of **Television,** persuading the psychotic consumer to EAT *while* she WATCHED. Using a simple post-modern catholic-categorization technique, the dieT has a similar appeal to that of religion and easily stimulates *reading* **while** *eating* — two acts of consumption. By labeling food with a *carry on* F-actor, American culture (advertising / media) was practically FORCING performance art down our throats.

The onion-sprout is chosen *in particular;* the onion bears a Striking resemblance in physical FORM [in color, texture, shape, and consistency] to the ovary, & consulting our List of Technical Palindrotic Double-Enténs, **p.117**, we find tremendous poetics, striking resemblances and parallels on many Literary Levels.

"O-varies," utilizes *subword-objectification* and *structural-stripdown.* It **coincides** with the variable-valancey-concept of Sprout Theory © [containing the sub-word-object, "VARIES," or

fill in the blank

"VARY"]. The circular "O" can behave as a **fill-in-the-blank**. Also, the letter o carries an identical sameness in printed <u>form</u> to **Zero,** the core number, the *supreme* Prime, that cannot be divided any further. It is also the degrees-symbol, used in measuring varying temperate degrees [degree of freedom]. In nature, it is the ovary that acts as a sack, containing that which is unconceived, unfertilized eggs, in the two-dimention we see *physical-mimic*, where the shape of an egg is drawn [an oval], an *acoustic-aphorism* because, both the word & and object the word represents contain these oval objects.

<p align="center">◯ - varies</p>

" sprout " carries *sub-word objectification:* "OUT:" owe you tee (golf) or, as simply: *out the door,* out the seed.

2 for 1 leapt triple-to-infinity, in the Surgeon General's making " f-acts," breaking FOOD down to three major sub-categories:

Example of *Dantéfication* © at the (decision-making) consumerist level.*

yes	-	heaven	-	protein
maybe	-	purgatory	-	carbohydrate
no	-	hell	-	fat

<u>Alternate Associations</u>
Fat = Cancer
Sugar = Cavities
Protein = The All-Mighty, Body

As a result, language became novelty, and about as *played-out* as television. As a pass-time (form of enjoyment) its significance . . . sang a tune similar to that of advertisment or commercial. But in abandoning the fundamental principles, people could not escape communication [people still spoke].

Something had to crack.

In (1995) the two-headed baby survived birth in Albuquerque, New Mexico. (Fallopian Phenomena ©) The Double-Enténdré takes physical anatomic functional human form.

* See *"The Fat Chapter:"* Dantefication of TIME - Trilogy of **Past, Present, & Future** p. 191

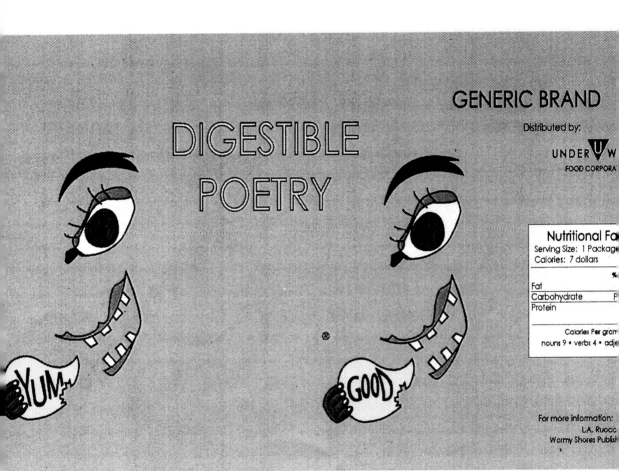

Nutritional Facts

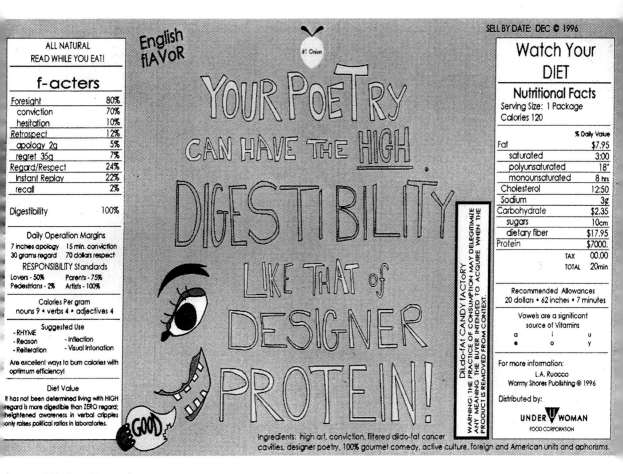

English flAVoR

#1 Onion

YOUR POETRY CAN HAVE THE HIGH DIGESTIBILITY LIKE THAT of DESIGNER PROTEIN!

GOOD

SELL BY DATE: DEC © 1996

ALL NATURAL
READ WHILE YOU EAT!

f-acters

Foresight	80%
conviction	70%
hesitation	10%
Retrospect	12%
apology 2g	5%
regret 35g	7%
Regard/Respect	24%
Instant Replay	22%
recall	2%
Digestibility	100%

Daily Operation Margins
7 inches apology 15 min. conviction
30 grams regard 70 dollars respect

RESPONSIBILITY Standards
Lovers - 50% Parents - 75%
Pedestrians - 2% Artists - 100%

Calories Per gram
nouns 9 • verbs 4 • adjectives 4

Suggested Use
- RHYME
- Reason - Inflection
- Reiteration - Visual Intonation

Are excellent ways to burn calories with optimum efficiency!

Diet Value
It has not been determined living with HIGH regard is more digestible than ZERO regard; heightened awareness in verbal cripples only raises political ratios in laboratories.

WARNING: THE PRACTICE OF CONSUMPTION MAY DELEGITIMIZE ANY MEANING THE BUYER INTENDED TO ACQUIRE WHEN THE PRODUCT IS REMOVED FROM CONTEXT.

Dildo-fat CANDY fACTORY

Watch Your DIET

Nutritional Facts
Serving Size: 1 Package
Calories 120

	% Daily Value
Fat	$7.95
saturated	3:00
polyunsaturated	18"
monounsaturated	8 hrs
Cholesterol	12:50
Sodium	3¢
Carbohydrate	$2.35
sugars	10cm
dietary fiber	$17.95
Protein	$7000.
TAX	00.00
TOTAL	20min

Recommended Allowances
20 dollars • 62 inches • 7 minutes

Vowels are a significant source of Vitamins

a i u
e o y

For more information:
L.A. Ruocco
Wormy Shores Publishing © 1996

Distributed by:

UNDER WOMAN
FOOD CORPORATION

Ingredients: high art, conviction, filtered dildo-fat cancer cavities, designer poetry, 100% gourmet comedy, active culture, foreign and American units and aphorisms.

igestible Poetry

The concept persists. The metaphors continued to knock. [2]

<u>You ARE what you eat</u>
> **physically** - in that your food constitutes the fabric of life.
> **metaphorically** - as in, "You're a nut."

But you what you eat ARE two different entities. **You are not <u>REALLY</u> what you eat. It is THIS <u>reality</u> explored.**

Then rose: THE ACCLAIMED IDEA THAT IF YOU EAT SPROUTS YOU WILL BE HEALTHY.

> **AXIOM** Logic: IF YOU Eat Sprouts, You'll LOOK LIKE a Sprout EATER.

After the dieT of sprout was underway there came an outbreak of fiber (FIBer, as: to fib), or the NON-FOOD:

> Smoke, as in cigarettes
> Bubbles, as in the carbonated beverage
> Gum, (can't tell people you swallow)
> & paper, Edible Napkins[*]

and concepts:

> I'm a LAXATIVE waiting to happen.

> I want GUM the consistency of Food.

In (1996) L.A. Ruocco ATE Poetry on Stage. (see Digestible Poetry[tm], Nutritional Facts **p.128**)

<u>Marketing my Identity</u>, this is where High-Art meets High-Fashion.

[2] I've had friends try AND talk me OUT of it. One suggested something to the effect that maybe the World isn't READY for Sprout Theory©.

[*What's on the menu tonight?* High Art.]

Le Menu

*a*ss a la carte

 sQuare
 round
 sweet & sOUR

I smile because I knew I wasn't gonna starve anymore; "Give me the hottest one you've got. Feel them all."

And one time I got a big splinter in my ass.

[see ref. Voodoo Theory ©, **p.144**, realeasing my Ass Ki. *]

* "Ki" also "chi"—(Chinese) acupuncture (pressure) release point. [also: to release the Ass Key (Asci)-[binary bitMap] on my computer.]

Baking Agent ™

Because Art goes both ways.
Art can be Bulimic conceptually and One-way physically.

UNDER **U** WOMAN

ARTIST's
BAKING AGENT

(BECAUSE ART GOES BOTH WAYS)

TURNING THE CLOCKS BACK

PLATE
B

WHEN IS
IT FOOD?

WHEN IS
IT GARBAGE?

<u>B</u>AKING
<u>M</u>AKING

OF THE BREAD

YOU MAY BE BULIMIC CONCEPTUALLY
AND ONE-WAY PHYSICALLY!

Pychosomatic Placebos ©

They make you SMART!
A pill in your mouth is a pill in your head.

Americans continually striving for regularity and consistency, could have what they've been made to want on a meso-scopic level as products of culture themselves.

Bulk-sized *Placebos* © hit the market big, while buying Artist's Baking Agent™, & Digestible Poetry © as a *Verbal*

UNDER ▼ WOMAN

Psycho-Somatic
Placebos ®
®

They make
you SMART!

A PILL IN
THE MOUTH
IS A PILL
IN Your HEAD!

For more information:
L.A. Ruocco
Wormy Shores Publishing © 1996

ACTIVE INGREDIENT: PILLS, COATED FOR YOUR PROTECTION
DIRECTIONS: SWALLOW WHOLE (METAPHORS ARE A TERRIBLE THING TO TASTE)

133

Custom Cut TuTu Theory ©
& Body Signaling

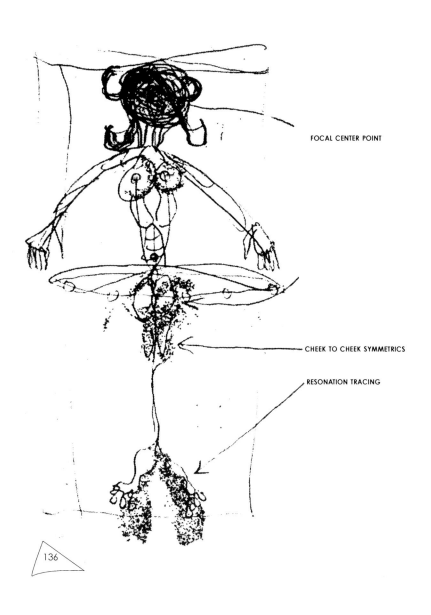

FOCAL CENTER POINT

CHEEK TO CHEEK SYMMETRICS

RESONATION TRACING

136

I have 10 Tutu's at home! (A Rack of Tutu's)
I've got 5 Tutu's to feed.

Resonation Tracing ©

(2 2 [linguistics double-entén] Theory) Body Symmetries:

Folds the body with the stomach as the center focal point

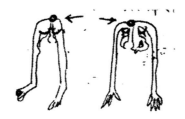

*TuTu Symmetry Diagram, could
explain possible evolution of animals
with the brains as a center focal point.*

Cheek to Cheek Symmetries / Boob to Buttock

Face-Cheek to Behind-Cheek Resonation & Breast to Behind Resonation

FRACTAL Phenomena
Foot and Ear Reflexology

REFLEXOLOGY CHART

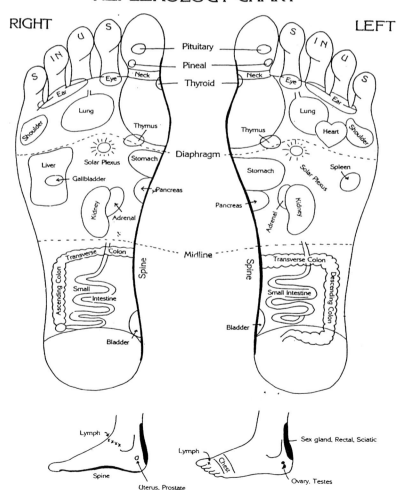

Resonation Tracing carries over to its most ultimate *match*, when a *print* of the entire body is seen entirely **mimicked** at the ear and the foot.

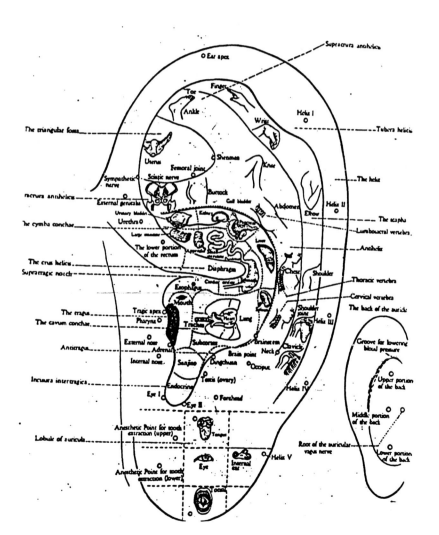

139

Voodoo Theory ©
& Narciss Theory ©

(I am offered to look away from myself through WORDS.)

No one does Voodoo like you do in a Tutu.

*Voodoo is a response to the Catholic system which does not give men and women direct contact with god. According to Voodoo, the Loa are lesser gods who are deeply concerned with the existence of human beings on earth and their fate after death. The most important object used in ritual is the asson or **rattle**. With it the Hungan or Mambo makes invisible drawings in the air.*[*]

In attempt to merge Voodoo with Custom Cut Tutu Theory © & to make direct contact with god, L. A. Ruocco acts as the Loa, through the use of Resonation Tracing © and the idea of the self-**Spectacle**, *becomes the rattle*, making drawings in the air with the shapes of her body.

 [Narciss Theory: the capability to become a metaphor;
performer / viewer proximity = 0

 & become anyone's impression,
 don't JUDGE me, because you will succeed every time.]
The Narciss Voodoo Doll, or Loa, opens her spirit for possession by the viewer:

* Kristos, Kyle. <u>Voodoo</u>. J.B. Lippincott : Philadelphia and New York, 1976.

L. A. Ruocco figured out Acupuncture on herself the same way she figured out psycho-analysis. . . as to whether she was cured is not the issue. (Note: An ass-Splinter, released my ass ki at a very young age, p. **131**.)

During the Voodoo-Narciss Performance, pins (acupuncture needles) were stuck into Under-Woman's palms, mimicking the martyrdom of Jesus on the cross, and the consequent resurrection of the spirit. In essence, she underwent a transformation from person, to super-human; a Catholic Voodoo Doll, beholding the **Stigmata**.

Masks,* needles, and various *props* are commonly used during performance to add physicality, and a realness to metaphor. Other items which lent form to the concept of the Super-Human are, a *Bird-Hat*, a hat built with a net surrounding a perch for a PARAkeet to sit inside and represent a second-head; the higher-self [the Bird-Hat was also used in the Fallopian Schizophrenia © concept and the Two-Headed Baby Phenomena.]

Shoes are major structures designed to illustrate ideas. Stilts were constructed to be worn with the Bird-Hat, and Clown-Toe-Ballet-Slippers with huge toes sculpted in the front were worn for Tutu Resonation Tracing.

Alternate Spiritual Separation:

— It is said one can go up to the mountains where the air is so thin the vampires stuck on your soul go screaming off of you.

In a book of positions: One Foot Forward;
 This one's called, "bend your BACK Leg.
 "How many people have seen me bend for every bend-BACK?"

* See Three-headed-baby photo, "Loa in Tutu"**p. 142-143** (Voodoo doll/Loa holds alter-ego masks used during performance).

144

L. A. Ruocco's audience held masks of her face over their own, symbolizing the possession of her spirit. By freeing her spirit into an attainable image, the concept of, *the image of the self looks more like the self than the self*, develops. The artist, as the Voodoo Doll, is separate from her soul, positioned as the viewer is.

<u>We</u> are in the coffin.

"I'm supposed to PRETEND I'm ONE in the Crowd!?! I replace all their faces with my face!"

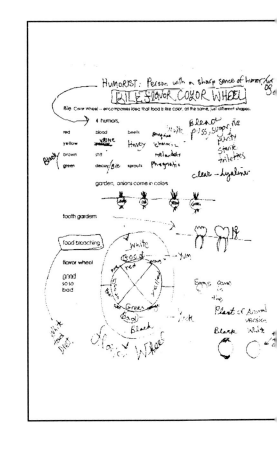

Bile Flavor Color Wheel ™

Food like color, all the same, just different shapes

Or

Green is the Same as **Yellow**, Just <u>Stretched</u> a little different.

I'm thinking I'm gonna die in a mess of my own Urine in the middle of a highly populated major-metropolitan area, AND it will be Sophisticated [a glimpse into the Personification of Color.]

<u>Humorist</u>: Person with a sharp sense of humor / Writer of comedy

The four humors,

Blood	red	beets	sanguine
Urine	yellow	honey	choleric
Defecation	brown	coffee	melancholy
Decay	green	sprouts	phlegmatic

Garden onions come in colors:

white	red	yellow	green

Introducing: **tooth** garden

Eggs come in the plant or animal version; associate white, yellow, also green eggs.✦
Feels sophisticated to be jaded - green (with envy in color break down, money [American]).
The egg<u>plant</u> grows a very dark purple: <u>BLACK {opposite of White}</u>

✦ Ref. Dr. Suess

Bile-Humor Flavor Wheel

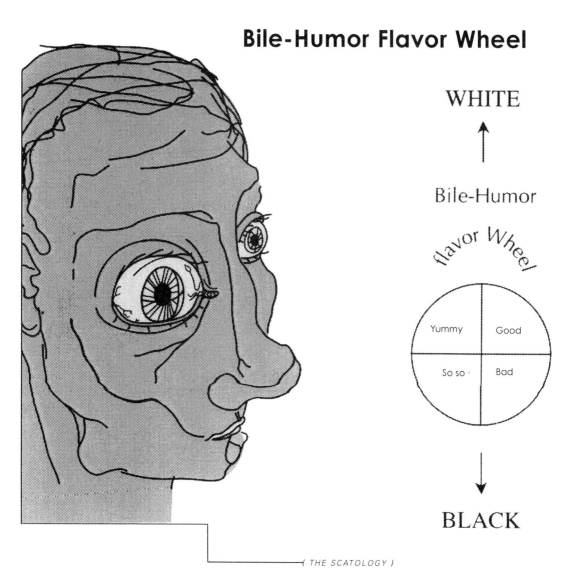

WHITE

↑

Bile-Humor

flavor Wheel

| Yummy | Good |
| So so · | Bad |

↓

BLACK

(THE SCATOLOGY)

Food bleaching - White Food Diet

Light radiates at different wavelengths, therefore associating colors to shapes, *or frequencies.*

Dantefication of Motion: "The traffic light"

 i. e., red=stop
 yellow=slow down
 green=go

Fluids: (In accordance with Yee, who frothed at the mouth.)

 Use your KamaSutra oil to raise your Chakra with your Tantra.
 You have to WANT to see a clear blue day.

Substance:
coffee *culture:*

 I flick my ash into my coffee cup.
 (Your ASH.) That's normal Reality stepped into my fucking gig.

Zippø Character List
(List of Alter-Egos)

Protagonists

Jonny — The male square. He doesn't want someone who plays dumb, he wants someone who IS dumb; Leg Waxes for a living. (The most acute and vicious, most perverted mirror. With him, you make yourself infallible to the sickest and most twisted disaster.)

Gabriel Lockwood — The obsessive compulsive; appeared to the Virgin, Annunciation *New Testament*: Lockwood: as in lock-jaw or the white worm in the wood.

Narrator — HeadQuarter's Secretary, *Interpretive Monopolizer*.

UnderWoman — Alter / super ego, performance-artist. Woman beneath the shell / mask of her own face.

Narciss — Alter / super ego, Voodoo Doll, *The Loa* [Sees her*self* in everyone encountered.] Semi-schizophrenic with physical-kleptomania personality quirks - as to watches her own characteristics in the counter person. Like Narcissi, who sees his reflection of the flower he adores as himself; Narcissism.

Double Agent — Alter / super ego, DOUBLE AGENT EFFECT © — working BOTH sides; escaping the jaded and suspect minds of the general-public (bourgeois-assed respectable-criticisms) critics proclivity for highfalutin terminology — tearing down of any post-modern labeling which is a removal, a numbing of suffering. [as Jonah curses the Lord for his (Biblical ref. Jonah & the Whale), she *asks* to be thrown over the side.]

Triple-to-Infinity Agent — Alter / super ego, Sprout Theory © Expert

L. A. Ruocco — Author, painter. Nice sweet chick.

150

Mom — Said to have strange fetish for M&M candies, winter of 1998 the M&M candy company came out with the M+M=2ØØØ ad slogan [See dedication].

Agent INFORMal — As to inform, (on gastric-knowledge)

Dr. Zippø — [See also Dr, pain and doctor pain] *"Dr. Pain puts himself in agony just to hurt you; he'll cut off his own hand to replace it with a claw just so he can tear at you, because he thinks it what you really need."*

FREE AGENT — Reports no one.

Secrete Agent — (Secret Agent) linguistic personal failure. *"There are Super Heroes I never wanted to be ASSociated with."*

Hannah — Sociopath; see also, *first Book of Samuel*, <u>Holy Bible</u>, King James, Red Letter Edition
1 Samuel 1:1 — And Hannah prayed, <u>my mouth is enlarged over mine enemies</u>.
1:1 He loved Hannah, but the Lord shut up her womb.
1:7 She wept & did not eat.
1:10 And she was in bitterness of soul
1:13 She spake in her heart; only her lips moved (Eli thought she had been drunken)
1:22 Hannah went not up, for she said unto her husband, I will not go up until the child be weaned

Michael — *Jackson* or *Portnoy* [performance-artist counterpart, ASSistant in the Famous Amazing Onion-Eater stunt.] Two Bad-Asses (Too Bad) Also Culprit-1, [practices an un-planned (natural) Morphic-Resonance in his art] instigated transition from *Serious Artist*, <u>You Made Me Into A Monster, Self-Documentary in Semi-Retrospect</u> ⊓ <u>Progression of a Performance Artist</u>, the movie, about L. A. Ruocco's Performance Genesis and Succession.

rita — She's handy for tissues

Abdule — Un-official guide

<u>Origins:</u>

(example)

> Ordering Out you are asked: "How would you Like IT?"
> "Milk, no sucre."
> Then you get to drink it, and anger bitter <u>*please*</u> get to Read <u>it</u>. *

List of (50!) Unfortunate Disasters

1. Author was never breast fed as a baby.
2. It's the Vaseline you're addicted to. The invisible cream. (Mom's like - "Put some cream on it." (Like you got a rash.) You caught it from touching your in-between. Mom knows the proper noun to use; Vaseline.)
3. Attention disorder (I just kept waiting for the death scene.)
4. All **he** HAS is *coffee* & *cigar*ettes
5. I'm dried up. No good to anyone but you. I savored it and threw that cheese away.
6. Catch some addictive diseases from your Toilette. You can Wipe the toilette seat before you sit down to avoid adhesion, but not much else.
7. I've had SO many problems with my purse; 7b. Ashes in my wig.
 > 7c. "Excuse me, your TuTu's on Fire."
8. "I've hated people for the complexes they've given me. (I've snorted Tooth-decay of the dental floss dispenser.) (I thought she'd be there And she never showed.) I woke accused of stealing, when I realized I'd been FRAMED. I walked right into a trap. I said, "Listen buddy, I'll PRETEND I robbed you tomorrow, today I'm too tired to be victimized." (song lyric, "Stick'm Up, We're the Victim now," CoCoLon Album)
9. "Tell it to your, save it for your acupuncturist."
10. Michael's in an oxygen tank, and I'm here dying.

*(German (<u>der Deal</u>, Ralf Bont - begins with a Man in a Supermarket and he is choosing which yogurt (come to signify "Culture")) cross-American Lingual noun-Capitalization (Verbification), as in *Blade Runner's* conglomeration "city speak," can account for authors use of her varied techniques.

11. I've stopped bringing men home with me. All I bring are wigs. I Get in them; get into bed with them.

12. The ONLY reason I know How to Spell Bellevue is because it was Printed on the Sheets I *slept* in.

13. I jumped out of a moving car on the Highway while there's a bus riding beHind.

14. Mom's holding the cup Upside$_{down}$ as she pours the coffee and it spills.

15. My Pee Smells *really* Funny.

16. I Get up Several compulsive times in My Sleep to Lock the Door or Hide in My Mother's womb Jesus.

17. I've fine-tooth-combed the sides of buildings looking for his approval.

18. [My heart sings immunity reminiscent.]

19. I've melted my Gun.

20. I can take it one day at a time just as fast as anyone.

21. How I think it mattered at some later date seems a very Routine way to think.

22. Come home and find an onion on my nose. . . drawing (double-entén) out the infection.

23. Like we *really* needed to know an Onion'll get you constipated.

24. "WHY AREN'T YOU IN JAIL."

 "Because they haven't caught me yet."

25. Good advice:

 Step one: Wake up to my success.

26. The weather's been so morbid. Whether or Not.

27. They cut-off your Hands if you steal.

 I am an armless woman.

28. I KNEW I was going because I stocked-UP on Birdy seed.

 I'm gonna miss you like leaving my bird in the sink.

29. I was faking it, so I guess it was my own fault.

30. Carrying nothing but the right accoutrements, (- meant) he's packing the heat.

31. Behind the eyes, there is a stretchy jading,

 a gimping at the wrist.

32. They raised the rent.

33. One way to make money is to turn-in your guy.

34. I'm STILL, *pulling* hairs out of my legs. They kept sanding them down.

There's been
an EPIDEMIC!
Of an
IDIOMATIC
EXPRESSION!

ANAL-ogy.

154

35. (Can't go out because the custom made shoes aren't back from the shop.)

36. I waited for a LETTER that Never Came. (double-entén)

37. I used to be afraid of Skim, Because it was semi-Aqueous-Clear.

 (I popped a zit and found out where that {white} fluff I ate went.) [epidermal]

38. There's been an Epidemic! Of an Idiomatic expression! ANALogy.

39. My pen's turned *Silverado.*

40. I'm in Store-Bought clothes and Store-Bought shoes

41. Then to be fucking dependent on some mother-fucker

42. I know what it's like to be caught into something you can't get out of.

43. He made me bald. You made me nosebleed.

44. I walk into a colorless night, I weep beet blood.

45. I'm already over that wig.

46. Every Sin I Make I Can't Escape

47. I used to wear a shirt on my head. Now all I wear is pants.

48. Truth <u>Matches Up</u>, like fire from my lighter.

49. If I had any feelings to be hurt, **they** threw garbage at me.

50. **And now I'm on some weird drug called**
 "Your Attention."

DREAM REF. #PAGE,

TITLE & CHAPTER DESCRIPTION

#1 p. 22 <u>Balls Hallucination</u> The noticing of eyelids blinking upon
The Greasy Spoon balls as if on a gigantic pool-table —
 balls situated at random proximities.

#2 p. 23 <u>Intestinal Innards</u> Author exposes how deep her love runs
The Greasy Spoon by bringing the Square back in memory
 birthing; could also signify a menstruation
 & exemplifies the most sacred space
 Idealizing it by noting its one [special
 s p a c e] created in a joined effort
 [fornicative sexual activity].

#3 p. 34 <u>Subway Toilette Horror</u> Nightmare of an instantaneous
The Pink Pony Stall-less bathroom in motion on City
 Subway; note, filth unsanitary, public.

#4 p. 59 <u>Placenta Scissors Castration Scream</u>
Zucchini Restaurant Castration - abortion nightmare

#5 p. 62 <u>Billiard Balls, Rolling Screaming, "Eggs!"</u>
Zucchini Restaurant Dreams use *Material* from reality,this could be a
 divergence *warp / morph* from the frightening thought of
 running out of paper, as well as a menopause night
 mare & the biological clock . . . running out of eggs.

#6 p. 89 <u>Pencil Head Nightmare</u>

RealityBakeshop Murder, as she feindishly hammers
 a pencil into the head of her victim.

In some cultures, they remove women's
sex organ — war crimes have been
documented (world history) — suturing of the
labia together, even during times of pregnancy
and labor.
In this nightmare, it is a nipple which plugs her
vagina, closing the port, *buttoning* it shut.
Divergence from Material-reality could be
checking for lumps, as in giving a self-mammo-
gram.

Every dream contains some hint
of impossibility. The impossibility of the
egg in the ass is realized.

My chest contained a milk-manufunctioning
company, mass production (like ant hills)
many udders lactated in two rows like
a big harvest farm.

Opposite: I wake and it's not a dream.

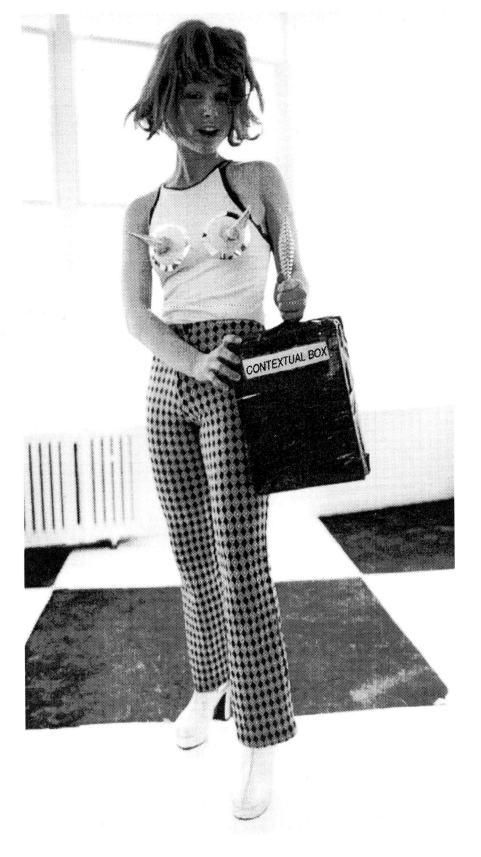

What follows are the **Instructions** for a triple-to-infinity recording device
(the performance informs as it operates).

[Can be used for circumstantial evidence.]

CONTEXTUAL BOX project

This box is collecting the signals of the entire room.

It's for the general public to get the **jokes** precisely
in the exact way they're happening in this room,

so it's picking up the signals that you would need
to communicate to someone what happened precisely
 astoundingly
you have to calibrate it
 to the level of sophisticlivity
 of action and response

start with the wig-to-box ratio at ZERO,[+]

jump on box and scream loud for high signal.

(then)

throw the box into the audience run OUT of the room,

for LONG Range signal.

then you've just got to wait it out.

159

✥ Ref. List of Unfortunate Disasters #45, **p. 156.**

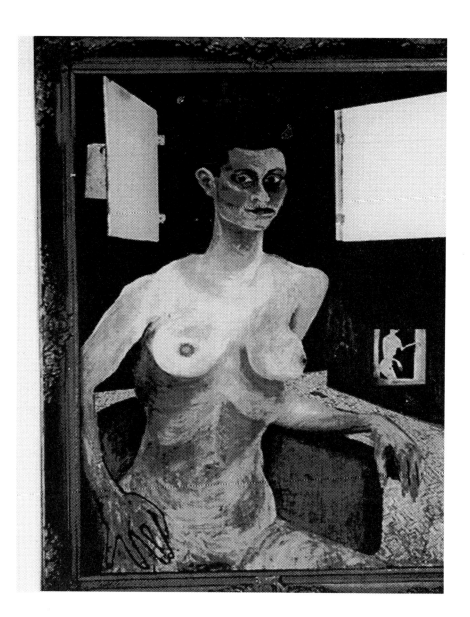

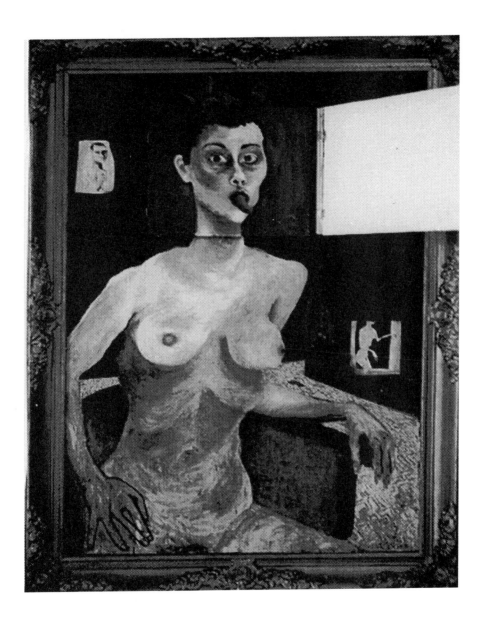

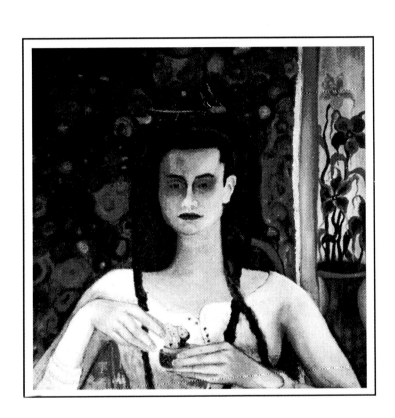

The Hannah Annotations

One Head

I picture Hannah with her head off. Just a head. And then I take it by its hair and swing it around in the air and fling it off into the brush.

I left home partly so I wouldn't have to sit at home staring at my parents' sorry asses, and it just makes me all *pissed*-off when anybody reminds me of it. So when Hannah comes into my room every time I fall asleep reading with the light on and my candle burning, she comes in here and who knows how long she stares at me while I'm sleeping, blows out my candle and shuts my light like a little mother. I just want to tear her head off.

I don't go around thinking about people with their heads off, it's just, I told her to stop a few times, and now I just caught her doing it again. Four in the morning — I find Hannah there looking at me, get so angry, "Hannah! Goddamn!" Look over at the candle, "You blow out my candle again!?!"

"Do you want me to re-light it?"

"YES!" I yell.

She stood by my bed for the longest time rummaging through that big fat purse she's always carrying around looking for a match. . . . "What are you doing for chrissake?! Just turn the light-switch back on!"

"But I thought you wanted me to light your candle," she cackled.

"Just get out!"

And she did, and shrugged her shoulders as she did.

Almost everything this girl does bugs me, her giddy laugh, her whine — she won't even curse at you if she's mad. She'll say, "Blank you!" and it just turns my stomach.

It's hard to have privacy when people don't leave you alone, when I don't answer to the first **thousand** knocks at my door. "I know you're in there," that damn Hannah will call through the door when she knows I'm hiding out from her. And then when I still don't answer she'll start using the telephone. The first few times I fell for it, but now I don't pick up the phone. And I know it's her and not some normal person calling, because a normal person would hang up before the first **thousand** rings.

My phone's all taped up from me throwing it against the wall and beating on it. But it keeps on working; it's a good phone.

Sometimes these things really make me nauseous, but it could be nothing and I'm just sick of all these pop-tarts I've started eating.

Anyhow, the next day comes and when I saw her I don't know why in hell I didn't tear her head off — I just must've forgot because sometimes she makes me feel saccharine ripe, but today I had to stop myself from socking her right in the mouth.

I got to thinking, "Hey, Hannah, do you remember that cocktail party we *weren't* invited to? And we snuck in there before it started and ate as much of the food as we could just to spite 'em, all that cheese? And then when we couldn't eat anymore we took that big wad of brie and hid it in that drawer for later?"

"Yeah," she squealed in that giddy voice, "that was so much fun."

"Yeah well, do you remember ever going back later to eat it?" I just remembered cause I was kind of hungry, and I started feeling angry about her again and I didn't remember ever going back there, and I was gonna yell at her for going back without me. But she shook her head, *no*.

She looked up at me wide eyed, and we both smiled hard at each other and we booked out to see if the damn cheese was *still* there.

As we were running I yelled out, "That was months ago!"

God, and it was *still* there, fossilized!

We were feeling so good after that that she bought me dinner, and our friend rita too. I don't know why I don't just always expect it, but we had another fight. I don't know how rita can stand seeing it over and over, she doesn't even get the satisfaction of yelling. Well I almost near socked Hannah in the face walking home.

I couldn't believe Hannah came into my room after this, but I didn't say anything, I felt bad after she just bought us dinner and. . . she keeps leaving these boxes of pop-tarts in my room anonymously because she knows I like 'em — so I just let her sit and read her magazine — but then she had to go opening her damn yapper, and she even said, "I hate you" to me, and I just lost it.

I screamed, "Hannah! Fuck you! Fuck you! Fuck you! Fuck you!" I yelled it so loudly it echoed out in the hallway.

Then the goddamn girl smiled at me. I hate when they damn smile at you when you're so damn serious, "Do we feel better now?" she said.

And I goddamn pulled that magazine from her and threw it out the door; she's lucky I didn't wrap her one.

She sat there for about two minutes just staring at me, like she does, not making a sound, *nobody* made a sound. I thought she was gonna damn start to cry. I just made like I was reading or something. rita got out of there, flew right out of there without a word — she knew what *she* was doing.

Then Hannah got up, grabbed the scarf from my head she gave me for my birthday, the new box of pop-tarts I knew she left, and all these other things I realized she gave to me. As she took them, I kept thinking it would be the last thing, but there was always one more thing, and as she finally left the room, she pulled out one of my desk drawers in a heated rage, turned it over and emptied all of its contents onto the floor as she left.

I didn't care none. In fact, I was practically ecstatic she was finally getting the hell out. But let me tell you, this girl drives me bananas — I prayed to god that it be the end. A few hours later — when I was *still* praying, there was a damn knock at my door. **Her** *blanking* knock; and then, like a stake pushing into my side, she proceeded to stuff the birthday scarf *back* under the crack of my door.

I just wanted to damn near cry *myself* over the whole goddamn thing. I *was* having such a nice day sitting out in the sun. I like waking up in the middle of the night realizing I left the light on, to blow out my damn candle and save my own damn life from burning in FLAMES.

163

But she'd never stop, that Hannah. And as she stuffed that scarf under my door, I took that very same candle she used to blow out, and brought it to the scarf and set the whole damn thing on fire. I don't know if she realized what I did.

Trouble Sleeping
(sequel)

The witch has been walking around this house with her PMS and her period for over a week now. Her nasty pheromones must have gotten to me — I woke in great pain, like a stabwound victim, blood everywhere, my thighs, my behind, my hands, all a week early. She did this to me, because all she does is stay in this house all day watching television, filling the place with her bad vibes.

And I promise myself, with this menstruation, I will expel Hannah, but I realize she is not even fit to mingle with the glorious waste muck stuck on my toilet-paper tampons which I flush into the sewer.

During dorm-room school-days she used to work the front desk, like a guard dog, making me feel guilty of my hatred toward her every time I came in.

And *now* she works the living room couch. For a few weeks this summer, we'll be subletting this apartment while I finish a job here. Meanwhile, she does everything she can to make me feel unwelcome.

She's completely inappropriate at all times and thinks it's funny.

She says, *You think you're safe?* when I go to the bathroom, and bangs on the door until the little nail I've stuck through the latch as a lock, goes ripping through the wood.

Hannah thinks she's clever turning up the television full blast when I get a phone call and telling the people I invite over she wishes them never to come back.

Yet she tells *me* she would have gone crazy if I hadn't been there with her.

I think back and I can only remember barely tolerating this mutant of a woman. We *have* the good moments together or else I wouldn't be with her at all. When I first moved in, I wanted to sleep with the window open but there were all these red beetles on the sill. I tried to get them but they were so hard. When I began to push down on them I could feel their little bodies indenting into my fingers beneath the tissue.

"Hannah, will you help me? I can't kill them."

And *she* could do it. I could hear their beetle bodies crunching, exploding open.

"Hannah, here's another one."

And only then, could I finally sleep, until she crushed them. But mostly she tries my patience, robs me of my privacy, and infects the air; *you know* — the pheromones. My ovaries are feeling like there being corn-popped.

I've stopped throwing tantrums and don't have it in me to make anymore scenes. Last week at the diner she tried to tear me to pieces, coming at me with whacking arms.

She tried to order a half-a-cantaloupe instead of the coleslaw!

You would have said it too:

"That's like saying, instead of the pickles, *could you please give me a steak?*

"Would you give me a Hawaiian vacation instead of the parsley!?!" Fucko continued with an unstoppable howl of a laughter.

Whacking arms is all Hannah was. To amuse our companions I pulled her to the floor by her hair into the isle, my tits were being exposed by her hanging from my shirt. She was trapped all tangled in the ball of herself. I laughed, as she did, along with the onlookers —except our waitress — but at least there wasn't any food involved, which is usually the case.

These incidents don't embarrass me, because they are fun, and provide innovative happenstance that supplies an outlet for vengeful aggression, which add demeanor to my character when talked about by others.

So as long as I've been living in this very nice house with her, I gulp and swallow, venting the frustration. I'm losing respect for myself, for no one should have to take such shit.

Each day that passes, her presence proves more grotesque.

She squanders her money foolishly until she has grown horribly poor and can't support her disgusting smoking addiction. Unable to afford another pack of cigarettes, Hannah laughs maniacally as she places un-emptied ashtrays on her lap and picks out the used butts one by one, lighting them, and sucking from them in front of the television. She may as well be sitting there picking and eating from her nose.

And the next day she'll call me up crying.

"Han?" I say.

"Yeah," she says.

"Han Solo?" I joke.

"Shut up!" She's lost her job and her life is crumbling. I can't help but feel better in her misery. But I can't be cruel, not like her. I come home, cook her up my special pineapple stir fry.

I tell her, "You never liked that job, anyway."

I tell her, "Look, it's only for the best, you seem to have more color in your face."

"That's make up, you fool."

Of course.

After dinner, I yell to her in the kitchen, "If you make me some tea, I'll do the dishes."

"What kind of tea would you like, honey pie?"

How sweet of her. But as I sit, her affability decays my sweetness, and she morphs into that witch, and I feel so betrayed that I was nice to her, ever!

As we sip our ginger tea together quietly, she is reading barefoot. I stare at her odd feet which is probably rude *of me*. But I've always thought she had very odd block feet. And as I'm watching . . . a fly lands on her foot.

She doesn't move.

I think nothing of it until *another* one lands and walks around on her for a *long* time — like you see crawling on starving Nature-TV. They must be attracted to the evil chemicals she emits through her oily skin.

I'm afraid I might swat *her* unintentionally, getting at those flies.

Since I've been living in this house, I've been able to kill these buggies with greater ease. I *can't* very well have them eating away at me while I sleep.

I can't stand seeing it any longer and roll up a magazine.

"Don't move," I say as if she would have anyhow, and I gave the fly on her ankle a light tap.

It fell painfully buzzing to the floor, rolled over a couple of times, but survived, and flew away.

"If you really want to get them, you have to squash them *hard*," she said.

And I wonder if tonight I will squash *Hannah*, just like she taught me.

Flip Book #2

Beware of Girls With Tails

By: L. A. Ruocco
© August 1992

Critical Analysis
(ANALIST URINALYSIS)

I peed and drank it. *

She has developed a poetics based on retraction, reduction, reaction which alleviates/elevates the lees of human existence to a pedestal. Performing for the last n years on the famous stage X, she has betrayed so much, exploited every orifice; one can hardly enumerate her works.

The urine performance, spins onto the platform tales of anti-sense and commotion by disrupting all "sensible" stage ritual, using an arsenal of techniques borrowed from the image industry, alteration of vocal range, pseudo-sexual dance, standardized postures and phraseology. She co-opts the sacred space for her pop iconic image-self; reduces the performance ceremony to one of its hidden gestural agendas; objectifying the performer to a star image.

After swallowing the stage amoebae-like, there is left only a tactic exoskeleton acknowledging the place itself, its audience, and its individuality. Substantially the place has become a fashion magazine or a vehicle Pavlovian indoctrination. Under-Woman sells America's biggest export:

Capitalism.

First, simply through its stylish use she affirms the necrophilliac and a self-destructive ideal, which hoisted onto women by popular culture confirms its propriety as a capitalist agent by selling with it.

She raises herself well above the audience like a priest and voids into a cup making a Holy Sacrament. **

The victory of such an abstract need over bodily repugnance obtains freedom by completely submitting to our simulacum, which makes and satisfies needs arbitrarily, bestowing only on the basis of submission, most generous to its most enthralled slaves.

She sells a vicarious, potential contact with her image, the very lees of human embodiment to a bathetic audience.

Invoking a product — vegetarian poetry, colored food — she associates it with phenylethylamine secretion (produced in a one-sided energetic tension) leading the audience to desire, to participate in one of the extremely bare (reduced) discourses as placebo conversation.

Blank discourse substitutes for an actual experience of love.

Beyond the freedom from mother and father obtained by Jesus, or the freedom from nation and class, from love and desire in the most common hovel of all — a perfect bourgeois slavery.

*In Aug. 1996, I Marketed NEW perfume, in the Trial Size and Spritze Spay version, "UNDER WOMAN juice," borrowing an existing cologne slogan, "Just Smell It." The main ingredient, essence of L.A.Ruocco, Pheromone.

Forward site, chapter: *The Sweaty Café*," **p.217 *He has me drinking my own piss, / He'll have you eating the flesh of your sons and daughters, / to avoid the Curse sent in the Lead that made the car go faster / and now they make movies of you when you go to the bathroom. (and when you go to another country they laugh at you in the street / at that's because they've seen your nudity.)*

DISSERTATION (part 2)

<u>#1 Onion</u> encompasses the effort to **Make the Media Before the Media Makes You**: the Double Agent utilizes reviews, advertisements featuring products and ideas which have been *worked-out*, and illustrated through performance.

Narrator insinuates we are under <u>constant</u> sur<u>veil</u>ance (sur-valance) introducing the world of "*Vector Space,*" satellites detect every position and momentum point, compiling data stored with DNA files. Spies are picking up the signals radiating from the **Uranium** we drink and make movies of us when we go to the bathroom. *They're* seeing you with the camera lens implanted in her bird's head. As if to demonstrate ideas are **Diabolical** in nature. And in other countries, they laugh at you when you walk by on the street and that's because they've seen your nudity *; an evolution as you feel Headquarters, the place in the mind of the author — the triple-to-infinity agent, O-privacy, one hundred percent information ALL in the voice of the narrator. She has invented a literature of scatalogic recovery, surpassing existential modernism, romanticism, and traditional classicism — an Ass Hard to keep your hands off of.
[The video footage taken during performances is to be used for a Comical Documentary called, "You Made Me into a Monster: The Self-Documentary In Semi-Retrospect — Progression of a Performance Artist."]

Within the Crack, [section <u>#1 Onion</u> which we are in] we explore the *Biblical* influence on decisions and categorization. <u>It explains what has been left artistically to default under the constraints of the language and material.</u> °

What follows is:

*Also Note: Author enjoys embarrassment/being in embarrassing situations but would never consciously put herself in one.

° Moses must have typed a million words a minute.

<u>Number 2</u> is the "travel" *Part II* of <u>Zippø</u>, the *Escape Through the Bowels of the Planet* (Morocco). It is a journey, featuring a coma-sick delirium through the Medinas, plus encounters with the hustlers and native families. The vivid images are situated against a melting of delusional dreams and memory, warped Moroccan reality.

It can also be seen as a historical comparison (historical opinion) between American and Moroccan culture, and shows change or development as far as <u>second-generation Burroughsian Beat poetry</u> is concerned. It contains section: **Writings on the Durham 250** and **Letters to Mom**.

Café Zippø
(THE SUB-SEQUEL)

"Honey and lemon?" asks the waitress.
"Yes," I agree.
She LAYS it on the table.
We're sitting at a café WAITING for the swelling to go down.

"Coffee's GOOD," I say, but I stopped drinking it for the taste, stopped putting-in and watching the milk and sugar, since I turned anorexic — and am going *for* the WIRED with the runs FEELING. And it started <u>tasting</u> Good like *that*, but I wasn't seeing any acceleration in the RESULTS. I'm *American,* so obviously looking for Uranium in the c^{ar} that goes Faster, AND THINK I can Kill TWO **worlds** if I take a step Back and start using herbal tea — honey's back in style 'cause it's endangered. Yeah the bees are fucked and the answer's not nostalgia.

I've stopped finding a cure when I found status quo; I've made the switch, and having déja vu in several different ways. 've stopped Thinking so much about elimination, and see *How* to live with different things for a specific AND a wide variety of lengths of time.

" **What** about the *bees?* " he asks as he milks his sugar.

"Oh, *they'll* be **fine.** They're practically **EVOLVING AGAIN,** like the Killer strain from Mexico, building an immunity to bee-parasites. Meanwhile Honey Prices are Shot-ROCKETING! The reason is *questionable*, it might be <u>FLOWERS</u> giving bees trouble with POLLINATION. You Never *Know*, so **I've** been acquiring large vats of *It* for when there's only synthesized everything, like in *Blade-Runner.*

And I'm eating MOSTLY Tofu. Beans **SURE** got fashionable when they became spreadable, and drinkable, and *freezable.* "

"I've Eaten Danté in one sitting,
I've gotten down to the BEAN with coffee."
Dec. 1996

169

L. E. S. (THE EGG SCREEN PLAY)*

And you're Hard-Boiling eggs (for a stage-performance).
You were wondering if you should bother, but it's easy enough.
Just ADD WATER. And it's safer in the long run.

"Is this going to be a commentary on menstruation (ovulation) or a vis-
cious ad for eggs?"
"Eggs, They Came First, & they're <u>not</u> for breakfast anymore. Eggs, the
food America loves to wear.
"I pulled the square. I had him ordering matzo soup,* which you should
NEVER do. He slices them into halves and quarters."
[That's how the ball, (baby), bounces.]
That's how the egg Cracks.

"DON'T GO getting all post modern on my ass."
I'm not funny then because I'm saving it for later. I'm a hedonist:‡ self-
labeling in the juxtaposition of a Performance Artist and a thief. Don't worry, I
won't mug you — I just want to take all you whackos out of context. Mr. Proverb
on my whistle-stick, I need a little pick me up & to sing tweet-tweet on my peat-
pipe, play my penny.

"Is that how you Prepare for your Performances?"

"The Doing's **not** the hard part about a Performance, *it's the TRAINING*.
The last few weeks you're tapering down,
you're getting **Stronger** because
you don't want to do <u>a whole 22 Miles</u> and then say,
'Oh No, now I've got to run a Marathon.' "

"What's it like during a performance?"

"Like **CROSSING** the finish line. Your body *gives-out*.

*The chapters of <u>#1 Onion</u>, are demonstrative of Technical
Pallindrotic Double-Entén, *Interpretive Monopoly*, p. 121 where
the narrative is dependent on the reader's ability to move with the
momentum of the author, and the story will then lend itself becoming
apparent in the hyper-cyber space.
* ordering balls, as from a catalogue and paying for it with plastic; as in buying a strap-on, a however-many-inch-screen-
television or car—purchasing his manhood.
÷ hedonism: a custom, a sadomasochistic *American* tendency known as DESSERT

"If you're a world class runner, you're fine after five minutes. But for *some* people, getting past that LINE is everything."

"When does your Performance END? Where does your performance-art end and your Life begin?"

"I'm not a performer as much as I am . . . a Scientist.

"Fuck continuity, I keep waiting for the death-scene.

"The HIGH digestibility of your poetry can <u>equal</u> that of insomnia, hard-pressed-wired*

"You've taken your vitamins & smoked your BLUE-GREEN algae.

"I'm psycho-somatic, like a semi-automatic."

Riding the Cold War self-inflicted-mild-rape AmericanParanoia escalator past possible-assumption-construct-escapades in the SuperMarket Produce aisles. ¥

And the spies are infiltrating. I'm so far undercover they don't suspect I've disappeared. ±

The song sunk
out ONE yellow lung
in the heaviness of the color pull
Pupil buckets overflow black, dark circles mold over the pale transparent mask
Poisoned porous pen poised.
The words drop smack to the bone chill wear-down
Removing the placenta face shedding
It's by no means a pass-time.

Ego-trip whose vessel has been my responsibility.
I travel light years on my intuition. à

Shall I turn the Light on?
No, that's okay; I have bat eyes. (She bats an eye.)

OH SHE's Taken 3 tranquilizers
and 9 Antibiotics. She's FEELING tired
But Really Healthy.

*The talent of charismatic masterminding is in *understanding* (readers) intellect (or, of audience), the ability to distinguish the complexities of Metabolism, the different rates everyone has, at which you tell *a joke* -- and the time and manner it takes the person to ASSimilate the "*joke*." To which I have invented and developed *the Box* to aide the process, see **Contextual Box**, Instructions for Calibration, **p 159** I made the cover of *Nostalgia* (magazine), gaining public acclaim.

¥ Video footage acquired in store-cameras is archived (in the produce aisle lenses), stored with the DNA files (sub-note: complete catalogue of Nation's entire chromosomes {DNA USA Collection} array is Kept [reason 007] concerning Alien Clone-Culture experiment, especially in the case of a nuclear-destruction. Along with video, *they* keep complete records of every where-about, Project: "vector-sector" (tracks: time, position, pose, & vector momentum) indexed via satellite [attained by following the Uranium in the Water *they* feed you].

± Under constant surveillance, it'd kill my Bird to extract the camera they've implanted in it's head, but that's okay, because they've forgot they're watching me.

à I travel light years on my intuition.

I know tRuth like as if you can BUY it like canDy.
Is my BODY **actually** DIGESTING That?

Express

Thank god you went to the everything dinner. There they give you exactly what you wanted when you walked through the door. You want coffee, coffee is ALL YOU'LL get.

And some man reconfirms you of everything and is about to tell you that he's EVEN thought about discussing it but never thought it was worth it.[*]

"How would you like your coffee?"
"Not too light not too dark."

The chef comes over to tell you how to eat your Noodles. You've lost yours. Yours. You never had them. Like Potatoes? I guess it depends on the Potato [deepens the Potato].[*]

[I stayed at home too much having too much time to play with my face. You are laughing because it was just a movie and yours keeps going. You got a book? I got a book . . . We must have been seriously brainwashed. I tell everyone we have ESP together. I got hit with a Cupcake Truck and died.[**] You were Bitch Slapped and he's got a knife on the stairs and wants to take you right there in the bathroom.]

He's a Real cowboy. He sleeps with his eyes open.
"He called to cancel the order."

"**Really**! How could you have a lover who you didn't eat the same food AS."
"You're really sick for thinking that. This is how demented people operate:
' Would you like to have dinner; I can't wait to fry my red onion.'
'I can't eat red onions.'
I *knew* that we'd enjoyed yellow onions in the past, 'Really, why can't you eat red onions?'
'Because, they just don't sit well with me.'

173

[*] This passage is a glorious exemplification of ambiguity: utilizing an array of <u>Technical Pallindrotic's</u>, namely: <u>*Elusive Adjectives*</u>, <u>*Meta-Structure*</u>, <u>*Double Standard Reverse Ambiguous*</u>, <u>*Symmetry*</u> at a meta-Meso-Scopic level, see ref. **p.117-119**

[**]The waiter doesn't believe you, ever since you passive-aggressed and accused me of taking liberties—I was born dead, and that is a relief.

Note <u>List of Unfortunate Disasters</u> #5, #13, #14, & #28, **p. 152-155.**

'*Jesus*, we can have yellow.'"

Normal people <u>stick</u> to their guns. And the pen he pulled out of the cigarette case is out of ammunition. Two puffs to go. Because as far as red onions are concerned, I believe they only belong in salads. Yellow ones get sweet in soup.

I dream of holding my eye-lids open.^μ There are integrities and recipes for everything.

THEN he told me he didn't SEE any RESULTS from beets.

I place jar of *To-Stomach-Zen* (to some extent) beet juice on the counter.

You told me out of curiosity, not to help. Intent is seven-tenths the law.

"I told him he REALLY ought to try boiling them. They get sweet that way too. That's for **beets**, not red onions."

And that was my sarcasm.

This was my secret. Beets are BEST when left to ripen in a humid refrigerator. Softened yet crunchy, there's nothing to it. I'm too smart for my own good.

May I please order an egg?

Jonny stumps the waitress.*
That's one up on him. #
She dodged him.

I can go shopping in my mind. I can think very specifically about the choice of what I'm going to get, and in the end I **can't** have it.

μ Dream List: Dreaming I'm Awake # 10, **p.157**.
*Note gender-change in the wait staff. "Stumps," as in double-entén [tree-stump], castration.
<u>He</u> scores a Point; ***They***'re keeping Score.

Sprout Theory © in Practice

"You said you just got home. But the beets are already boiling." How is it you peeled the beets and put them up to boil so fast?"

(I look down at my pinked fingers,) "You're right, I've been lying about the whole thing."

How do YOU know beet skinning takes time? Say, I was Halving skins, on them! Just face the facts.

Intrigue isn't everything and the mind is a terrible thing to taste.

I regret re-DOing Things Over. THAT's WHY I'm so caught UP on this double entendre.

COOKING doesn't matter.

It's the EATING that COUNTS.

People don't care about **HOW** you cook.

They care about How you TASTE.

 :| | *if* you've cooked

It doesn't matter if *you're* cooked;

THEY"LL eat you anyway.

I REGRET my Tofu since the Chinese decided to Grease it.[*] Since then it's nervous; I see it shiver.

"Grease is the WORD," it's not the food.

We look at the color test of our urine. Mine is pink from beets.

I'd prefer it if people came with **Nutritional Facts** depicting our reservedness verses anticipatory actions.

175

NOTE: ab c-def ghi j(e)kl m-nop q(u)r stuv w(i)xyz

"I'm gonna go **Pee**."

"I'll **Cue**."

Linquistics offers the commonly used double-éntén: PEE as in, "Mind your P's and Q's;" co-existing with the chronologic order of the alphabet: l m n o P-Q r s t u v

People'd operate with different percentages:

% enough, or too much, foresight

% apology

% regret

% fantasy

And so YOU GO through your whole life learning how to nip war in the bud, and isn't that pretty? Boring yourself with consistency and regularity. And that is me, always trying to make it true instead of beautiful and now I want my severance pay.

If everybody had a personality, it'd be nuts.

"I don't care about the Static. I want to Watch the **Static** and discover conspiracy theories, in the TV, in the ink, the print, & in the color," moving fast like light; With light.

Did you ever hear of a neurotic disorder that was picking at your gums.

I don't succumb. I eat napkins.

"I have to depend on existential objects."

"I can't help but regret."

"*Most* people leave clues."

"They just don'T REMEMBER?" [*]

"No."

I go away crying, "I Left my *GOOD* Performance *at home*."

"You're Not Leaving here until you see my Ass go from Round to Square," I pleaded.

Then you found out your mom *enjoyed* fighting with you, and wasn't kidding when she said to come over and argue. Meanwhile he is gagging on your tears, suffering from misdirected passion and stress-late periods. [**]

"*Really* Mom, just how-many eating binges am I supposed to blame on *going-to-get-my-period*."

Serve the beets.[♣] She's eating her art, *again*. Talk to the onion. Oh no, she's **talking** to **it** now. [*]

176

[*]If I ever lost my sketch-notes, I'm in **REAL trouble** because Mine are Explicit, (not cues to remember the next joke to come) MINE are **Pictures of Ass**.

[**] *Double Standard Reverse Ambiguous*

[♣] a musical—"*beat*" Cooking Show, "We're having a big Special on Sprout Theory ©. Tonight's recipe: "Rhythm," also ref. Ass Menu, [p.131], "Sprout Theory ©.

[*] get into the crate (*shopping basket* [I'm a Basket-Case]), "I'm doing a survey on *How Many* ways I'm like the Onion."

He want's a fool. Someone who doesn't care whether <u>there's some goody at the center of an onion or not.</u> I wish I could throw him a fooler fool, but I never heard of a bigger idiot. So I want too much for things to be true. Sue me.

Impolite is one thing, disrespect is another. It was Primitive-Debauchery-Carnality, God's own jealousy which interrupted the flood. I hold things so sacred. Fine if I'm mean, but being polite doesn't CLEAN the toilet.

You rely on honesty, but your honesty held no grace.

The Square wants me to get him a Box,

A box for which he can **Organ**ize his ideas. An idea box. ¤

I looked at him with my cunt-eyes connected to all my Idea Receptacles in dismay. Take a walk outside for a breather down to Chinatown to pick up some sweaty tofu.

177

¤ Not the **Contexual Box** [a] , he wanted an ordinary box for notes written on napkins.

Nero Carni
Black fish
fillet

Pesshi con Piedi

The "a" økay - Café

The chapter where Gabriel gets the "a" fixed on his typewriter.

And you realize there is a hunger in the belly of your soul and when you feed it with food, you're turning it into reality.

A woman sits down next to me and she calls a greasy grinning waiter and she orders a coffee.

"Could you pass the milk? . . .

"And the sugar please? . . .

"The coffee's a little flat today. " The cream she pours explodes up within her cup and Liquid tattoos appear at the surface.

Mom said my grandmother was so big she didn't even know she was pregnant. And one night she ate too much and got indigestion; except when she went to the bathroom she found out otherwise and brought forth a thirteen pound baby. Suggestion of indigestion in question.

He's hung up about how I don't come during sex. Jonny hates Hannah more than me. I go under, I don't resist. I dreamed Jonny had a breast farm on my chest and every morning he'd come out to milk them.[*]

And there's a woman who takes a job as a ticket booth lady at a two-headed baby show. If conveying an idea in a certain way is art than sure, I've got art.

Next time you remember to while you're dreaming look in the reflection of your behind in the toilette of your soul.

IN EVERY CASE YOU SACRIFICE EVERYTHING

The problem IS I'M AMERICAN. And americans WANT FUCKING EVERY-THING. I LOVE the new kick FLICK of my bic. Wacky adventure. YOu're ON a

[*] Dream List: Breast Farm # 9, **p.159.**

Wacky venture. I thought I was living in a cloud. He said your eyes seemed fogged up. I could feel my life deteriorating before me.

I worry about my job, tomorrow I'm gonna worry. I'm gonna stay and work a lot and smoke in the bathroom so that Merle can go right in after me and SMELL it and then tell AL. And Al's the boss so then AL'll tell the coworkers, "Somebody's been smoking in the women's bathroom," and they'll say, "Al, what were <u>you</u> doing in the women's room?" and maybe I'll feel like I'm not gonna get fired.

It'd be like, "What are you doing?"

"Procrastinating."

"Oooooo, how SEXY," ooooooo.

I'm gonna get skinny; I'm gonna fill my fix and AND START TAPING **THINGS** TO THE WALLS.

You know what? <u>he</u> want's to replay his life to see where he left his keys.[Y]

"What's N A?"

"You know how an AA meeting's for an Alcoholic? Anonymous"

"A meeting for a Narcotic? That **can't** be! That'd be like saying, *You're a PILL* (rather than, *on the pill*.) One'd have to say narcoticsist. I'm not a narcotic-sist, but I *want to be one*, narcissist narcotisist. Wait a minute! Uh oh, I think I **am** a narcotic.

Like

I'm a HEROINe"

"Hmmm"

"What do NA people say ABOUT drugs?"

"That they used drugs because they had Low self-ESTEEM."

"Didn't any of these people use it because it was FUN?!"

"Not any of *those* people."

And in the bend came the fold. And I ate drugs for breakfast and I didn't know why, just knew that I did. And everything we know as three-dimensional just flattened out. The fingers would find a place to fit between the keys as everything melted, right down. [*]

181

[Y] "Keys" to the Car, to the Typewriter.

[*] See *Symmetrics*, back ref. **pp. 117, 136 & 137.**

Le Jellø Møld Cafeteria

If <u>WORDS</u> can have breakdowns so can you.

Go to the bathroom and find the army of toilets shining, thinking WHICH one is going to give you the disease.

Mom doesn't think there's anything wrong with me working corporate, and dating a Leg Waxer. Working late until the cleaning ladies came out with their mops, re-shining the same floors every night, the *floor* waxers. And that's where the cankerous plotting takes place.

In the shame spotlight — didn't know what year it was — I only knew their kindness, like a prepubescent boy on the verge of his first lay, devirginization divergence etched in celluloid, burn scars bleach-hearted; it's blurry. ZONKED OUT OF YOUR BONKER, and never figured out SOMEWAY SOMEHOW TO RID OUR-SELVES OF THE INFLUENCE, YET KEEP THE (KNOWLEDGE) MEMORY.

I'm dying of thirst at the café where the waitress won't pay attention.

"Do you think just because your spiritual guide leaves you, <u>your story get's untold</u>?"

She brings me a coffee; you've expressed that you should have ordered tea an she takes it away from you and brings it to you again!

"I have a critical analyst, because, if I can't explain it, I find someone who can.

If I were to order an egg from the waitress, how would I go about it?"

"I'm not sure, but penguins DECIDE How many eggs to lay."

"That's impressive."

I'll have three eggs over easy, calling the man I love from the lap of another.

Nero Carni. Black fillet. Peshi con Piedi. ^à

"She is a better fish to fry, baby.

You make me want to puke in my purse. It's so hard to quit something you

^à Dark Meat, Fish with Feet / also "fish," as in , to *search*, *probe*, **dig**? & Dark, as opposed to Red-Meat. Also, see illustration, **p. 178**

carry around in your purse.*

Through centuries of evolution and engineering, we are KILLING MY KARMIC Devils, who ate up everything you left for them. They take S&M so far, and have little Girl Scouts visit me and steal my boyfriends. I become you and you posses me and we become one. ** I am vacant and my audience consisted of a group of Clairvoyant Perverts. It was easy to accommodate everyone's expectations of the things I was about to conceive."

Experience, the **non-Show**, and to witness it, you can't be there.

*"I have this personality, and I have another one in my purse," [It was like all I had to change was my wig, my purse and my shoes and I was all new!] (also, in *the carrying* of **the spare** [wig] in a purse.) Note: second-personality, Celebrity: **the Cheap Imitation**, (also self-immolation). "It took me four hours to pack my purse."

** Narciss Theory ©

CAF«E LIMBø

I HEAR THE BELL AND I WONDER IF IT'S HIM.

Come out the bathroom, and he says I smell like smoke, (the smoke of knowing.)

Oh no, he's gonna find out that I did it again, that I 'need drugs to have fun.[δ] I look at him with yellow eyes and two lungs in me hanging shrivelled yellow from the smoke I ate. I trace the sunken caves with my callous finger burned-blistered, dark circles.

Jonny suggested that I might be all lung inside and has no way of knowing otherwise.

I got a stomach fulla DRUGS DRUGGED since i smoked it. Since I'm so bad at smoking, and little piece of Drug on Fire dislodged from the masses in the thrust of my whole hearted inhale, shot rocketed through the pipe and beam-pierced the back of my throat, on fire. ON FIRE I inhale a fireball of drug. I ate smoke before Jonny was trying to weasel out of coming over here.

Since I smoked I ate it too.

Hope my parents don't smell it.

Everything falling down and I'm not gonna have to explain the things on the floor.

Highgigling horny over Jonny turning into Mute-Out man [*] slow motion man and in bACKWARDS WORLD or in ParaNOIA LAND, he says that MAYbe I'll come.?! And I didn't know if I might. I told him, "No.

No No, *don't.*"

But he says. *"IIIII* think you'll like it,"

I am every come at once since baby school days; the million comes, came in the bathtub with the shower massage. He's catching, entrapping the reaction from the longest take for ever come I'd ever seen, from sex that FELT ice fucking hard.

The fire drug fell down my lunG coldburned breathing opened-window-air-wide-so-my-parents-won't-smell-IT.

It's always I think he's on the way and he's calling to cancel.

I thought he was on the way when I did drugs.

I just couldn't go up to a woman I didn't know and fondle her ego.

You're remembering how it used to feel but have really totally forgot what that felt like.

Jonny Leg Wax says, "I'm just not *interested* in my bowels."

"No?"

"No."

"Oh. . . . But don't you ever get diarrhea, or hard ones?"

"Yeah, I mean, *sometimes,* but I've pretty much gotten used to it after doing it for 22 years."

"And so if you were a girl, you wouldn't think it nothing special if you got *a period* or something?"

"Mm Hm." (That's right.)

"You'd just be pushing your tampons in and taking them

δ Ref. List of Unfortunate Disasters #5, **p.150**, "*A new drug called 'Your Attention.'*"

* Mute out Man making like I'm deaf speaking with out a voice, and snapping with out a sound.

185

back out."

"Yeah."

"And no Star Wars action figures."

"No."

"WHY NOT!?"

"All right, but only Chewbacka because he's the tallest . . . and hairy."

Tied in my non-literal metaphor at the subliminal level, transmitting the striptease microphone tone of an idea that cannot be communicated through language or understood by words, only TRANSPOSED by them.

Got to scratch out the digestion digression.

I'm sending a telepathic message, "I was just wondering if you were conscious of it."

"No, I'm not conscious of anything. I'm unconscious."

I send the **X**-boyfriend to New Mexico, where they birth two-headed babies. And that's okay, because I'm from Cuba, where they cut Prisoners up into little pieces and flush'm down the toilette.

I remind myself although I like to think of myself as <u>VERY</u> practical, *this* is not for *practical* people.

I go to Limbo so much I gave the number to my mother; and she calls it. And at Café Limbo the pay-phone rings; the telephone rings and I get it.

My mother says, "What are you doing at Café Limbo? And why are you answering the phone!"

Gone into a colorless night, like a holiday in a motel room is your last stop on the road to transcendence. I have to pluck the coherent images of my sleep, out of unseeable haze. ^à

Turning into the trees which is the last most skeletal form, it browns, and to color it otherwise is only to do more damage. . .

The onion hangs heavy in me

à I pluck <u>Too, To</u> Voodoo Theory out of my dream.

stalk protruding
Unplug myself of this crisp yellow white gland and eat it.

The Onion is hanging heavy within me
It is twisted.

I pull my concept out of me
in egging ovulation feed upon my womanhood
an impossible imprinting of soul under Woman
She boiled her onions whole and offered them to him, to LIE like Balls
He declined
and she sat, sweetened and ready to eat.

life could <u>mean</u> taking responsibility
for the way things look
the way you live
the action you take
or you could say you were a *product of.*
You're empowered by your perception in ways you never dreamed.

if this is madness
I'll take 5

and like a television gone dark
in a room of birds chirping
ovaries popping[f]

If enough people love her
I love her
this is poetry of sheep
but poetry
I go to the super market
and I buy what I SEE.
And I see art.[*]

There is a Warning Label:

[f] See: *"Crap Happy Warehouse,"* **p.68**, & *Hannah Annotations,*
p.167, "Trouble Sleeping."

[*] See "Ass Section" of the Supermarket, **p.135**, *"Can in a can."*

**When You Eat the Art
Don't let the Art eat You**

KEEP YOUR MIND NOURISHED!
with CONVICTION

The FEELING you WISH THEY COULD MARKET.

That thing that that woman said left a burnscar
image in my head and now it's going to come out my art.

In popular nuclear thinking, (as in ameba-like), nobody deals with the Body as a
Big-Cell with the Brain as the nucleus.
If you took a Rorschach (Association) Image-Test of my Brain,
you'd get: Zippø.

The Missing Chapter:
THE BAD SHOP,
THE FAT CHAPTER

Mom's asked me why my teeth were too big for my head, and I only opened my
mouth in a showoff preen-gleam slow-going smile. [Assimilation (or injestion) may
occur at a very strange rate, varrying with structure alone; as only one audience
member is laughing hysterically for an extremely long time. . .

Scientists wonder what you lose in the pace change, in the mechanics
of the building of the soul to the surface -- in the DRAWing Up of the plans, in the
designing of the equipment leading to escalation, transcendence.

I've been bald fat & ugly, but not all at once.

My teeth fell out in my dreams again.

Mom's tooth-picking her teeth saying, "I'm eating a second meal."

I'm not an actress, but I play one on TV.
You have to have been something to know what you've become. The thing that
makes you think of something a certain way then think of it again.
I only need 2 (too) reasons to do anything. (The Left and the Right is enough.)
- I'm going to shoot you & kill you
- Both!?

In the Dantéfication © of time, I want what you déjà vu, Yin Yang footnote:["Y"
is a crooked letter & a fart, a cathartic release.] pH Balanced in the Trilogy of the

nmon phenomena—teeth falling out in dreams. ref.:**p.146** Tooth Garden from Tooth Table

191

Past Present & Future collapsed to a point.

If you think I'm such a Genius, TAKE A LOOK AT MY ASS!* I burned my ASS Down!
I'm gonna have my funeral just to get Catholicism OUT of my system. I know, but
I'm wrong. I'm Catholic; forgive me.

My concepts been growing cold at the bottom of my fridge, at the bottom of my
belly. I wonder if I heard His voice when I was younger, and it got inside my head
and grew. [footnote:Genetic Evolution]
We ALL have our OWN little inside Joke! (completing the circle)
I'm supposed to feel groovy. Don't give me your fucked up aphorisms and say
something completely advertised. One end doesn't hold anymore dignity than
another. Any end, an Ass.
Let me take you down the Ass Section of the Supermarket!

I eat my underwear for breakfast with a side of Econo-Ass.** Products that
changed the face of store-shelves of america.
In america, if you're not verbally raped you're not officially part of society. We
bring consumerism & sensationalism to an anticipatory cataclysmic hush.
Because this compositional-breakdown just doesn't CUT it! This is apocalypse, no
choice = NO COMPROMISE, NO DECISION = NO LABELING, no metaphor-cloud
[spiritual-implosion] encapsulating pain, like color has no boundaries and Picking-
Perfect merely entails a little palette-mixing, & it all costs a Quarter of a century
to buy. Lymph (gizm) clear mis-fit spaces like uncompleted true-blue circle rain-
bows have no ends. [No Right, No Wrong, No Yes, No NO -- That was a no no, this
is a 2 too. Tutu's do too come in colors.] The religionism in writing is that it can be
more like painting, not even like typography Type-O-Science, but a series of
TONES like symphonies, like string and slide-wind instruments, muscle misery bristle
pigment floating in oil dulling and slowly cracking, clarity crystallized.
He fell into my periphery and superimposed himself into my subconscious so fuck-
ing deep. I let him simmer there. I've taken you so for granted in my extremely-
subtle accidental-sarcasm for TOO long. People can come & go. I never notice
them leave, only that they're gone.
Half of me wants just to find out

194

*The study of an Ass, pp. 122-124; Also, List of Unfortunate Disasters, #46, p.156.
**See p. 135

Half of me wants the answers
Some people just Split on you, split into two.
On double bi-valence dichotomy two things are missing and nothing fits, no morals, no values or vowels to fill. You count your ASSets.
It's not just me here,
 it's half you
& half him
and half me.
Having schizophrenic conversations with yourself, "You're my Id. I'm the Superego".
"I'm speaking to your subliminal - I'm talking with your sublime, your verbal-cripple."

Jesus*, what the god-damn-hell are you doing with yourself?
I don't want you anymore
I have found behavior too ugly to ignore
You doused out my fire / you broke my desire

"How are you?"
"Not thrilled enough to find out.
 "You Too?"
 "Me Tu." (Me You)
I'm just going to eat napkins until he gets here." [edible toilette paper if not already said.]
"I know people who'd enjoy it more and that's every reason to stop."

I walked long hoping to get wet, but it never rained.
I regret trying so half-fastly half-assedly. I've met people who seemed to be serious, but I never met anybody as serious as me.
Give me back my false confidences. Only "semi-with-it" & can't close my stomach pants, lost in the ever-widening bourgeoisie ass. Let go psycho (somatic) in a self-fulfilling prophecy.
I let myself go. Toe nails so long I had to get the next size.

Hung up with a square on the Shape-Mobile tinkling in the wind, like that thought I'm never gona halve again.
In the dream the memory believes before knowing remembers, reassembles -

193

* When you're alone it's just you and Jesus.

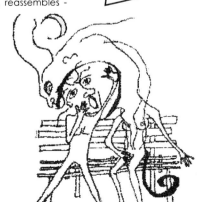

resembles. And you're having 3 kinds of Déjà Vu and the artificial sugar is turning to formaldehyde in your belly. I pass the stomach store (economy is one up on me) I want to buy the one with the tape-worm on Sale with a Coupon cut out of the Paper (a bull-shitter friend of mine once told me the average American HAS 4 tape-worms! hence 4 distinct personalities. (also ref. stomach behaves like purse in form and functionality).

I'm trying to KILL my stomach and get a new one quick. (the high density of brains in this one ticks my wiggle)
The stomach has the highest metabolism of any Limb ("part of you"), and completely replaces itself every 5 Days; I couldn't Polaroid wait.
I get flash-backs; my limbs become limber. Oh, to make a lie (lye) big enough and gum-wrapper it up, Eat the whole pack at once I Swear.
MOM Warned me, "Don't go to Morocco, they cut off your hands. . . they cut off your head!"

Every time she told it, a Bigger Limb.
The problem is there's never been a lye big enough written to cover all the ground I've skid upon. The problem is, every word I say is a lie the way I go changing my mind.
Come home with stains on my ankles from crooked pissing.
The bones cry I am not alone, carcass, scabby armed sick-smelling grime swindlers have dreams I'm shopping for toilette paper.

I lied about eating some moldy jelly to stay home from work.

In all the fat-free yogurt they try and teach you not to be afraid of fat (like heavy machinery). Tofu makes me nervous. (The Shiver). I heard they have new tofu in plants. It was on the News. I did not see this as an arousal.

I'm not anorexic as much as I have a fear of food. I eat to rid the world of it.

195

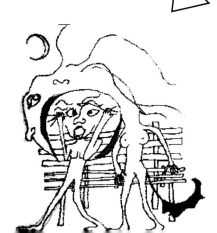

Never buy a fish in the sea, unless you're me.*

Since he told me I'll see you Tuesday** I wore my wig extra tight. For me that means I'm never speaking to you again because, you know what, by the time tuesday rolls around, I won't know what the fuck. Like there's all the time in the world, but for me there's no tomorrow.

Within my Purseñality, I do a little switcheroo. If I can't tell if you're making a question or a statement, I won't answer you. I think you should insult somebody for as long as they'll let you.

If the purse fits (Get in it)***

I'm already over that wig (List of Unfortunate Disasters: #7 & #45, **p. 155-156**).

My Purse was run over by a traffic-car vehical, The contents of my Purse were scattered in the street (footnote, note: an over-exposure) and at once it was all let out of the bag.

It's easy for the Clairvoyant perverts to be stealing my ideas before I'm having them when I'm so damn apparent. Got to be careful, because the wrong people pin me down quick-silver prick [double-éntén "quick-silver" = needle (acupuncture, Voodoo) also Silverado -Pen] seeing through my transparent fabric Onion-Skin figment-passing. The bible is about turning away and not seeing what isn't intended.[ref. Bible "Noah" son seeing his drunkeness, he did not walk backwards like his brothers. I know people who've said the wrong thing, and they got killed in a second because they didn't know GOD was in them (Uranium). There's no excuse, it's even written in Braille. You play with all kinds of things and add it all to the plague. The CIA'll put you in Jail for telling the Truth quicker than telling a lie. That's why Peter was beheaded. I've written down what I DiDn't do: operate at O-effect, 100% valancy, Free-Agent at sur-valance, that's you.

Veil my actions in art or religion or love or any metaphor you choose, I reap what

196

*Performance fish experiment, shape of the ass in the buoyancy of the ocean & seaweed.

"Bottom and Back Down Again," **p. 212;.Noah's son)

***Sept. 1997 "Performance in a Purse or Bag O'Performance" Performance Artist manufactures Transparent-Purse large enough to be (fit) inside it, like a placenta (see: "Baby in a Bubble") [Also, lend to portability concept, as per Contextual Box]. To keep secret(e) you're not in Fashion [ref.: List of Unfortunate Disasters #7, #37 & #45 **p.152-155.**-Unless you have a plastic-see-through Purse, carrying your Wig and your Puke and a Test-Tube sample of your Feces stool-pigeon, and a (so-sick-of-your-prick) castrated cock in your pocket(book) [and you don't have to use it. But knowing you have it gives you the power of the switch-blade Gun. Like a Paradigm-Mannequin, borrowing your equipment I want to be a model and not look like one] more human than human.

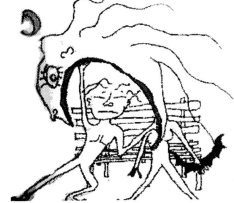

I sew Good or Bad, and it'll come back 30 or 60 times depending.
The bad man at the bad store is a short-fingered fat-sticky old guy with hair grow-
ing in the opposite spots, smiling his sweaty close-lipped I-know-what-you're-hid-
ing smiles. Just found out they call each other by hissing & shouldn't feel offend-
ed. (I regret all the fingers I flicked.)
I drank the fever, gimme the poison and the world got swervey.

My eggs Are the screen play*

Things were becoming frighteningly polished. Each time I cured myself.
(on the other hand).

He musn't have gotten the letter. I taped it together so carelessly, but now I've
got it in my head that he read it.
I'm a man on the run, victim of situational circumstance compromised to a com-
mercial sell-out borrowing the words they chose to keep.
Narcissism-Dyslexia: you might hate the mirror I am. But you can look into a metal
mirror / and you can see your image there if you don't know what an image is.
De-fine defilement, the narciss might take the personality of the media and their
facial expressions are remarkably matching the ones you're wearing. {NOTE:
SUPERFAMILIARITY, in Language and Behavior, you learn a lot about yourself when
you hang around schizophrenics, personality-kleptomania} The narciss becomes
dyslexic from looking in so many mirrors (one of those being Media) .

The Physical-Mimic physically bends with inflection, the paradox of syntax con-
flicts itself but contains truth, Lives above predictable response social program,
hereditary circuitry. Find an equation and disappointment's creeping upline slow-
ly. Words Overfilled to the Brim and anger was moot now.
I seem so deranged, a fluctuation in stabilization Query.

Another waiter episode:
Stop playing Jedi mindtricks with the waitress. She's HERE to serve you.

*Performed play in which the lines were Written in a carton of eggs, the
actors read off the shell of the eggs. ref.: Detachable Eggs concept
derivative of John S. Hall's *detachable penis.*
Dream: #4, "Catsration," **p. 158.]

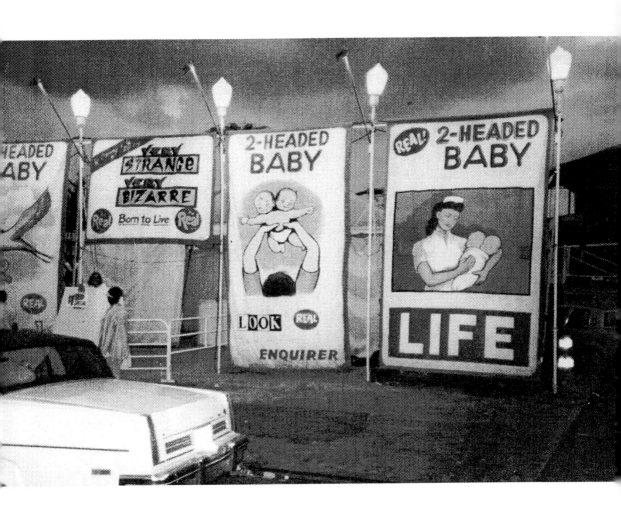

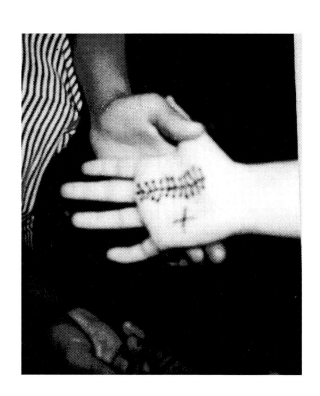

Number 2

ESCAPE THROUGH
THE BOWELS OF THE PLANET

CAN I HAVE
A GLASS OF WATER?

MY HEART'S ON FIRE.

MoM ALWAYS TOLD ME
PEE it out;

Dowse the flame.

```
PREPARATION - H                          5.59
DEODORANT STICK                          2.59
LEG WAX                                  3.59
CAN CORN                                  .59
CAN CREAMED CORN                          .59
CORN ON THE COB (8)                      1.07
POP CORN KERNELS                         1.09
CANDY CORN                                .59
BLUE CORNY CORN                           .59
HORNY CORNY                               .59
CAN BEATS                                 .65
ANTACID TBIT              3.99
         Total Tax                        .00
         Total                        $ 23.72
         CASH                           25.00
Change                                $  1.28
```

The Sad Sandwich Shøp

His penis is yellowed, flaccid with the shimmer of dirtied KY. It'd been in my holes; and it'd been tough in there.*

I apply hemorrhoid ointment between my coitus sore buttocks, stick the tube up and squeeze the cream out. It makes me feel creamy inside.

"There better be corn cooking when I get back."

Corn makes it easy on the hOle going slipperly by in its whole kernalness. And you can SEE it when it comes out — like when you see pink, and it's from beets, and love every slippery inch of it.

I'm MAKING the cream flow down from its binding in the constipated spine of the book. And in the shapes expelled, I see jelly faces hardwrinkled from ache and age, and yellowed and pinked from the food I eat.

The shapes expelled are shapes of penises; they sit like eggs, porcelain dwelling sleeping deep fish.

206

*Preperation H: "H" as in Him and if I should put some in there and have him sodomize me, it would shrink His.

morrocan toilette shop

It was sexyblood lust, a sexy hunger as, seeing it hanging, I wanted to borrow my boyfriend's cock. My eyes only registering flashes imbibed with wavelengths of fear. *

Off-kilter altered with the idea of a Prosthetic Ego.

Cheating yourself is like drinking from your own boob. In milking the desire, I'm jerking the cock. [If I lean my head back one boob should erect itself and lactate comingly.]

I'm reeling in the terror of it. Fuck, and stay in bed, plucking my cord, trying to distract myself without distraction I'm worrying myself psychotic thinking about how long she can go without feeling love, the same way anorexics think about how long they will go without food — anorexics always allowing themselves one or two foods that they can eat as much as they want of, like corn. It's not an antidote, but keeps the underbelly of the city down, keeps the cork from falling out that already ruptured off in a place there wasn't supposed to be a hOle. Holding steadfast-pretending and trying hemophilia to keep the pressure down.

Trying the Preparation-H and the laxatives in the city at the sad sandwich shop where people don' t tell crazies, where to go — like Gabriel who I have a head full of files ON. Boxes full which I had my shaky hand agent bring, which I translate. Gabriel's mind, my tool; and the chisel can't conceive what the shit is shaping into. Ink oozing, and boiling down the vat, blue ballpoint molten, I have to shake the shit OFF my thoughts, **cracked in the crack/half-time,** the blink out blink on **pupil dilation** zone, and in the panic, stricken against the smell that stretches your nostrils, it's easy to get violently terrified.

Boxes telling you to put-out-the-fire in your ass with preparation-H, that's a big H for your hemorrhoid, for your aneurysm cancer.

I get home, "Man, my ASS is ON FIRE! I think I need laser surgery."

The hole of my buttocks widens as the medicine works; when the pain is gone something crawls in and eats at my numb shrunk-swollen tissue.

I've got the creeps gagging me over my words, caught in the night like a frozen dildo stuck in the gears of a machine screwing up notions about your

*Yellow light radiates at 2345 l.

own identity, crooked and malfunctioning.

Palms rubbing into the hairs of my crotch, a crotch that had the idea of castration intuitively. Born having the absence feeling, the desire for the abscess. Lifting the skirt exposing an ass no matter which way I turned. —

I'm standing agasp jealously skeaved-out, pointing at the bulge in the crotch of some abnormal young girl from babyschool days of someone else's memory, and one kid declares, "she has a penis!"
I'm *obscenely* jealous, before she breaks out in wail, and says, "NO I DON'T. I just have a fat pussy."

— fat pussy complex and women with penises attached and not sure if they function. And *I've heard*, if your thumb is destroyed, for example freak accidental, surgeons'll take the big-toe off your foot and reattach it to your hand and it works just fine.

His penis lay like necks of sliced-necked chickens slung-over on the chicken counter gone rubbery bad, unharvested sun-flowers slumped heavy fluke cooed in the market of my mind lie the feather-plucked, dead. They are so many, many chickens slung-over dead in the market of my mind, I can't help but mention:
They sit in my mind.
They LAY in my mind. Lay eggs.
Boiled eggs, set in the toilet of the book in the toilet of my soul.

Gabriel collects the resin off the mounting agitation, the crust off [the cunt at the] core of the cosmos. He gets that feeling like he was in a café carved out in emptiness, knowing he can make contact through his typewriter, which he says makes the telephone ring, but really he's just typing all the time and the telephone happens to ring while he's typing. The telephone rings and tells him where to go, and he goes there, and when he's there he sees something that the tapping of the keys led him to — and he sees what she can do for his cock.
Gabriel is dripping himself like semen at the point where the thing you were counting on going right went wrong. His files are the mind of Satan stolen

209

out of the toed-grip of evil, and the only thing that keeps me sane. Reading them is picking the *love-me/love-me-not* petals off the flower, plucking feathers off the skinny chicken, pulling the limbs off a voodoo doll. [*] And too distracted myself, to understand too many of the words, roomer has it, he's got thousands of new pages I've yet to get my hands on.

A device slave to certain verbal constrains. Stuck like a hard one stuck in the hard curl-intestine of an anal-retent. The gate is locked so tight even in the spasm of ejaculatory creation.

Hannah never called me back, [2] in the urgent impulse that I leave. Sick of earning MONEY at the regimentry **day**job where every day is Monday, nothing changes from one day to the next except for the food you order. Cube culls cube asking what lunch they've eaten, and planning lunches for tomorrow.[3] And can't DO the **night**job I accept as the ticket-booth-lady for the **Two-Headed-Baby Show**. People pay a dollar to go in and see. Some people argue, that there ain't no Two-Headed-Baby in there. But there is.

Don't touch me or I'll get internal bleeding.

They call in other doctors to grope a feel of my schizophrenic-ovary [4] juicing hormones. Gabriel'd have a field day on my ton of agitation.

No one taught me to be good. Mom only told me not to steal while I was *there* because they cut your hands off. In *America* they don't stand for that. If you're walking around without hands they transplant your toes.

My limbo-bound mind keeps me from being nourished by any kind of conviction. Might as well forgive everyone because as far as I'm concerned, every face may as well be a metaphor — every sneer, hiss or false tongue.

I get on the plane dreaming about the Two-Headed-Baby and the girl with the Fat-Pussy hoping to god, the corn will be ready when I get back, and worrying if I'll come back with hands.

My mother's furious *at me for* smelling up the kitchen with onions, for watching Moonstruck too many times in a row, and for going to Morocco alone. She cut the plants down in the backyard.[C]

I lived in hot uneasiness, wrote with the throbbing in me of my stomach

210

[*] Voodoo Theory **p. 140.**

[2] Hannah Annotations, **p.163** & List of Alter Egos **p. 150**

[3] **Cubicle** (ky»b"-kel) *n.* exponentially worse than squares. *pl.* cubicles, *adj.* cubically; as in cubical, cubic, sounds like pubic. [Lat. *cubiculum.*][colloquial: cube]

[4] Two Headed Baby, **p. 199** & Fallopian Phenomena, **p. 114**

[C] List of Technical Pallindrotic Double Enténs, Physical Stripdown, **p. 117**; Cite: *The Stomach Monster* **p. 119**

rumble my many and MOST exciting eliminations — the feels of them passing, acidy, and I'm sure he didn't appreciate me writing about that and Cher, and no wonder there was no response.

They told me TAKE YOUR FINGERS OUT OF YOUR NOSE, THERE'RE GERMS UP THERE! That's what I learned. Breathing stiffly through stiff nostrils and sorry you made your mother worry.

Missing the company of my male square who comforts me, I counted the sheared sheep on the roadside to fall asleep, no sooner, counting plague rats to wake from a nightmare. Change in your life makes everything look different.

DRUGS	FREE
MINT TEA	FREE
GERMS	FREE
DYSENTERY	FREE
WC	FREE
WEIRD BUGS	FREE
TEMPO TEN PACK	10 £
HOTEL ROOM	30 £
DOUCHE	2 £
HAMMUN	5 £
MASSAGE / WASH	15 £
MANUAL TYPEWRITER	250 £
Total	362 £
DURHAM	400 £
Change	38 £

The Bøttøm and Back Døwn Again

Like déja vu, Only it's true. ±

I never wake up until tuesday. Squirming in my bed, in my hotel room, writhing over my stomach full of bulk, a bulk giving me jarring bellydance cramps.

The food quakes down my intestines, pushing into aching guts, and when it hits my internal ass — my hole puckers and is telling me it is ready to vomit and my face curdles into something tense.

I pinch my buttocks closed and pray it can wait; but it doesn't.

Shouldn't have eaten cause you knew you'd be sick; and you have to use the makeshifted toilette you constructed in the corner with a bucket and the Koran as a lid because you're too afraid to walk to the Water Closet. [closeted]

I pray my next crap will have some hint of consistency.

The food I'm shitting became looking more and more like how it entered my mouth.

Corn is nothing special anymore.

Get dazed from the Water Closet, the dazingly small place at the end of

the hall. The tiles, not the pristinely mr. clean-commercial-white, instead mosaiced with a dizzying kaleidoscope, and in the middle is the hole in the floor, like the one in the head of a hustler you'll meet — a hole where there used to be his eye. A sunken-in blood eyelid hangs over it.[*]

Go to the dream city and see what you become.

Hannah would turn into a black-ash beetle here; and I, into a slimy sweaty silver fish with a slick wet curve of a back and little legs that were once my fingers, yeah like Kafka and Croonenberg.[**] Shining out slivers wriggling spiderweb tentacles dancing out the crescent of my opening eyes when I had that queer crazy pussy inside-out feeling, every touch or look, an offense.

Wake up to a silverfish crawling up my neck, get it off me and it crawls under my pillow, I go back to sleep.

The sink in my room runs water for three hours a day. Most days I miss it.

Here is the Venice of Africa, fecal canals run through the Medina at night. *Here* is the bowels of the planet.

Trapped in the place where the way out isn't as easy as the way in, closing the door on their hands as they try to chase you. I won't make it to the WC, **they'd get me if I could,** if I could make it to the hole, not a porcelain to steal piping plumberage. The hOle in that rOom is a continuing digestion, an intestine-extension. Squatting into an empty eye socket, a hole which gave a nostalgia feeling, and plugging into it was an addiction.

The big Stomach gives a growl. [*]

Strip the cock clock pale and push the hands back with your fingers, and scared like someone who's just heard the call of the demon on the other side, and who doesn't want to admit to herself that she knows she's heard it and knows what it meant. She knows that she's about to melt.

I'd admired those people who'd live portions of their lives without income, in a solitary state for one reason or another in the new place, whether they panicked through or not, who've endured one day pass into the next without diver-

213

sion. No starting point or end, nothing to compare themselves by, like a meter or a dollar, consumption=0.

I haven't even begun to learn the meaning of seclusion because fear conflicts with the seed of amorphousness. I'd be in isolation, except for the guides all talking with that same hiss, and one with two eyes I'm resenting, who's always got me wearing his sisters clothes, comes for me twice a day, shouts up to my window and struggling against visceral impulse I go. He's nothing like Burroughs's; mine's a homophobe. I tell him I'm too sleepy, or pretend I'm not there. Ignoring the call in the night like the one from your stomach that gives you the creeps up chillingly your spine, convulsions like the ripple of a lump of sugar in a cup of a higher power which is stirring you till you dissolve, getting you so side tracked you can't get it together but it's tingly sweet.

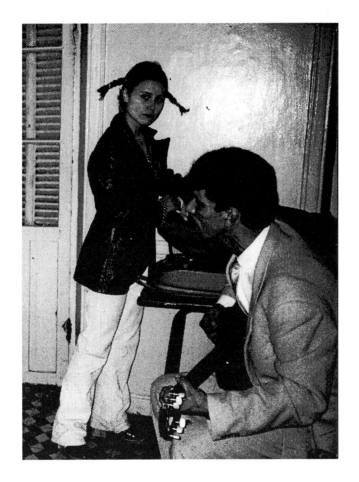

Lost Limb Lane

In the darkness of your mind when the devil appears because you're scared, and you can see the bulge in his hard-on crotch, don't be surprised when he asks you to jerk him and he opens his pants and it's a toe transplanted there, cause he's the fat pussy girl out for revenge, and if he should fuck your mind with his jointed finger clit, don't be surprised.

The Sweaty Café

Sweaty Café its humid and chilly bone aching whether over looks the sea and you're outside alone and pushing off the flies that stick to your sweaty skin.

You've come with intentions and too many expectations.

Shocked out of the blue room fable fairy tale.

Yellow greasy sick, bad toothed juiced strained.

You add it all to the plague.

He has me drinking my own piss,

He'll have you eating the flesh of your sons and daughters, Û

to avoid the Curse sent in the Lead that made the car go faster.

Economy is set up on the curse.

It changed overnight with Reagan and Nixon,

Uranium, the Satellite, and the video-tape. That's how they make these movies.

It's in the water we drink and * that's the white worm in the wood that eats on us forever.

They have chosen to Scare me **pickless**g; predicting a large % (percentage) of my maneuvers, organic / natural & culture induced.

I've been so scared I didn't drink my coffee; I left it there. I've confessed my sins into the faces of Evil..

It's easy to Spy on someone who Wants to be Exposed.

And before you Blink an Eye the Angel has gotten to its destination.

217

Û Cheating yourself is like drinking from your own boob, <u>Number 2</u>, **p.206**, "The Sad Sandwich Shop."

* ***They*** have tracking devices, [They, being the FBI & the CIA.]
 Note: "**Bill Clinton's been going through my garbage**."

g **Pickles-less, picking-ness**

Page Zero

The writings on the Durham 250

Marrakech, Fez August 1995

&

Letters to Mom

Page I

Better take it easy on the Tempo. Tempo brand tissue. Having a *wish-I-hadn't-thrown-the-powder-away* rash feeling,
Fez donkeys, Marrakech motor-bikes dustyrunning. Abdeliah-7000007, Big Lips Bad Teeth, keeps me from getting run over by them.

Given an infusion of tea *from* the dried poppy *flower* buy a man in a shop. A handful of them boiled up with sugar *for* taste made me sick and crazy. I walk drunk through piteous crowds in the souks and medina, landed at a café almost vomited twice. I order two coffees.

But I only drank one.

7000007 found me there and sat down. Argued politely with the waiter that he didn't order a *coffee*, and I told him, they were both *for* me.

Inking, inking thinking, having that, *I-can-taste-the-coffee-in-my-mouth-again* nausea feeling. The typewriter is hard; not easy to hit the keys; the ink smudges, I spend all my time opening it up. Get my *fingers* inked *fixing* screws, trying to get the *f* not to stick, and re-threading the ribbon.

Page 2

Escaping the presence of abdul-700005, and his brother abdul-7000006. Get back to the hotel, and give them the money, pull the Durham out of my pants and put it on the desk and he gives me my key, and I run up the stairs, step up the stairs, get into my room and check to see if I've got all my limbs. I didn't do anything today.

Seven-triple-double-o-7 took me far out. I followed him mistakenly. I didn't even get the Tempo I needed, or the oil for this typewriter.

It's always the same story, not today, comeback later.

I listen to the go-at-night flush'n. Too bored, feeling the same old unwanted feeling sitting in the sweaty night.

Page 3 Thug-O

Baby, when you get tired of the souks, you know where I'm at.

Leaving one blue room for another, with no flow on the fucking epic of a stinking mixed up lettered ribbon-come-loose-all-the-time. It's the Durham 250, the Durham 250, and it comes in powder blue, cheery like the rooms. You can't afford the slick

metal insect primslick high action kicking model. Zap shooting
thunder bird no letter sticking American.

The pages are looking like his, except shittier, shitty-
er

All the English they know is song lyrics. Beggars come to
me asking for Durham, "Sorry, all's I got is big bills"

I don't want to know you anymore.
I don't want to know who's outside my door.

I don't care about routine, not afraid of it the way I
feared my get up go to work, come home for television, maybe some
other stuff lifestyle. I'm not afraid of cooling off in the sink
jerking off, wake leisurely, get up to get a fried egg sandwich,
hell put three eggs in it this time, and yogurt — the ones your
afraid to eat because its store-made, cold and sweat-store-made
yogurt, the ones you're afraid to eat because you think you'll
get sick, but if you try one you'll want another.
I miss blue candy and Yoohoos.[*] The last thing I ate
before I got on the plane.
Fuck this fucking typewriter needs the ribbon re-wound
every five minutes.
As I rewind the ribbon which is the only way I know how
to make the thing work, I start feeling bugs on my arms and it's
getting late and those dust particles you get on your eyes are on
mine; seeing spots spot things like bugs, and feeling them on me,
but really its all dust and the heat, my hair falling out, and
falling on me, and I'm tired, and my hands are tired. This morn-
ing I was a little bit constipated. My ass and finger tip's hurt-
ing from all the hard pressing action.

[*] You whos

Wake up and it's not a dream; wake up and it's not a dream.

If you come home too late at your hotel something bad happens . . . there's a dark thugo lurking, thugo comes knocking at your door. I don't open it the whole night, (only to slam it on his hand,) don't open it the whole night even though I have to go to the bathroom; and so I use the sink.

The sink fell off the wall.
I have abused my sink privileges. I have busted the sink.
It's ripped clear right off the wall. I tried to fix it, have it balanced on a pipe and a bolt and a chair.
It was already looking topsy, I should have been more careful as fucking usual.
I was in shock for at least three hours after it happened.
This is the kind of sign that lets you know its gonna be your last night in any given hotel.

Page 4

Better go out for a breather and some typewriter oil, and I'm out of Tempo again. Better go out for a breather after my three hour

shock siesta. Got to sew my pants up and that's
why I came back in the first place. Someone's in
the water closet and I'm gonna be sick and my sink
is dysfunctioned.

The tourists are sick to their stomachs
because of something they ate.

"You Hoo . . . Ahem . . . you who (behind
the counter) Do you mind if I take a picture of
your brains?
The brains? the brains . . . camera,
brains . . . camera . . .
CAN I PHOTOGRAPH THESE BRAINS?"
Can I photograph these brains behind this
glass slung about with the chickens;

sliced-necked chickens hang hung with
their heads still on.

It's too bad the maid who just cleaned my
sheets is gonna get crushed when she moves the
chair which is holding up the sink. Maybe if I
find some crazy glue I could super-glue the chair
to the floor.

In the baths cushioned on her fat roll
rolls of fat thighs and big flabby breasts, moth-
erly, rolls of dead skin coming off you and she
scrapped it all off you, green black snot look-
ing.

223

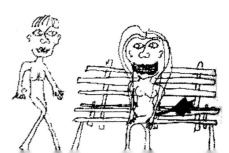

Page 5

Out for Eggs

I met a number million.
He took me out for eggs.

We sat around the egg pile,
we had them hard boiled.
The egg man cracked them
They opened.

 I knew the drugs weren't gonna work on me. I kept think-
ing is it happening? Is it happening? I'M NOT FEELING THE EFFECTS.
Only itchin' to get back and try out the oil I got on my plastic
Durham 250.

 After a day of heat, the sink didn't need the chair any-
more to stick to the wall, but I think if I touched it even a lit-
tle, I'd fall again, yeah, better get out of town, I'm losing
sight, all I have are problems here, all I care about is a sink.

 Yeah what the fuck am I doing, what the fuck am I doing,
café to box-car. I ate before I got on the train but I got a long
ride ahead of me, I always get hungry on the train.

 You find that you've got machine oil on the only pants
you have. Just can't wait to be in my hotel room hoping it's a
good one. Jerk off forever and pee in the sink.

 As I was sucked in a dirty grimy claw reached down my
throat and grabbed the thing that was eking to get out of my stom-
ach, and the pain of it scrapping out, gave me dysentery, com-
bustible shot rocket waste that'd shoot me away.
 It saved me.

224

Turn the clock back, rewind the ribbon, I had that not-flushing feeling, the don't-even-have-to-push, orange spill feeling, lonely sandwich shop come and sit down anyway, because in the sandwich shop it will be warm and time will go on with out you there. If you leave you get the sinking sinking feeling in yourself that hurts you so bad, like you're gonna get your period, or that its time to vomit out your ass again.

Might as well stay here all my life because its not worth feeling the unwanted feeling that his love dictates. Sometimes when you're outside you still feel like there's no way out.

Because, back at the hotel, there's waiting, the typewriter you took apart because you thought you could fix it, order two coffees, but you only drink one. I never used to be such a coffee drinker and you can't explain because nobody speaks RABID ASS ENGLISH.

I can never tell if I'm getting my period or if it's another case of dysentery coming on; it's always dysentery in the end.

I looked into the eye and found I was only looking deeper into his head, into his brain, hey can I take a picture of your brains mister? *

I hear the quiet zapping flicker of the florescent bulb electricity. In my small small room with the hard as a rock bed.

Fez Citi
page nine but it doesn't matter anyway

You walk into the *bad store*. The owner is fat and stupid, the yogurt is warm, the juice is sour and the eggs are bad, you wish you'd never gone there and you never go again.

I am in my room with my bed of stone. Free drugs to smoke and I smoked them so much I can't make it out.g

Sink to sink, in the hotel, splashing water to alleviate nausea, crawl to the café out in front, get my coffee. Walrus

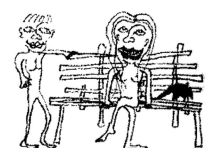

225

*One-eyed guide

g "I did it because it was free" dialogue between Gabriel and the narrator, *The Pink Pony*, **p.29.**

serves it to me, he's a real nice two-tooth man, gives me directions to the baths.

I'm at the bath every other day and they're starting to get suspicious because I'm not dirty when I come there anymore.* Just to see bluberous blub of woman form,

Clean already except for my sticky face from the Sahara Desert (dessert) I ate on the way over. I stood outside and ate it before I went in. Then I was feeling kind of sick. I go to sleep on this bed of stone with a big big headache.

I hear the buzz of the florescent, and the buzz of a mosquito coming in for the kill.

Today you meet the man with no limbs — lying on the curb in the Medina trampled after rush hour.

"Gimme money"

"No"

"GIMME MONEY!"

"Why, what are YOU gonna do with it?"[C]

Fucked up disfigurations. I'm sure it's nothing a little CREAM couldn't fix. In my head I'm thinking about Gabriel somewhere out in a fast boat speeding in the car. One turns to the other. "What are you doing?"

"*I* don't care."

Rewind the taxi meter back to zero. Morocco's too Modern for any real adventure.

Don't look forward to shit'n cause it's gonna be hard as a rock.

You send yourself far away and nothing's open except for the Bad Store.

In the room with the light off in reach of the munchy fix and eat them and taste them and feel them go down my tube that I was, feel myself swallow echo esophagus wall, sex substitute.

227

*Letters to Mom, **p. 240**

[C] List of Unfortunate Disasters #27, **p. 155**.

<u>Every thought, an after thought</u>.

Swigless Berber women, with a sway shimmy. Feeling the swingtread thread feeling.

FINALLY GOT A HANDLE ON THE REWIND OF THE TYPEWRITER RIB-BON,

I felt myself die, driving in the dessert.

"You don't think we all feel the same? And go to the same place?"

"No."

And the druggers would talk about the things they figured out in their head *on it*, and can't remember.

Word laxative and passed through the Flash Frame strobe light time, spin out zone, spin cycle *turned-inside-out* phase. And I can't leave because I got that, I can't leave feeling. <u>They ask me what direction I'm writing in today</u>.

Following the Prophet's way of life.

Cross eyed nutsoes pass me in the street, watch me eating all day in front of a café until I can't close my pants

And then I go walk until I can't close my shoes, eat a lot and start gaining so much weight and not care anymore, life is so strange that the only thing you're sure of is that you want a fried egg sandwich, gluttonous gone so out of my mind behavior, getting fat, and that's the only thing I know I'm doing.

American pining over my fat while I shovel candy down my throat, American constipated.

I might have just died on the floor of my room.

If it were day or night I couldn't tell the difference, the only thing that breaks the monotony of the room is the man-

ager's coming to collect the next days rent.

The Walrus tells you to leave your life.

People know there's something wrong with you when you spent most of the time in the blue room. They know something's wrong when they see somebody else walking around with your type-writer. They know that they are with me in the place that you go when you say you fell off the planet. That's the place where I am now.

You've got to be just the right amount high to be able to type, too much leaves you dysfunctional — notice me stagger from my hotel through the café to go throw up.

I ate some stuff that kept me in apathy for three days, it didn't worry me . . . in the meanwhile I could die with it, too hot and lie there staring out into my room, knowing I'd have to pay for the stinking room another night.
Staying with mind-sick physical absorption. I could leave, if I could; if I knew where I even was, or what I was supposed to be doing . . . but I knew none of these things.[c]
I fell in and out of that nearly dysfunctional til it's the next day, like it was yesterday around THIS time. Days are continuing to pass.
A drug induces laziness that keeps you from picking up the place, a distraction mesmerizing, remembering last night lying on the floor, thinking maybe I should get up or at least open the door in case I'm really dying and if it isn't all a dream someone will find me and help me. And a startling noise awakens you and you find that you're still on the floor and do not know how long you've been there.

You didn't think this could happen to you, but it does. It is you.

[c] List of Unfortunate Disasters #42, **p.155**.

Koran Café for a cup of coffee. You sit, you know you're working for the other side; and divulging all their secrets.

YOU ALREADY AGREED TO GIVE UP YOUR TYPEWRITER TO THEM. They're not going to let you leave without it.

You can't get off on too little but just enough will send you over. They told me that my eyes where red, that they look red from it.

I met four brothers and six sisters who are basically all the same and just a little different, I say "Don't you all have that superfluous-extraneous kind of feeling?"

Sit by the water (waiter) with drug in my belly watching adolescents strut with their no breast chests and all the people around ev'got crumbs on their faces.

Got to pick me up,

Figure out about my own inadequacies. The bus hits a bump. Sometimes you get that rumble in your belly and you know its time time time. And as fat as I got, I tried to fit into the baby-american-underwear I bought, and with spots in your eyes thinking they're little bugs and you go around chasing them smacking bare walls thinking that you're killing them dead, no you're not, you're just being crazy. Better go to the cafe before things get worse yeah.

So hot the walls are sweating sweating and you wonder why you did anything,

Ever wonder why you did anything?

Except stick to the sweat of the walls.

Page NexT Episode.

Don't bring your friends to interzone, even after the
fact, having (halving) them sit with there possessions clenched in
there arms and skeeved out in there chairs and the only thing they
can say is Eew out there twisted faces. They ate their pills for
their gastrointestines and nervous disorders and drank their bot-
tled water, shot pictures in front of the things.

I walk through the isles of the large large super-market,
picking up cans and reading nutritional facts. I'm looking at the
new foods I can choose. I'm eating what's new, and what's on sale,
the brand with the coupon from the newspaper.
Wheeling the push cart of my soul, buying the food that
makes me.

LETTERS TO MOM

Dear mom, My guitar melted in the heat of Spain. Left it out in the sun too long and it melted. Couldn't play a note on it, and its melted, but I keep it with me.

Dear mom, I got my guitar crushed crossing two-way fast-moving traffic. I'm still carrying it around even though I can't play a note and it's warped-melted and smashed by traffic.

Dear mom, My broken guitar floated me to safety. It was not useless.

Tuesday July 25th 1995
Dear Mom, Have you ever shit in a hole, stoned and alone? That's Tangiers for you. Venice instead with FECAL canals that run through the Medina at night. These are a people of dirty irrigation. They throw the sewerage into the street, shit rivers run down cobble stone narrows. It is clean by morning. My room's window opens above one of the narrow tiles-like-Paris old city labyrinth lanes. I stay in a bulb-hanging-on-a-wire from the ceilings room, the bed is big, the floor is flat, the walls are dark baby blue, very cheery.
I've been here one day and already have a guide, two in fact, and both are named Abdule; they pay for everything, except my pension. You are in a very slimey dark place.*
They think I'm a reporter, and taking notes on everything. And that I'll write an article how Everything is Free in Tangier because the people are so nice. And when all the tourists of the world read it, they'll come rushing in again to tour, and when they finally come, they'll all get their wallets ripped off.

You are in a very slimy-dark place. I felt thieves unzippering my backpack in Spain — but here I'm safe as long as I stay with my guide — who has abducted me into his family. They sewed and washed my clothes, and brought me to a wedding. "Your lucky you've got Abdule," one guide says about the other, "because everybody knows him. He's more famous than Coca-Cola." ±

232 At a pre-wedding Bride's ceremony they're putting henna in brown patterns on

*Get off the ferry and meet your black-toed black toad guide-man with one sunken eye. He takes you for a hot glass of leaves; you reject him, but you cannot escape Ñ the American traveler gets fat and blisters and is about to expel her continental breakfast because she's been drinking the water. YOU CAN'T DRINK THE WATER.
± "It's the real thing, baby."

the Bride's hands, fanning her in the heat.

How long I will stay here all depends on how well I ration this one pack of Kleenex some girl named rita happened to give me in a hostel in Madrid. There *really* isn't any napkins, paper towels, tissues, nothing. No napkins to be eaten here. I thought this Canadian Backpacker was being disgustingly crude when he said, "you better grab a roll of ass-wipe before you go over there, eh?" but I should have listened.

I was CHOOSEY with my guide. The one following me from the ferry had one-eye, (the other just a sunken in lid!); he hid it with dark glasses. I almost didn't notice.

I HAVE to trust the Abdules, because I am alone — and couldn't make it out of the medina without being lost, I'm afraid. The men are ugly and most of the women are beautiful.

I have to be careful with my customs, eat and drink with my right hand — it'd be okay to drink liquor out of your left though, because it's a <u>bad</u> thing. Now I think it's awfully fishy I write with my left hand. Writing lefty lately. [à] I love you.

I will write again soon.

Dear Mom, I'm having that not-so-fresh-feeling all over my body. I went to the Hammum [Turkish bath] for relief - they strip you down to your underpants, put you in a hot sweaty room with other women in their under pants, except they've got big droopy breasts and they're big assed. They sit you down and throw hot buckets of water on you and scrub you with a very abrasive mitten and olive residue soap. You see rolls of skin peel off. My back had been sunburned - from trying out the beaches — (the Mediterranean one day, the Atlantic the next). But it was good.

I hear music, chants on loud speakers echo, and cars beep because of weddings.

I'm really beginning to resent that stupid Abdule[l] — he's got me wearing his sis-

233

[à] As art mimics life, the novel mirrors the author in her ambidexterity.

[l] Un-official guide

ters clothes (getting dysentary in Abdule's sister's underwear), the family does my hair; they're all creaming over me, trying to teach me all the Arab words for different private parts.

I found out they DO have Kleenex here — I saw the jelaba women fixing their makeup with it and I think I know where to buy some for my trips to the W.C. — a closet, except for some pretty tiles, a bucket of water and a hole, if you're lucky a faucet.
I don't want to learn or even fathom how they use the closet, and without tissue — I can't even seem to piss without getting it on my shoes. If I squat TOO wide in order to get my feet out of the way, I might piss myself in the face. * I used to look at ALL Americans with the same disgrace because I knew they all had to shit and wipe — but here I have a deeper disgrace — and it's because they don't use toilette paper. They'll tell you it's more sanitary, but they're a third world country: Where the most horrid people befriend me on the planet.

July 30th Sunday
Mom, woke up to a silverfish crawling up my neck, get it off me and it crawls under my pillow, I go back to sleep. It's like living in a dream.
Spend most of my time getting sidetracked. If getting sidetracked's doing something, then I'm doing that.

I've become slimy, like the people, and the fish. Wonder if it ever rains here. The sink in my room only runs water for about three hours a day. Most days I miss it.

There's always some weird over friendly Moroccan offering to buy it and carry it for you where ever you may be going, and they really don't want anything in return.

> I have always admired those people who've lived portions of their lives with out income, a job, in a solitary state for one reason or another in a new city, whether they panicked through it or not, who've endured and experienced one day

234

* "I can't even pee straight anymore," Zippø pp. 9-14.

pass into the next with no distraction. No starting or end point, nothing to compare themselves by. I almost have that, Ôcept that guide who's still coming around a lot — but now a days I get out alone.[f]

2 Durham for a small packet of tempo (Kleenexes). I eat delicious food and French pastry. I feel that I haven't eliminated solid waste for an eternity. I don't drink the water anymore. It must be the lack of toilettes — actually it's not the seat I miss so much as the flush. The flush. The loud loud sound as you left the bathroom of the water speeding around and down, <u>The most sanitary sound in the world</u>.

I have to beat off the Abdules getting fresh with me. I clonk them over the head straight away, yet I'm a little lonely for companionship and a little upset that I came alone. I spend most of my time trying to keep cool in my r00m throwing sink water over my body. I found a place where when you pull a string you get a flush, you must know how happy it makes me. I've been living on fried egg sandwiches. I try to sleep through the days. My skin is browning[x] no matter how much sunscreen I slap on to my arms and face. It's becoming tough and dry, such that I can't feel the flies that land and crawl on my skin.

Dear Mom, I was just starting to settle down in Tangier, finding the cafés I like to sit in for Turkish coffee and mint tea when a Dutch gentleman asked me if I needed some help from getting away from Abdule #7, *smelly and dopey*, hounding me. I said I was fine but I left with him to Fez anyhow by train. I took a third floor double bedroom with him, and before I knew it he was in his underwear, those Europeans. .

Here the Moroccans lie you down on couches for couscous in this magnificent place — In this hotel he is reading my book — as the waft of the bad air is floating into the window as if the whole city farted at once — it is cleaner than Tangiers — but the sewerage problem is everywhere it seems — it rises up to our room. This one is also painted blue -- two beds, I let him have the big one. He leaves in a few days.

235

f"The Bottom and Back Down Again," **p.212**.

xMichael Jackson skin-bleaching technique; List of Alter Egos, **p. 153**.

I'm still having bowel problems — my biggest mistake was eating again — and today I've eaten so much good food I dread tomorrow. As I finished expelling my gruesome liquid waste into that hell hole (using my sacred Tempo tissues) I was on my way to the shower when my second comings from my innards erupted — such ass-vomit type episodes are not uncommon for me these days but I always made it to the hole — this time I didn't. I'm so dehydrated I fear my O-varies might dry up and snap off.

I love you.

Mom, took two full days of come-back-laters to acquire the cheery blue-like-the-room colored plastic gizmo I bargained down to two hundred and fifty Durham, There was a slick black metal one, but they wouldn't bring the price down, they took me to a **second** shop, where a man gets on a bike and rides away, yeah, and after a while comes back with the goods, the portable typewriters. Then we all shuffled to the general store to purchase a new ribbon. But now I've got a look at what this thing can do I wonder if you prefer I hand-wrote. Listen, mom, and listen good, writers who hand-write their material never make it.

Jane hand-wrote all her stories and she never made it.* A writer needs type like a painter needs paint.

Yeah, in the café with abdule 7000004, "Biglips-Badteeth." I don't understand the guides, but that they want to marry me, follow me everywhere. This one carries my typewriter for me and never says anything. A pleasant change from Abdule **Number Two** "*The Snake,*" who would just never shut up with his snake-hiss voice. This one is getting nervous, as I have opened up the typewriter case and the tap clap of the keys and the bell echoes shortly and sharply semi-loudly in the semi-ritzi, café. But no one minds it.

*Jane Bowles, wife of Paul; Also see ref: <u>The Sheltering Sky,</u> for origins of causality in retrospect

I could spend my days living in hotels and going to cafés for
Turkish coffee, café-olés typing about how I just fixed the typ-
ing ribbon. Typing: the skeletal backbone of good stories. I'll
spend a couple more days in Marrakech then head back to Fez, The
weather's cooler there. With love,

Don't let 'em know you're American. The only thing they want
from you is your money and your body. They only get some of my
money

Give the finger to anyone who hisses at me. Don't give 'em
any time to hassle you.

They're rotton-tooth mouths will crush.*
Their malnutritioned bones will crack under the pressure.

They can be in big trouble if the police found out what they tried
to do.

I don't know the purpose of the Teeth Men -- selling loose
teeth and sets of them on tables in the square.
Dentures paradise.
They display them like diamonds in the store-fronts.

The people here are just too skeevy to associate with.

Perhaps it was the particular place I chose, but the Hammum in
Tangier was more or less run by abrasive Gypsies. Here, naked her-
self, dark and fat, laid my small fish-like body over hers and I
was cushioned on her fat massive rolls of thighs and big flabby
breasts, motherly, mother, like you've never been a mother to me.±

In a café with a triple fried egg sandwich, a coffee and another,
I've been swindled. A trillion abdules, but I am alone

* "The Pink Pony"—compare Garbriel's teeth "yellow and dissolved," **p. 30.**

±"The Greasy Spoon," Toothsalesman, **p. 28**.

Now I've become a little constipated, must be all the egg sand-
wiches, egg sandwiches cost less than a cup of coffee. must be all
the eggs, egg sandwiches cost nothing. I can regulate my bowel
movements by drinking the Moroccan tap water, as a laxative, or
am I too used to it by now.

My pants are ripped all the way up the side and I need some machine
oil for the machine that sticks, coming apart at the seems, pair
of wet underwear in my purse, wet from the hammum, rusting over.[a]

I wonder about just what the hell i think I'm doing here. my days
are so strange and full of hustlers . . . but it feels like a mis-
sion, one I've been itchin' to fulfill.
I wash my pants every night, i think that's why they're breaking.
and fried egg sandwiches are not enough to write a book about. I'm
not ready for a steady job if I come home.

Back in Fez. August 10th 1995, Thursday. . .
Dear mom, instead of leg waxing, you'd tell me when I started
feeling down, to go take a visit to the Hammum. . start feeling
a deep-lonely feeling, no one speaks real English and conversa-
tion is kept at a level of . . . "you are happy?" and "big wel-
come". ran out of Marrakech because I broke the sink and every-
body in the boxcar train knows Brooklyn because they've heard of
movies like — THE LAST HERO IN BROOKLYN — it's really no differ-
ent from the freak show at Coney Island. and maybe when I get back
I'll take that job as the ticket booth-lady for the see the two
headed baby show . . . people'd argue about how there ain't no two
headed baby in there, but there is.

Anyway, now there are 200,034 abdules in Marrakech wondering where
I am and why I didn't keep the appointment we made. And maybe they
won't notice that I pulled the sink off the wall by accident

[a]My spare personality is a dank pair of underpants.

because I used it to pee in and sat on it and damn near killed myself. But I was doing it to save my life because even though they had real flushing toilettes in Marrakech, there are spooky hoodlum thug-oes, who follow you to your room at night and try to get in and you end up closing the door on their hands and banging in their hands so they'll get away, and they do. And you lock the door and prop the guitar against it as a safety measure, and you pee in the sink, so you don't have to chance going through the dangerous never-know-who's-lurking-out-there-hallway hallways...[μ] maybe they wont notice, I propped it back up on the pipe and a bolt and a chair, but I hope it doesn't kill the nice maid who cleaned my sheets. If she moves *anything*, she's gonna get crushed by the sink. I have crumpled letters I've written to you about jonny; I wonder about him sometimes . . . but really, I'm happier not under his love spell.[∂]

So now I'm swing kicking back in Fez, in my new little 30 DH room, with a little hard as a rock bed, the window is too high to look out of and there isn't a sink in it. It's not far from a shower and even though it is very pleasant here, and the scenery is more Moroccan and beautiful and there's a hundred times less hustlers hassling you, I miss Tangier.

Dear Mom, yeah, so I like this little area so much that I'm willing to get used to sleeping on a bed of stone, in a tiny room ever so strange, at night I stare at the four walls listening to the constant buzz buzz of the florescent, and the occasional buzz of a mosquito coming in for the kill. Keep track of all my mosquito bites, try not to scratch, and try to believe the headache you had yesterday is because of the bed of stone and not the disease you just got from the last mosquito that bit you. So I'm spraying my room with the anti-bugspray, apply anti-itch cream.[*] The worker at the café, Walrus (if you saw his teeth you would know why I

[μ] Get to practice a little Lamas breathing.

[∂] I live in total disregard of Him. (100%)

[*] Technical symmetrical mimic, hemorrhoid ointment, **p.137**.

call him that), keeps the place open late especially for me, I
think so I can sit and write.
They've got more dentists here than you can shake a stick at, but
every body's got bad teeth, more people have bad teeth than are
named Abdule, that's a lot of people. If you saw what they call
the Moroccan toothbrush, you might say that explains it, because
it looks like the stick you could shake at the dentists.

I gather that no matter how backwards this country may have been
or has become. . .it is conceivable that this place did at one
time contain some dignity. . but that has all been lost in chin-
cy gold-high-heels, hairspray, tacky moose-haired men, living the
Philamina Romano * low-culture-high-ethnic existence, kitsch to
make you sick, so sad to see the traditional old places being
occupied thusly. I don't want to put them down . . . the old
Medina's trampled with mirror-set-disco-ball-tech-like bride-
cages.
 Morocco's too pseudo modern for any real adventure.

I spend my days on my new mission . . . every day a different
Hammum. I go to them just to watch the old fat ladies bathe. Oh,
some of the asses I've seen. ±
So I think they're starting to get suspicious, since I'm ever so
much cleaner every time I go to one. I think they're beginning to
wonder, just what the hell I'm doing there, sitting in the sauna
sweating, watching the women, during their busy hours, chase their
babies, run and slide on their soapy behinds across the slippery
floors. Watching young girls bathe the real big fat ladies, get-
ting lost, disappearing into the fat flab crevices for periods at
time and emerging from other ones.

They don't know what they've got stuck in them, small children
that never made it out caught in the fat flab of an arm pit.
They don't know what they've got, and the old city filled with a
people wanting only to get out, too poor or just plain not allowed
to leave . . .

240

*Sing cheese, cheesy sounding
±Continuation of *The Shape of an Ass Study.*

At the hotel the receptionist says, she talks to everyone, she's gonna get in trouble.

get back and me and Gabriel are talking on about how we wrote, not what we wrote, embodiment.
And he is off ranting while I'm trying to keep it cool in the already cooled nipple-hard place,
You have to stay beHIND that <u>LINE</u>. And he says, "Darn it," and is trying to reach me now liying face down with only his feet behind the line reachin' me.

They say your novel is a lovely safe place to stay.

Well, good, because it's established.*

The water's spinning.

That's the plastic lid on the Toilette to Go.
The Porcelain cup of coffee.

Playing games drinking water and seeing how long it takes to come out and measuring how much.
It has become interesting regiment of drinking a cup then pissing a cup.
Drink a cup
Piss a cup
Sometimes the cup overflows, sometimes it fills it perfectly. I inspect the cup. It is warm, is it yellowy, it doesn't smellso bad, I have not tasted it yet. I think I will next time.

I do.

* Like a day on a calendar.

New from SOFT SKULL

REPUBLICAN LIKE ME:
A Diary of My Presidential Campaign
by Sparrow
$8

"All slaves freed, all debt forgiven" was his campaign promise. He unveiled shocking proof that Lincoln was a Marxist. How could Sparrow NOT have beaten Dole for the GOP nomination? Find out in *Republican Like Me*, the story of the vociferous and impassioned campaign trail of a revolutionary poet.

"One of the funniest men in Manhattan....Over and above everything else, Sparrow offers something to believe in."

— Robert Christgau
Village Voice

the haiku year

by Tom Gilroy, Anna Grace, Jim McKay, Douglas A. Martin, Grant Lee Phillips, Rick Roth, and Michael Stipe
$11

"The beautifully designed *haiku year* consists of daily haiku written by a group of seven friends....There are some pretty awesome haiku here. Here's one: 'Before you could hang up/my machine caught/ a half-second of bar noise.'"

—*JANE* Magazine
August 1998

"The real revolution will begin when we all start communicating with each other with love, honesty and purity of heart—and this book is a three-line leap in that direction."
—Todd Colby

Distributed to the trade by Consortium Book Sales & Distribution, 1-800-283-3572. Access www.softskull.com for the latest Soft Skull catalog, text, and information.

 Soft Skull Press
98 Suffolk St. #3A • NYC • 10002

Instantaneous Order Fulfillment! Cheap Shipping! & Friendly Customer Support @

1 800 BIP-OKLE (1 800 247 6553) OR
WWW.BOOKMASTERS.COM
Thanks!